# Florence
*A city with a view*

## *A great deal of water has flowed under the bridges of the Arno*

…many people from other countries come, not because of necessity, but for the abundance of crafts and arts and for the beauty and decoration of the city.

Dino Compagni, *Chronicle*, 1312

…we emerged from the Apennines and saw Florence lying in a broad valley which was amazingly densely cultivated and scattered with villas and houses as far as the eye could see.

J. W. Goethe, *Italian Journey*, 1816

Have you experienced spring in Florence? When the roses begin to bud along the avenue? When the delicate blush of the fruit trees flows across the soft hills? When the primulas and yellow narcissi cover happy fields with gold?

H. Hesse, *Italian Diary*, 1904

It was pleasant to wake up in Florence…to lean out into sunshine with beautiful hills and trees and marble churches opposite, and, close below, the Arno, gurgling against the embankment…

E. M. Forster, *A Room with a View*, 1908

This is one of the few cities where it is possible to loiter, undisturbed, in the churches, looking at the works of art…You can pass an hour, two hours, in the great churches of Brunelleschi – Santo Spirito and San Lorenzo – and no one will speak to you or pay you any heed.

Mary McCarthy, *The Stones of Florence*, 1956

# FLORENCE

## A city with a view

*Text by*
Mario Sabbieti

*Picture research by*
Ilka Singelmann Guaraldi *and* Auro Lecci

TAURIS PARKE BOOKS
LONDON • NEW YORK

Published in 2002 by Tauris Parke
an imprint of I.B.Tauris & Co Ltd
6 Salem Road, London W2 4BU
175 Fifth Avenue, New York NY 10010
www.ibtauris.com

In the United States of America and in Canada distributed by
Palgrave Macmillan a division of St. Martins Press
175 Fifth Avenue, New York NY 10010

ISBN 1 86064 831 2

A full CIP record for this book is available from the British Library
A full CIP record for this book is available from the Library of
Congress

Library of Congress catalog card: available

*Editor*: Mario Sabbieti
*Picture research*: Ilka Singelmann Guaraldi
and Auro Lecci
*Graphic design, layout and cover*: Auro Lecci

*Text*: Mario Sabbieti
*Chronology*: Rosaria Parretti
*Editing of Italian text*: Giovanna Bergamaschi, Leonardo Cappelli-
ni, Rosaria Parretti
*Translation*: Jeremy Carden

The publishers would like to thank Vittorio Giudici and Mariarosa
Schiaffino for their valuable assistance

Printed and bound by
Eurolitho, Cesano Boscone (MI), Italy

# Contents

# Introduction

Appearing at the end of Via de'Servi...as one walks along Via dell'Oriolo...or from a corner of Piazza Santa Croce...there are not actually all that many points in the medieval heart of Florence where Brunelleschi's dome is a dominant presence. To obtain a better grasp of its relationship with the city, it is best to go to Piazzale Michelangelo, Forte di Belvedere or up to the hills of Fiesole. Seen from there, it rises – *erta sopra i cieli* – above the sea of roofs, with the red of its sails and the white of its marble crests. From whichever point one looks, it is impossible to tear one's gaze away from the dome, which exceeds all the other buildings in height and dominates the space; the soaring elegance of Giotto's Campanile and the nearby tower of Palazzo Vecchio form a complementary retinue. Dynamism and solidity, energy and balance, line and volume have never been expressed with such perfection.

By virtue of its dome, Florence is a 'city with a view' like no other. The ribbon of the Arno and the embracing links of the bridges are also essential elements of the city's profile, but the true spirit and character of the city can only be grasped in the details, the warren of streets, the open spaces of piazzas, the angles of palaces and the secluded gardens.

This is not always easy to do. If it were not for the rigid traffic restrictions, the city centre would be intolerable. Even as it is, it is so crowded that it is difficult to see the monuments.

Henry James observed a hundred years ago that in the 'long outer galleries of the Uffizi...there were not more than two or three figures, Baedeker in hand, to break the charming perspective'. If he were to visit Florence today, he would not believe his eyes. Hundreds and hundreds of people – fellow Americans, Europeans and numerous Asian visitors – fill the porticoes to overflowing as they wait to fulfil their dream of entering the Uffizi. Almost ten million people visit Florence's museums each year and four million descend on the city's hotels. This obviously has a major impact on the city, particularly from March to October, the height of the tourist season. Of course, this brings a considerable amount of money into the city, which goes a long way towards justifying the strain it must endure, which is perhaps the inevitable destiny of a small but important city of art. Only on certain bright winter days is it possible to rediscover a more authentic atmosphere and a more measured pace of life, which allow a proper understanding of what the perceptive art critic Federico Zeri described as 'that exceptional equilibrium between intuition and rationalisation, imagination and regulation, sensual colour and intellectual coldness expressed in Florence, in its sculptures and paintings, architecture and gardens'. In the noisy summer season, it requires a major mental effort to look around and immerse oneself in the signs of the past, to grasp the language of the materials, the play of relations between the medieval city in brown *pietra forte* and the monuments of the Renaissance in *pietra serena*. And to note how everything is inspired by a measured sense of proportion.

The English historian Sir Harold Acton, who lived for decades in the charming Villa la Pietra on Via Bolognese, claimed that 'the Florentine instinct for simplicity and harmony – its avoidance of excess – must have been influenced by the surrounding landscape', which was 'seldom spectacular but always civilised'.

The hills enveloping Florence are central to an understanding of the city itself, but Sir Harold was mistaken. Those hills have been shaped by human hands and are the product of Florentine civilisation, first during the Renaissance and then under the reforming and scientific initiatives of the Lorraine rulers in the eighteenth and nineteenth centuries.

Culture transformed the countryside and shaped generations of rural peasants, who possessed a quite unique intellect and knowledge. This was another reason for the rapid change experienced in the Florentine world. Mary McCarthy had this to say in her appealing and incisive portrait of the city written in the 1950s: 'Every Friday is market day on the Piazza della Signoria, and the peasants come with pockets full of samples from the farms in the Valdarno and the Chian-

ti: grain, oil, wine, seeds. The small hotels and cheap restaurants are full of commercial travellers, wine salesmen from Certaldo or Siena, textile representatives from Prato, dealers in marble from the Carrara mountains…'

Everything has changed in the intervening decades, almost more than in the first 1900 years of the city's life. Peasants no longer throng Piazza della Signoria on a Friday, eating *baccalà* in the local restaurants, because they no longer exist. Although the province of Florence (and Siena) produces some of the finest wine and oil in Italy and, indeed, the world, agricultural workers (no longer peasants) form less than 3 per cent of the total workforce in the area. Barely half a century ago, almost half the working population consisted of rural families, who had close relations with the city and the actual owners of the *poderi* smallholdings, with whom they shared the products of their labours. Those families have basically disappeared and their houses, which were inspired by the medieval and Renaissance buildings of the city or were built to a specific eighteenth-century design with a characteristic porch and dovecote, have become *case da signore*, first or second homes for Florentines and for those foreigners who have made Florence and the surrounding hills their adopted home. The social composition of the city and the surrounding area has therefore changed radically; apart from the small number of people who work on the land, about two-thirds of the active population work in the service sector and only one-third in industry. The area's vocation for tourism, trade and crafts is clearly evident, while the little industry that does exist is mostly light and highly specialised. There is also a well-developed fashion sector that competes with Milan. And so, Mary McCarthy, *addio!* Everything has changed.

Trams no longer run along the inner ring-road; when they did, boys would often jump onto the footboard or dash to grab hold of, and sit astride, the rear buffer to avoid paying for a ticket until discovered and thrown off by a furious conductor. The clear silver waters of the Arno between Albereta and the weirs of San Niccolò and Santa Rosa, where young children learnt the rudiments of swimming, do not exist anymore either. In the 1950s, boys used to walk into the surrounding hills, often with their girlfriends, and stop for a snack, or *merenda*, in small village shops heavy with the aroma of cold meats, flasked wine and Tuscan cigars. Almost all of these have now been turned into sophisticated country restaurants. In those days, a few lucky people had Lambrettas, one of the early motor scooters. 'Can I have a go?' friends would ask and, a little hesitantly, one by one, they would experience the thrill of winging their way through the dozing city streets.

But there is no point in being nostalgic. Florence is better nowadays. There was considerable postwar poverty, and even though people may have been more generous and sincere in those days, many people ate only once a day. Yet frugality was also customary, as McCarthy notes: 'how to make a little go a long way: the best Florentine dishes are recipes for using leftovers…a simplicity of life Florence shared with Athens, and the great Florentines of the *quattrocento*, Donatello and Brunelleschi, lived like barefoot philosophers'.

There may have been more moral tension and political passion, and also more division between social classes. Indeed, passion, factiousness and extreme views have characterised the Florentine people throughout the most decisive phases of their history: Guelphs and Ghibellines, Whites and Blacks, Arti Maggiori and Arti Minori, Medici and anti-Medici factions marked the course of the three centuries of Florence's Golden Age, from the middle of the thirteenth to the middle of the sixteenth century. Florentines slit each other's throats and exiled each other in turn but, while doing so, they also funded major public works – the Duomo and Palazzo della Signoria – and encouraged the finest group of artists of the period. They were jealous of their freedom and political autonomy: 'perhaps no other city', wrote the historian and politician Giovanni Spadolini, 'has embodied in its history so many and such diverse forms of political regime as Florence has: the sovereignty of the bishops, the marquisate of the Empire, the regime of the consuls, the government of the *podestà*, the dominion of the magnates, the corporative order, the dictatorship of outsiders, the democracy of the Ciompi, the bourgeois oligarchy, the family *signoria*, the enlightened and paternalistic state. In its evolution…Florence offers a mirror of all the various kinds of social organisation.'

Following the siege of 1530, when the Florentines were forced to renounce any semblance of democracy, they lost their creative energy, and the supreme power of the Grand Duchy, which was imposed and passed down by the last of the Medici and then by the Lorraine outsiders, extinguished their passion. The Florentines and Tuscans at least had the good fortune to find an excellent ruler in Peter Leopold of Lorraine, who made up for the passivity of his subjects with enlightened economic and social reforms, although artistic creativity slid from the excesses of Mannerism into the elaboration of rather precious artefacts to supply the collections of the Grand Dukes. It was also fortunate that although there was a decline in the artistic field, Florence acquired a name for itself in botanical and scientific studies. Galileo found encouragement and sympathy here. The passivity of the Florentines only ended two centuries ago. There was support for the Risorgimento, a revival in the arts with the inventive energy of the Macchiaioli (forerunners of the Impressionists) and that masterpiece of children's literature, *Pinocchio*. Collodi cannot of course be compared with the likes of Dante, Boccaccio or Machiavelli, but his work stood out in the stagnant literary scene of the time and became a world classic of its kind. The mid- and late-nineteenth century, during which time large-scale building work was carried out when Florence became capital of Italy in 1865, was characterised by periods of light and dark. While this period saw the development of the harmonious avenues on the Colli and the bright, airy organisation of the Lungarni, it also witnessed the brutal destruction of part of the historic city centre. Although the Mercato Vecchio, the Ghetto and many slum buildings disappeared, so too did oratories and towers, to provide room for imposing buildings of often mediocre quality. At the turn of the century, Florence was at the forefront once again with the early workers' struggles and the institution of working people's clubs, mutual aid organisations and socialist circles. The city was divided in the early years of Fascism, which then brought a period of repression. Yet the flame of resistance burnt bright and, in August 1944, large crowds welcomed the partisans as they preceded the Allies into the city for the liberation.

The rediscovered energy of the city endures to this day. That energy is now being channelled, as it was by the corporations, guilds and big trading and banking families of the past, into the production of wealth. In the past, that wealth became the material base that stimulated intellectual thought, enabled the city to produce art and build the monuments of the new Renaissance epoch, considered by many to be the beginning of the modern age.

In discovering perspective, Filippo Brunelleschi conferred a sense of measure and harmony on the new vision of the world. Donatello moulded new ideals into the dramatic forms of his sculptures. Masaccio, taking Giotto as his starting point, provided a powerful affirmation of reality. The work of these three leading exponents of humanist culture, and the early initiators of the Renaissance, would not have been possible had they not been supported by a proud, self-aware society and by a business and working community that used its wealth not merely for instant gratification, but also to guarantee the pleasure of future generations. Even the last descendant of the Medici family, the Palatine Electress Anna Maria Ludovica, sister-in-law of Emperor Leopold I, left all the family's 'art works to the Tuscan state, on condition that it should never be removed', thereby becoming 'an ornament for the state, to be used for the benefit of the public and to attract the curiosity of visitors'. The largest art collection in the world – now in the Uffizi Gallery, Pitti Palace, the Museo Etrusco and the Laurentian Library – is the fruit of a far-sighted donation to future generations.

Many people ask how Florence will continue to manage its abundant cultural inheritance. The surrounding hills have been protected since the 1970s, but the plain to the west has been ruined by haphazard suburbs and industry, prompting many to wonder whether the environs of the city can enjoy a renewal along rational lines. Since the Second World War, Florence has had a number of intelligent, determined mayors, but the city's problems are serious and complex. The Florentines of today must emulate the figures of the past, those painted by Masaccio in the Brancacci Chapel, and described by the great art expert Bernard Berenson as follows: 'Everything that these characters do, merely by virtue of the fact that it is they who do it, is striking and important; every movement, every gesture can change the world.'

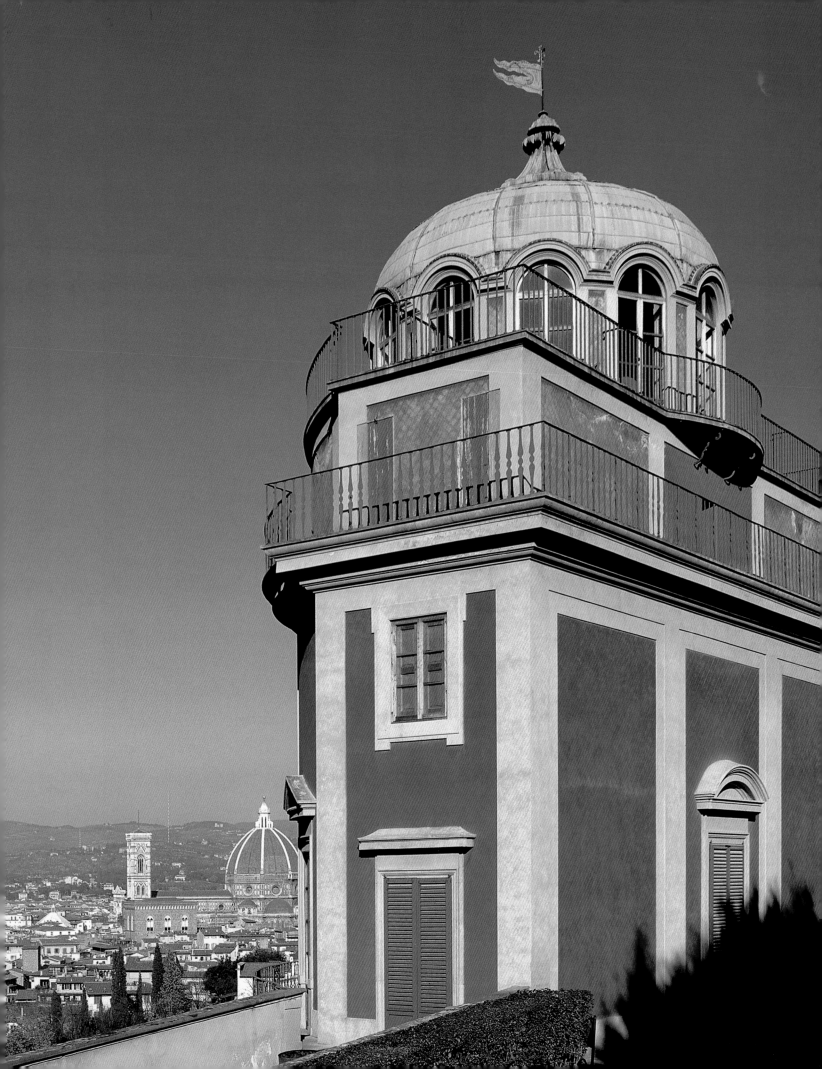

# Marble and stone

*The ancient heart of the city – design and geometry as expressions of
religious faith – the tower and palace of a proud and free comune –
the opulence of the Signoria in the Uffizi*

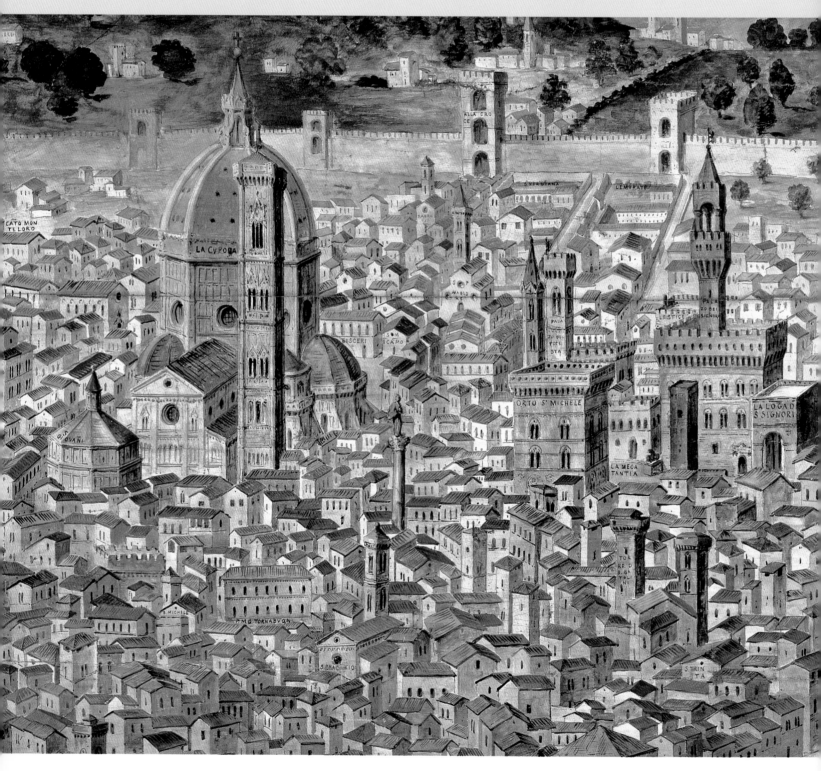

A quadrangular space of just a few thousand square metres contains a wealth of monuments that are in themselves sufficient to justify electing Florence as the capital of Italian art. This is the heart of the city, where the Romans established a *castrum* and where the Florentines forged their identity from the thirteenth through to the end of the sixteenth century. In those three 'golden' centuries, civic passion and religious faith produced an extraordinary architectural and artistic complex that is still today the living, vital centre of the city. Ice-cream parlours, shoe and souvenir shops, pizzerias and crowds of tourists cannot dim the value of a legacy that continues to fascinate humanity, hemmed in between medieval houses, Renaissance palaces and the results of nineteenth-century 'renewal'. While the bulk of the Duomo and the nearby Baptistery seem to struggle for space, Palazzo della Signoria stands out above a piazza that is both the political centre of the city and an open-air museum. History, life and art have been inextricably woven into Florence's identity since Arnolfo di Cambio was commissioned in 1294 to design both the Duomo and the seat of the city government, the Palazzo del Popolo, which then became known as Palazzo della Signoria. Even in the midst of ferocious factional rivalry that stained the city streets with blood, the Florentines embarked on the construction of proud, imposing works, expressions of religious fervour and secular awareness that were testament to, perhaps above all, an increasingly powerful economy – the gold florin was one of the strongest currencies of the time and circulated throughout Europe.

Thanks to its many powerful trading guilds and bankers, Florence enjoyed wealth that, through the talents of a group of superlative artists, was channelled into masterpieces of stone and marble, permanent expressions of power and culture, works of beauty and harmony, of human genius and innovation of a kind never previously seen. Work continued on the Baptistery, an eleventh-century Romanesque structure built on the ruins of an older classical building; in the middle of the fifteenth century, Lorenzo Ghiberti hung the doors that are dedicated to the patron saint of the city, John the Baptist, which Michelangelo declared fit to be the Gates of Paradise. In 1296, perhaps witnessed by Dante before he went into exile, Arnolfo laid the foundation stone of a Duomo that was intended to hold at least thirty thousand people, the entire population of the city at the time. He was followed by Giotto, who began the construction of the Campanile. At the base of the elegant, marble-faced parallelepiped, he had Andrea Pisano place a series of relief panels that represented the encyclopedic culture and work of the time, as if to emphasise that the upwards thrust towards the heavens originates here, on earth, in human endeavour. But it was with the brilliant work of Filippo Brunelleschi that the massive Duomo moved towards completion. The inventor of perspective, Brunelleschi, together with his friends Donatello and Masaccio, laid the foundations of Renaissance art and defied widespread scepticism to erect the massive dome, creating a powerful and harmonious link with both the city and the line of the surrounding hills.

Halfway between the Duomo and Palazzo della Signoria is Orsanmichele. Once a public granary, it became the site of an oratory venerating the Virgin and a showcase for the guild corporations, who decorated it with statues of their patron saints. The interweaving of religion, secular power and a culture of work and art continued.

If the graceful green, white and pink marble facing of the Duomo and Campanile (in keeping with that of the Romanesque Baptistery) is an expression of spirituality, the *pietra forte* of Palazzo Vecchio is testament to the vigour of civic power: red-brown in colour, it symbolises Florentine republican liberty and political and economic independence that lasted for almost three centuries before the city became a ducal *signoria*, as did other Italian cities, following the siege of 1530. Democratic government was replaced by the dynastic rule of the Medici. However, like their predecessors, they too continued to promote culture and the arts. So while the New World was being discovered – Columbus set out on his voyage using maps produced by the Florentine mathematician Paolo Toscanelli, while the Florentine navigator Amerigo Vespucci gave his name to America – the sculptures of Benvenuto Cellini and Giambologna were being positioned in the Loggia dei Lanzi next to Palazzo della Signoria. Michelangelo's *David* remained on guard in the piazza, the symbol of a now-defeated Florentine Republic and, in 1560, Vasari began the construction of the Uffizi. Intended as the administrative arm of Medici power, it soon came to house what was to become the largest museum collection of Renaissance art.

*The Baptistery, the Campanile, the Duomo – the religious heart of Florence in the Middle Ages and Renaissance – dominate all else. Other major monuments such as San Lorenzo, Palazzo Medici-Riccardi and San Marco are visible but what is most sublimely evident is the cathedral complex of Santa Maria del Fiore, with its extraordinary play of volumes and colours culminating in the stunning energy of Brunelleschi's dome, described by Jacob Burckhardt in 1855 as being of 'awe-inspiring power'.*

*The rulers of what was by then a rich and powerful city commissioned Arnolfo di Cambio to build a large cathedral on the site of the Palaeo-Christian basilica of Santa Reparata, which dated to the late Roman period. On 8 September 1296, Florentines watched as the foundation stone was laid for Santa Maria del Fiore, a building that, according to those who commissioned it, had to be of 'the greatest lavishness and magnificence possible'. Little by little, the old building was swallowed up and disappeared under the new construction, which was finally completed 175 years later in 1471, when the ball and cross were raised onto the dome.*

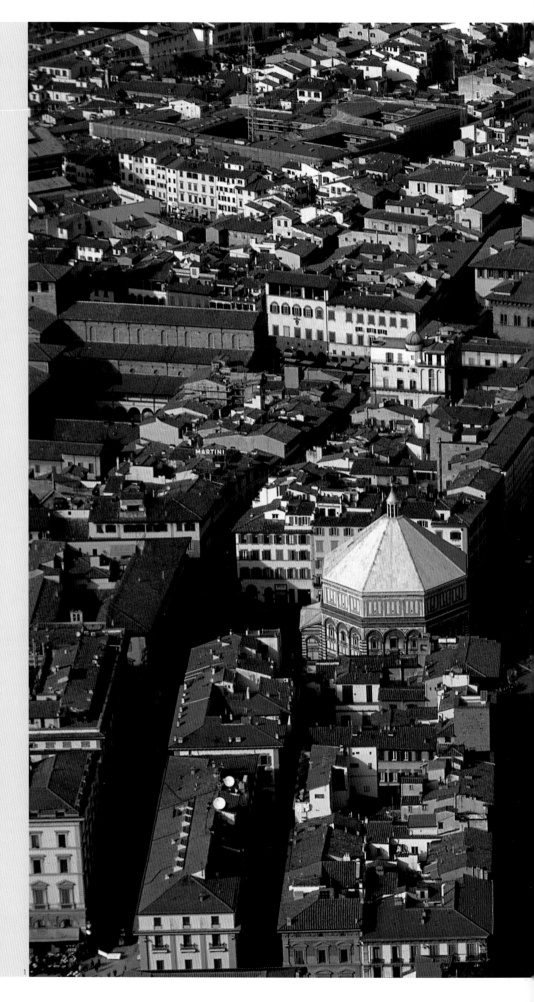

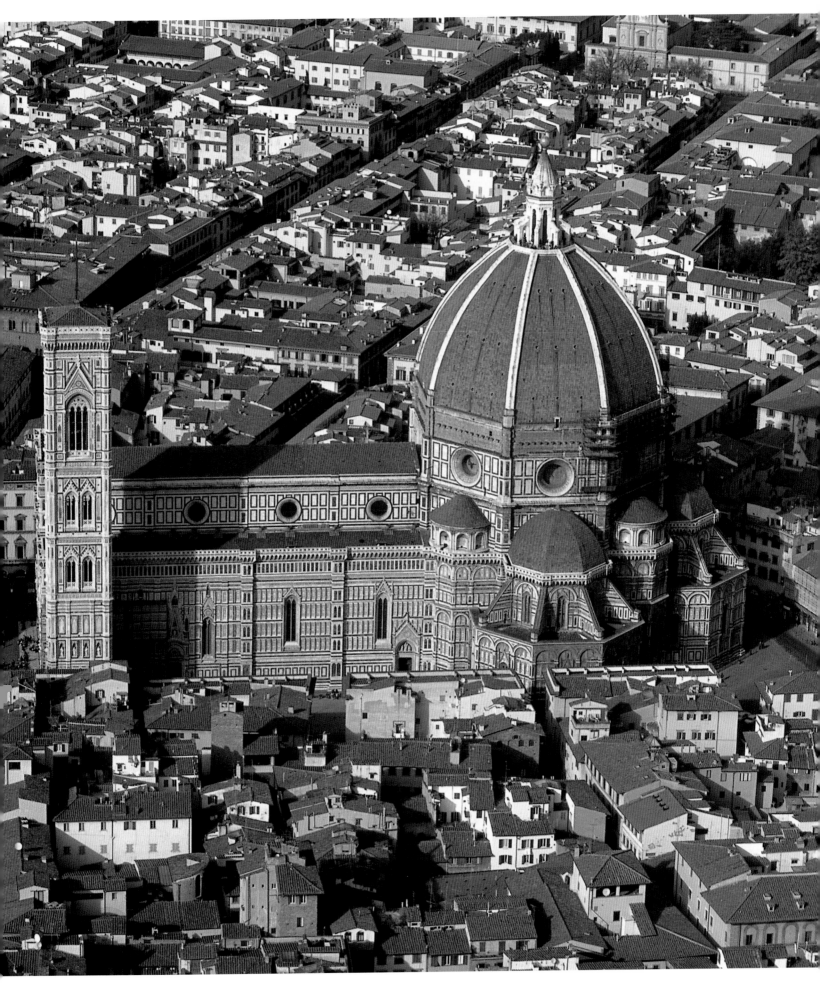

A century later, continuing the work begun by Arnolfo and brought on, amongst others, by Giotto, Filippo Brunelleschi succeeded in raising his dome – 'soaring into the sky, so wide that its shadow covers all the people of Tuscany' (Leon Battista Alberti, 1436) – brilliantly resolving immense technical problems and defying widespread scepticism to build a dome that was even higher than originally planned.

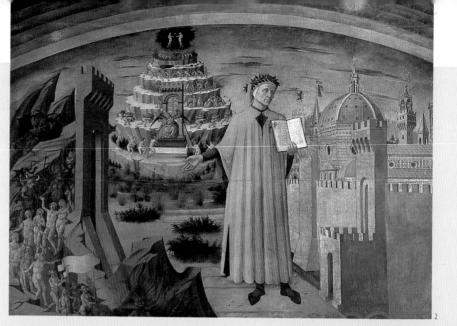

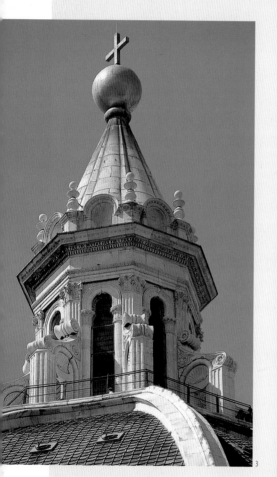

Glimpses of the 'Cupolone', as it is known to Florentines, materialise suddenly in the converging streets, and it has a power that imprints itself indelibly on the memory.

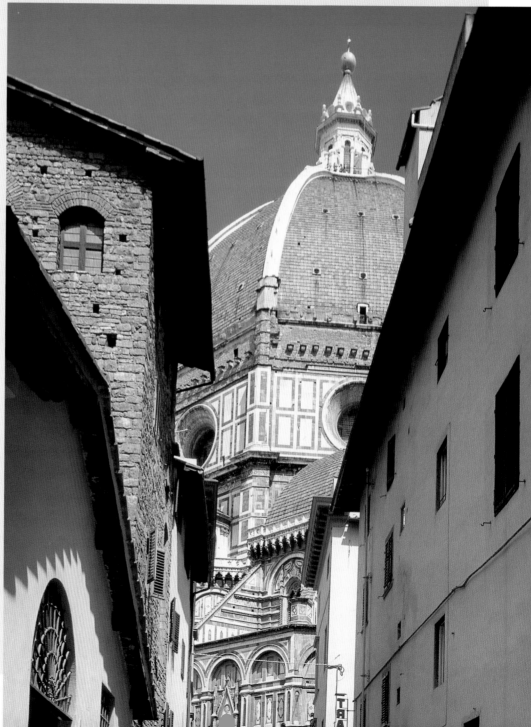

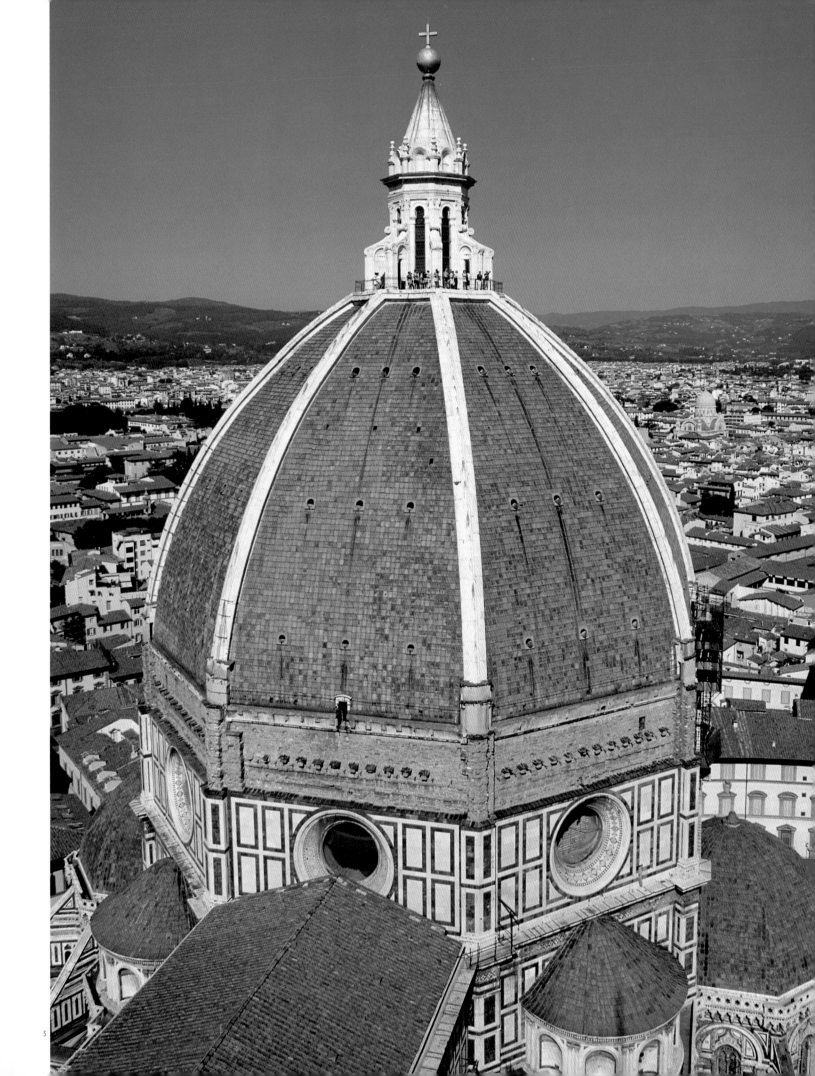

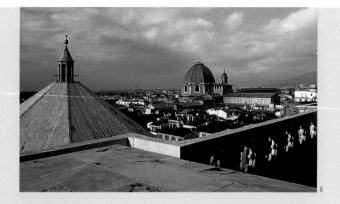

6

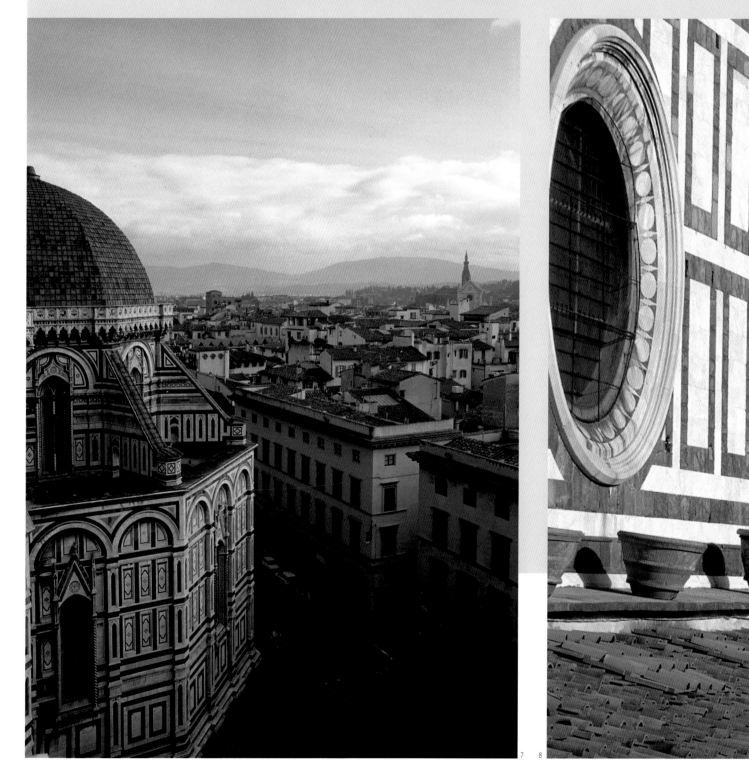

7  8

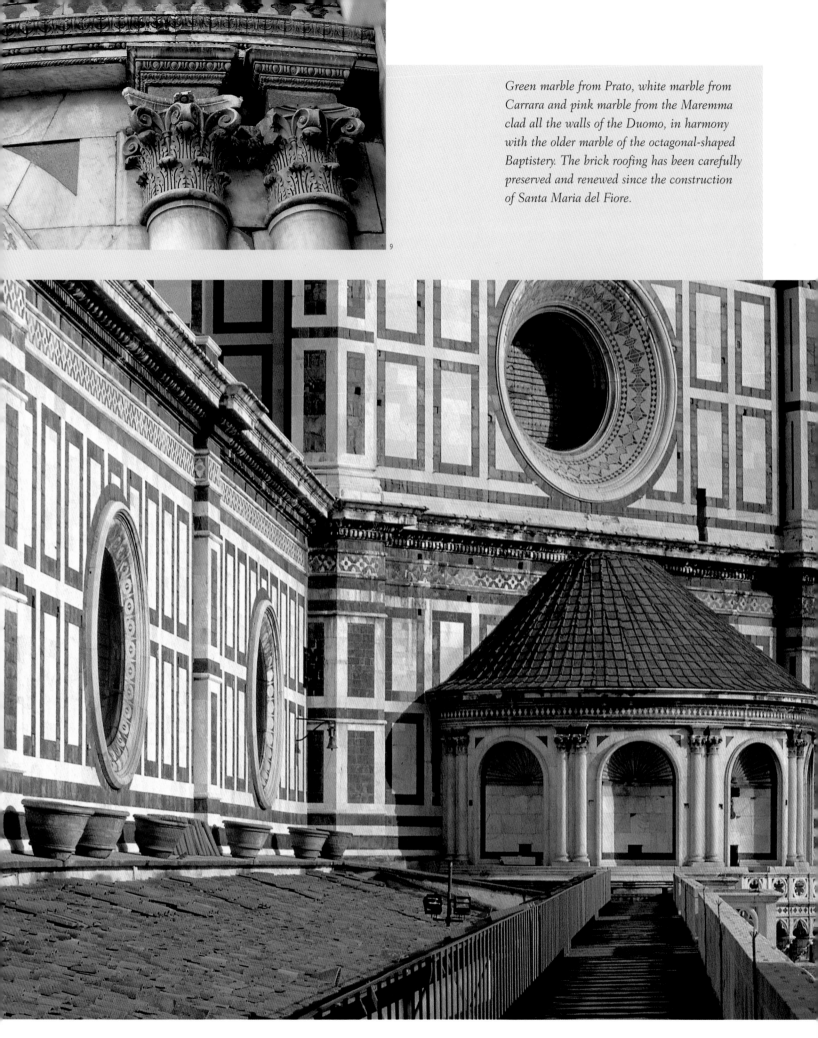

Green marble from Prato, white marble from Carrara and pink marble from the Maremma clad all the walls of the Duomo, in harmony with the older marble of the octagonal-shaped Baptistery. The brick roofing has been carefully preserved and renewed since the construction of Santa Maria del Fiore.

9

17

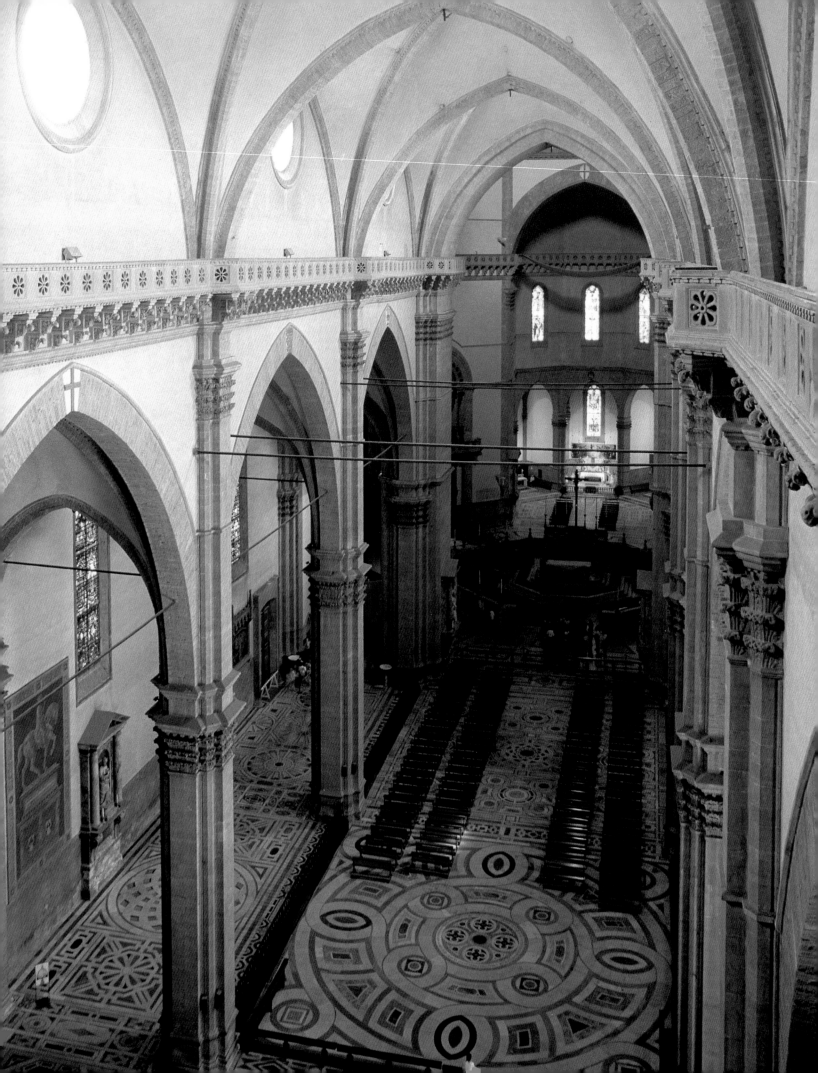

The vertiginous, soaring Gothic style
defines the interior of the massive Duomo,
the fourth-largest cathedral in the world.
Below, one of the reliefs by Andrea Pisano
decorating the base of Giotto's Campanile,
which John Ruskin described in 1845 as 'one
of the most atmospheric examples in Europe
of the representations of human art under
heavenly guidance'.

13

Luca della Robbia and Donatello compared: once in the
Duomo, the two Cantorie (marble choir balconies) continue
their dialogue in the Museo dell'Opera del Duomo, giving
expression to two different conceptions of Humanism. Luca's
is classical, measured and calmly serene, while Donatello's is
orgiastic and frenzied. While Luca evokes an ancient slow
melody and almost allows us to hear the sounds uttered by
his young singers, Donatello imprints into the marble the
pulsating movement of a pagan dance – Apollo and
Dionysus, the eternal contrast between West and East.

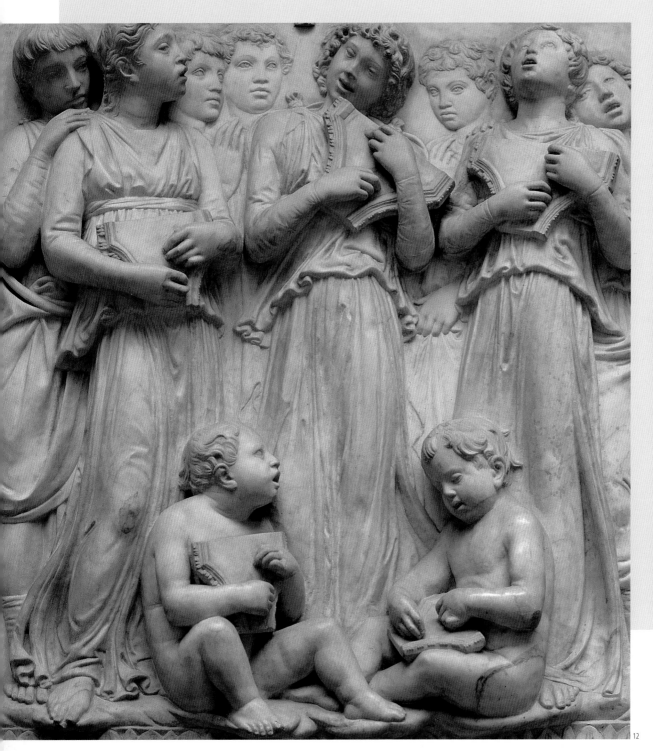

12

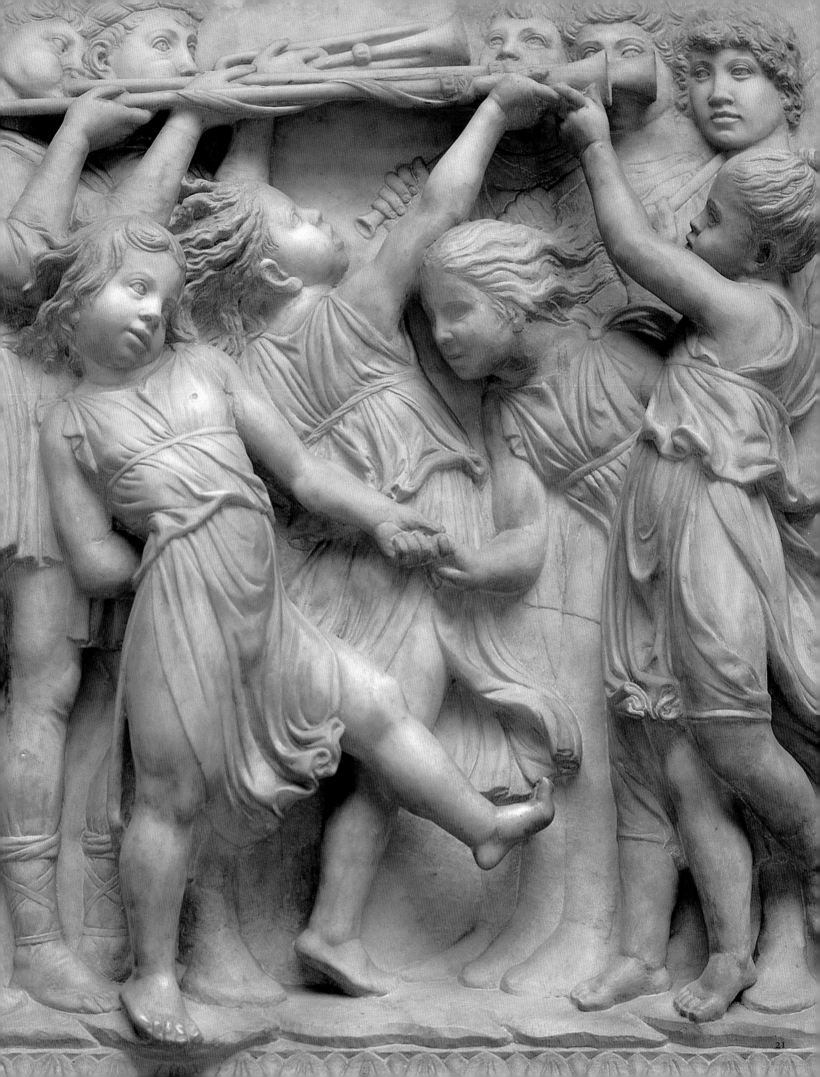

The continuity of architecture in Florence from the Dark Ages
to the height of the comune period is evident in the 'dialogue'
between the two monuments closest to Florentine hearts, the
Baptistery and the Campanile of Giotto – the place of worship
dedicated to the patron saint of the city, John the Baptist,
and the 'precious jewel', which, according to the Emperor
Charles V, 'ought to be preserved under glass'.

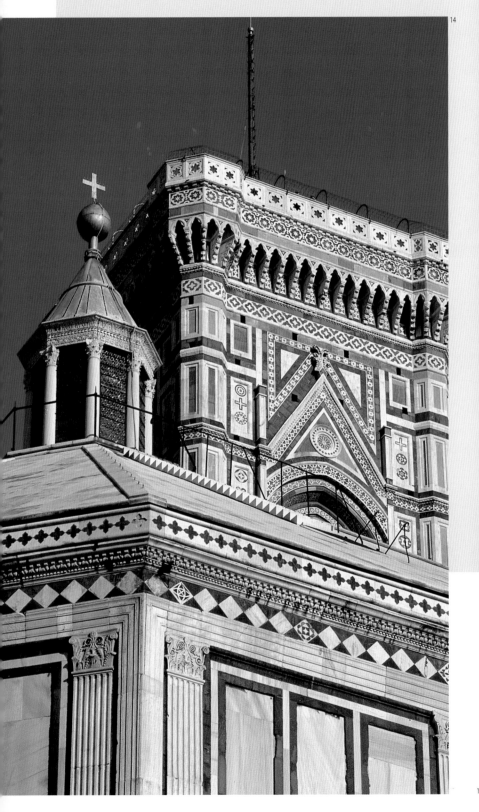

14

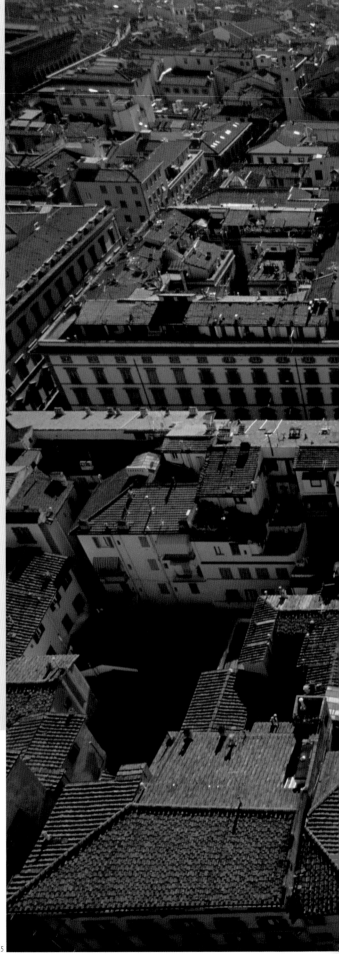

15

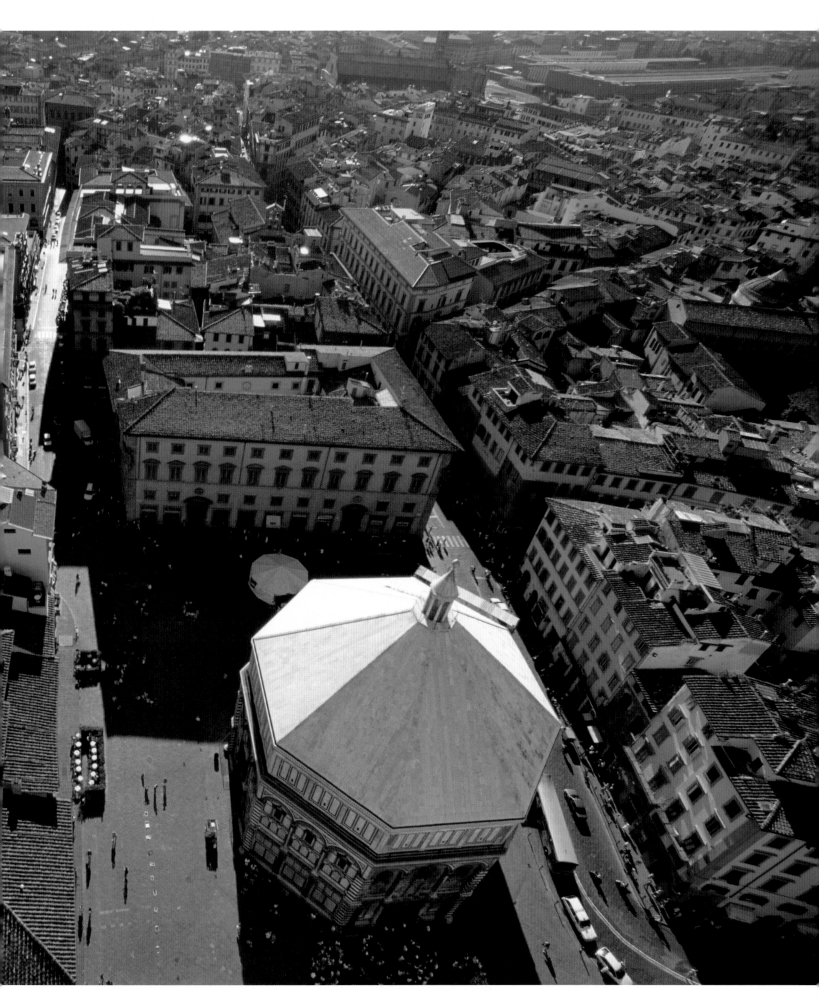

*The Baptistery of St John is perhaps the most ancient monument in Florence and a paradigm for later Romanesque constructions. These pictures show Florentine building measurements impressed in stone – the* braccio *and the* mano. *Alongside: a window of classical simplicity. Below: an ancient bas-relief decoration.*

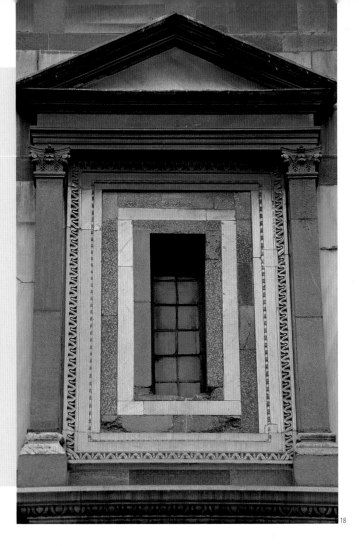

*The interior of the dome, with its glowing, whirling mosaics, represents the first major expression of Florentine art in the thirteenth century. Supremely talented artists such as Cimabue did their first work here, as did minor, yet fine, artists like Coppo di Marcovaldo, the Maestro della Maddalena and Gaddo Gaddi. Venetian artists still steeped in Byzantine stylism probably also worked on it. From the horrors of Inferno to the lives of Joseph and John the Baptist, from Adam and Noah to the Risen Christ, who saves everyone in the sacrament of baptism – we find here a religious encyclopedia, a narrative account and the early fruit of the great art that was to come.*

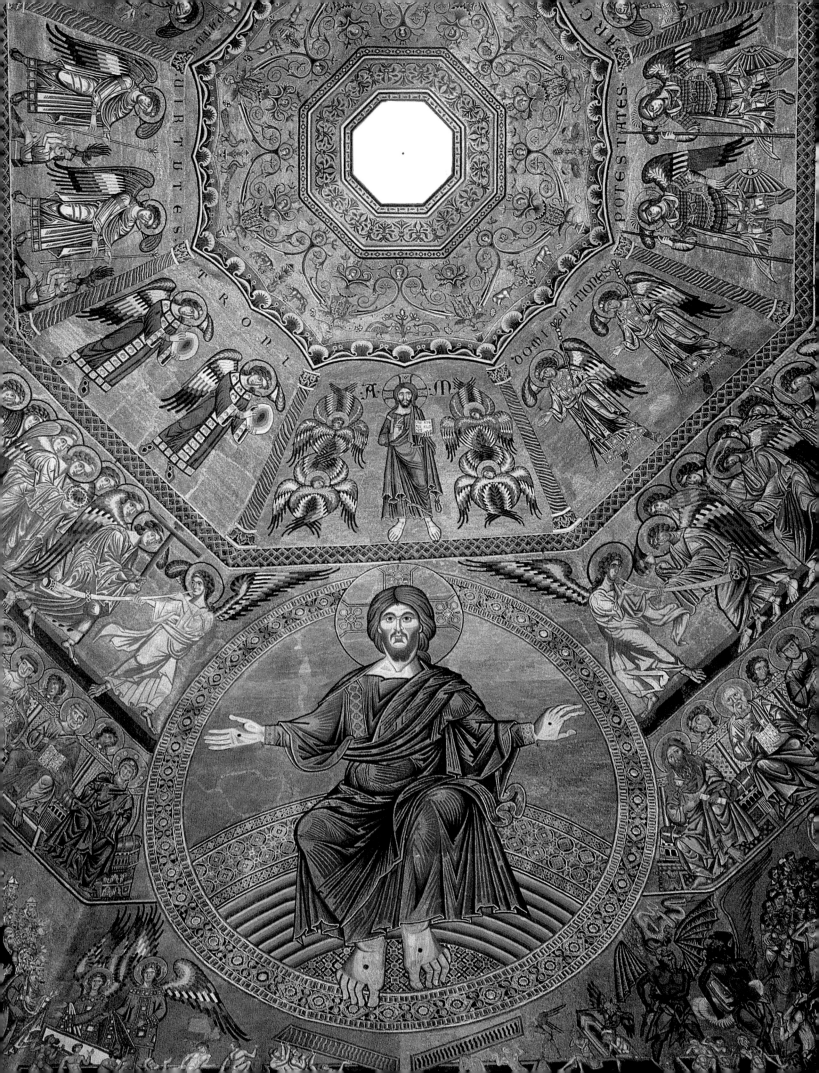

In 1401, the twenty-year-old Ghiberti won a competition, in which Brunelleschi also participated, to realise the north doors of the Baptistery. From 1425 to 1452, he worked with his workshop on the east doors, which Michelangelo declared 'worthy to be the Gates of Paradise'. The work occupied the final years of his life. Inspired by the great humanist Leonardo Bruni, the iconography of the doors appears to be a 'kind of supremely elegant golden Biblia pauperum *that is a complete illustrated Christian catechism' (Pier Francesco Listri, 1999).*

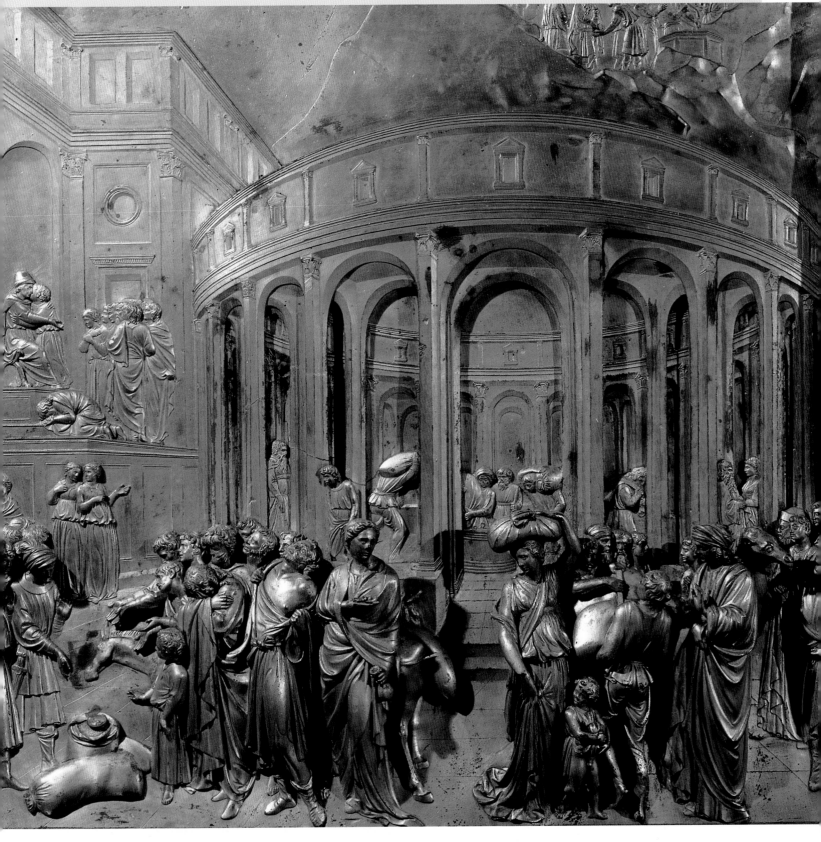

The centre of Florence is not just characterised by the major monuments. In the old streets, besides signs of their history, there are more secluded and modest spaces and locations, which nonetheless provide precious nourishment for body and spirit.

The small vinaio (wine shop) not far from the relief on Giotto's Campanile depicting Noah's Drunkenness, is a point of reference for every good drinker. The crest of the Corporazione dei Beccai (the Guild of Butchers) – a becco is a billy goat – seems to be pointing us towards the modern butcher's in Via de' Neri, while the inscription at the wine shop door coexists with a modern form of transport.

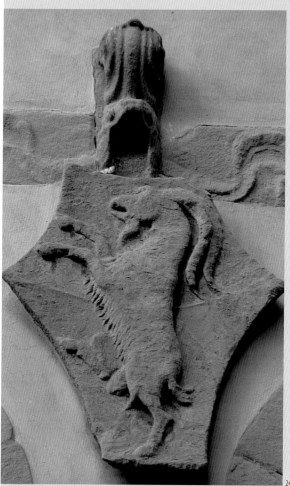

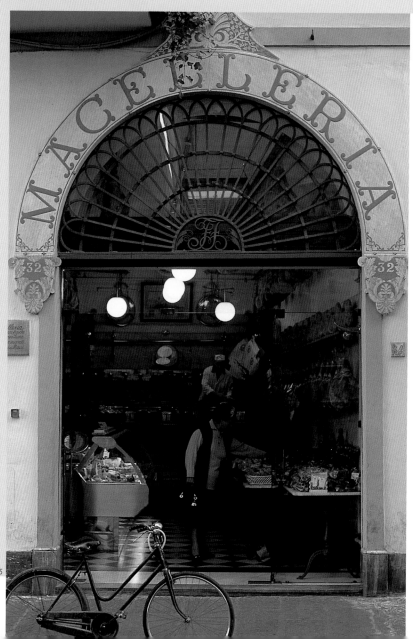

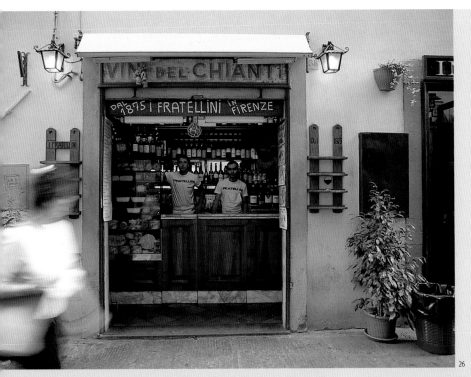

26

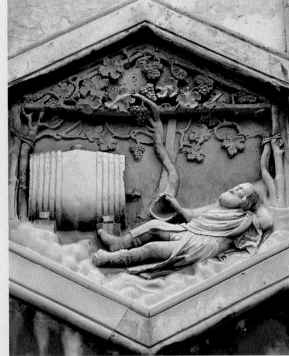

27

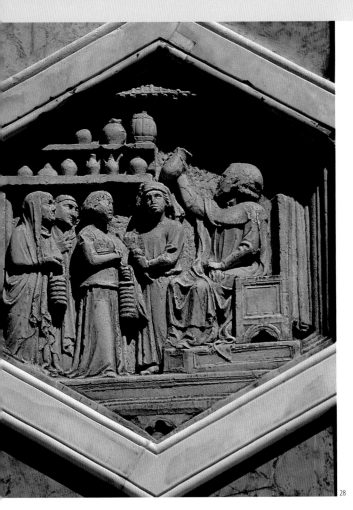

28

LA CANTINA RESTA APERTA ALLA VENDITA
DAL PRIMO NOVEMBRE A TUTTO APRILE
DALLE ORE 9 ANT ALLE ORE 2 POM E DALLE 5 ALLE ORE 8 POM
DAL PRIMO MAGGIO A TUTT OTTOBRE
DALLE ORE 8 ANT ALLE ORE 5 POM E DALLE 6 ALLE ORE 9 POM

NEI GIORNI FESTIVI RESTA APERTA ALLA VENDITA FINO A ORE 3 POMERIDIANE

29

30

31

This spread reveals all the traditional
elegance of Florence. Florentines have
always gone to Silvi in Via dei Tavolini
in search of the finest passementerie,
or to Giannini, in front of Palazzo
Pitti, to a shop steeped in atmosphere
to choose decorated paper (well-
informed foreigners do likewise) that is
still produced using traditional work
tools for the complex sixteenth-
century-style bindings.

32

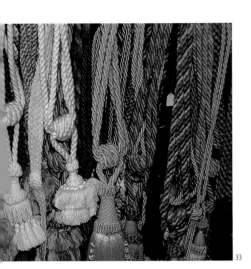

33

34

35

36

37

Originally a grain market and later a place of worship and veneration of an image of the Virgin Mary, Orsanmichele lay between the religious (Duomo) and the political (Palazzo Vecchio) poles of Florence in the comune period, just a short distance from the commercial centre of the Mercato Vecchio. Administered by the Compagnia di Orsanmichele, it gradually became a showcase for the religious devotion and wealth of the Florentine guilds, who in the early fifteenth century decorated it with bronze and marble sculptures by the most important artists of the age.

38

39

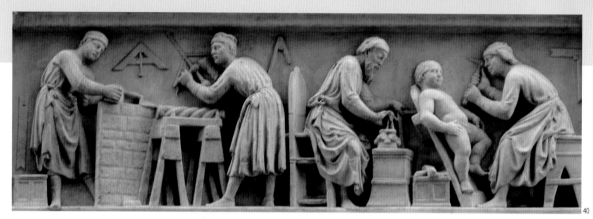

40

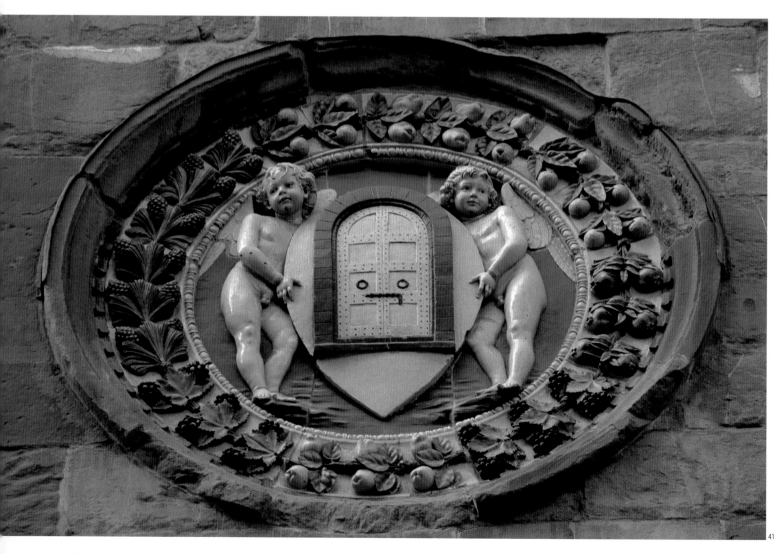

41

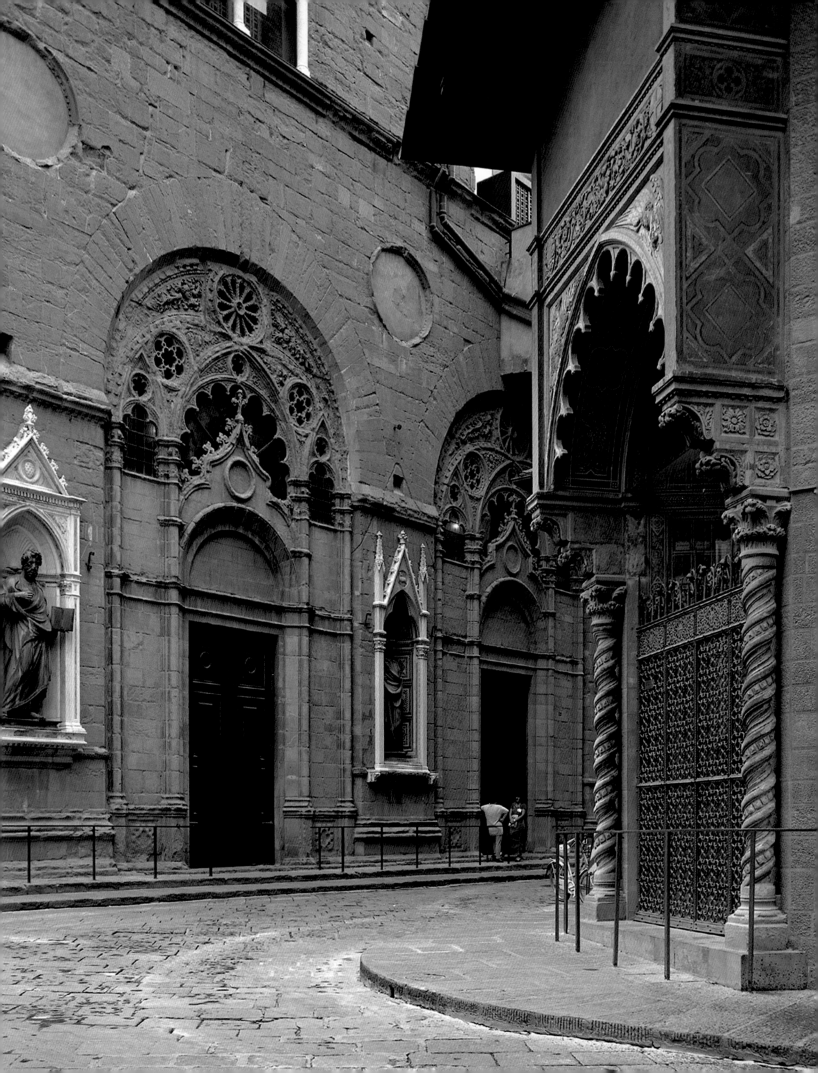

*In its niche on one corner of Orsanmichele, Donatello's St George is one of the purest personifications of Renaissance Man, a free and rational being, more man than saint. The marble original is now in the Bargello and it has been substituted by a copy in bronze.*

*The Bargello is the oldest palace in Florence from the* comune *period. Built in the middle of the thirteenth century, it was the seat first of the Capitano del Popolo, then of the Podestà or chief magistrate, and finally of the bargello, or cop, from which it takes its name. Since 1859, it has housed the Museo Nazionale, which has one of the finest collections of Tuscan sculpture in the world, including work by Desiderio da Settignano, Luca della Robbia, Brunelleschi, Ghiberti, Donatello, Verrocchio, Michelangelo, Cellini and Giambologna.*

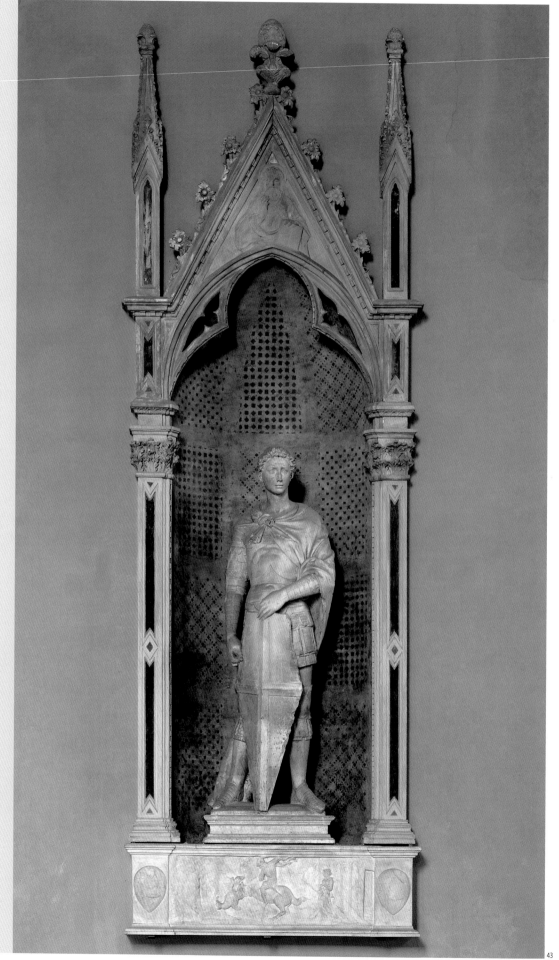

43

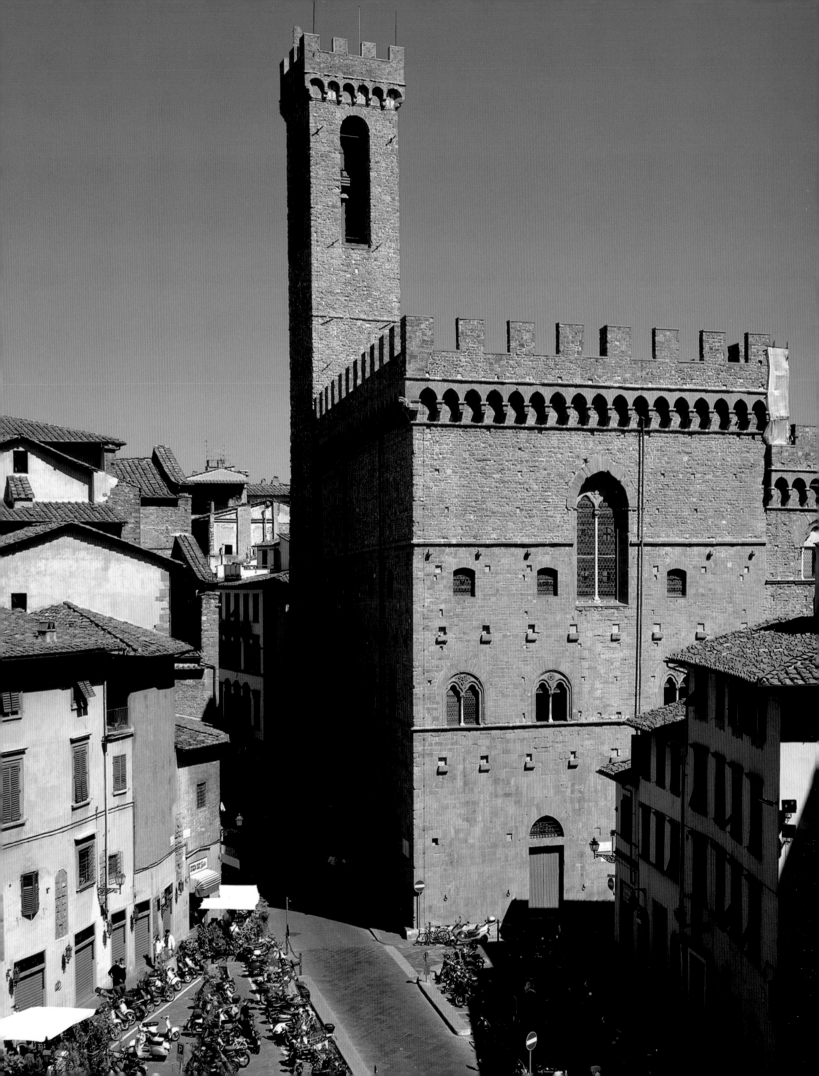

*Death sentences used to be carried out in the courtyard of the Bargello until, in 1786, the enlightened reformer, Grand Duke Peter Leopold, became the first ruler to abolish the death penalty in Europe, before succeeding to the throne of the Habsburg Empire. The rooms of the museum offer a fit setting for sculptural masterpieces like* Michelangelo's Drunken Bacchus *and* Verrocchio's Young Lady with Flowers.

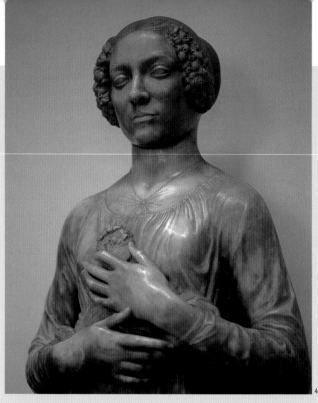

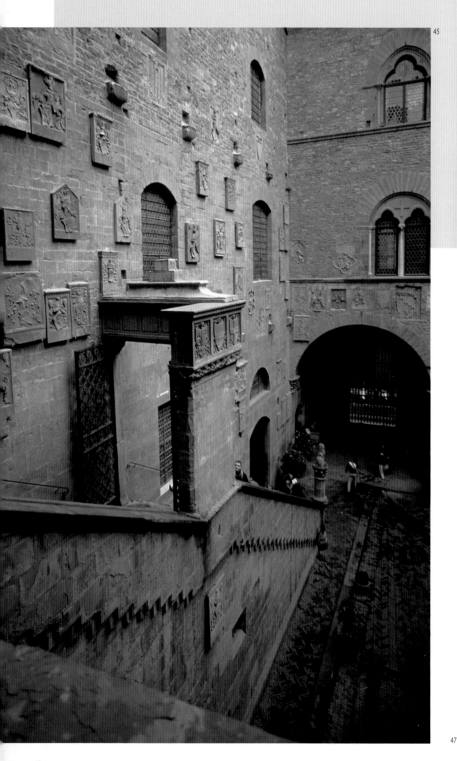

45

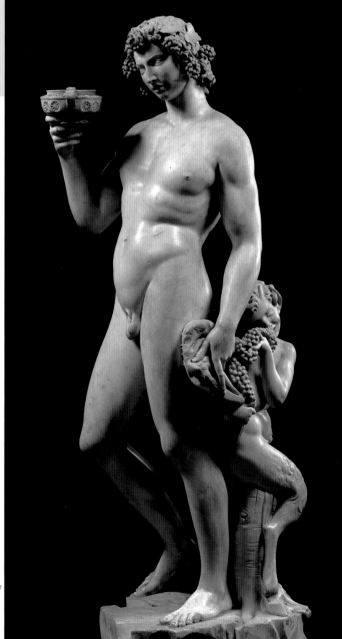

46

47

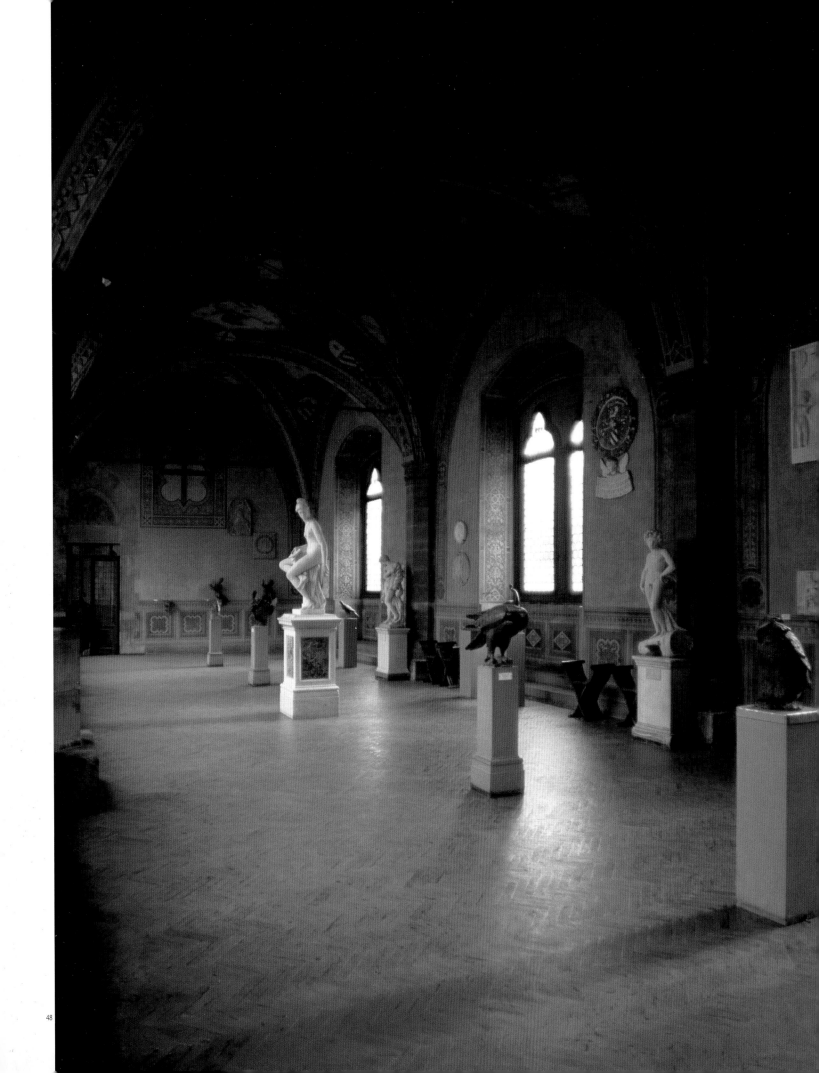

*Palazzo Vecchio, imposing emblem of the* comune *and of secular Florence; the burning of Savonarola at the stake; the crests of the city and of the Medici family; Lorenzo il Magnifico receiving European ambassadors; and finally, the gold florin, the most sought-after currency of the time and an instrument of wealth for powerful Florentine families in the fourteenth and fifteenth centuries, seems to seal the pride of the city and its government.*

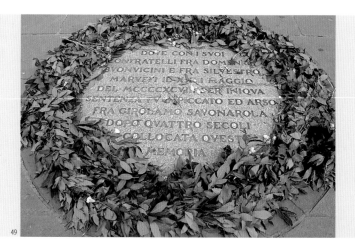

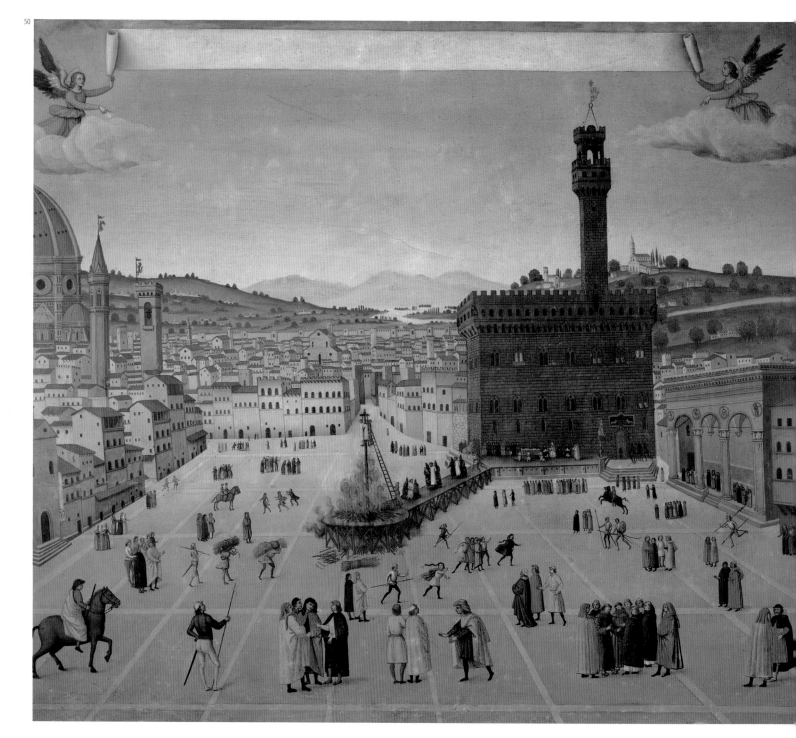

51

52

53

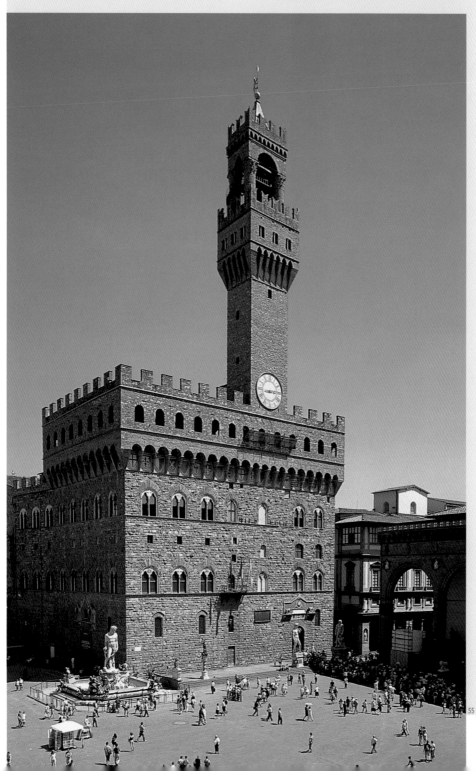

55

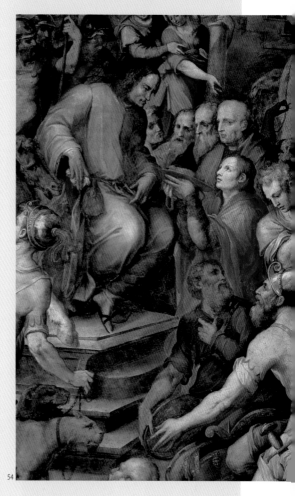

54

After careful restoration, the Perseus (1545–54) of Benvenuto Cellini once again dominates the scene in the magnificent open-air museum of the Loggia dei Lanzi in Piazza della Signoria, competing, as it has for centuries, with the superb Mannerist spiral of The Rape of the Sabines by Giambologna.

With this complex and cruelly beautiful work, Cellini, one of the most volatile goldsmith sculptors of all times, intended to surpass at least 'three-fold' Michelangelo's David and Donatello's Judith and Holofernes, which were originally guarded and protected in the historic piazza.

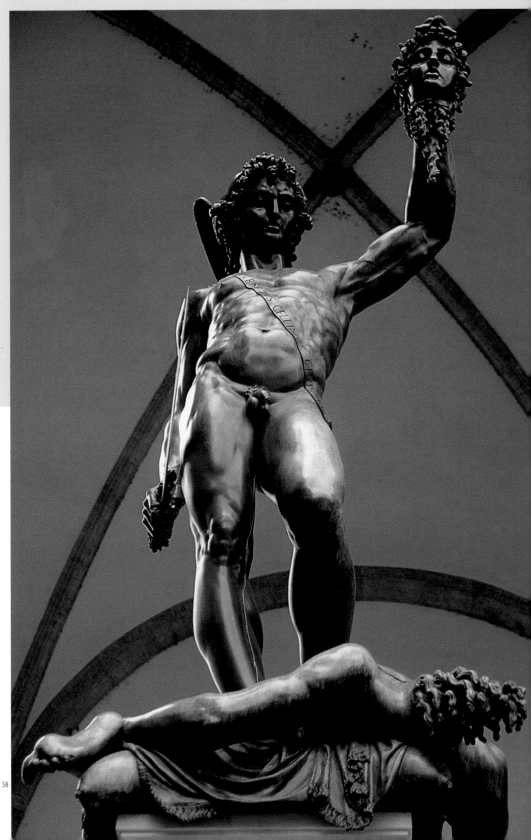

56

57

58

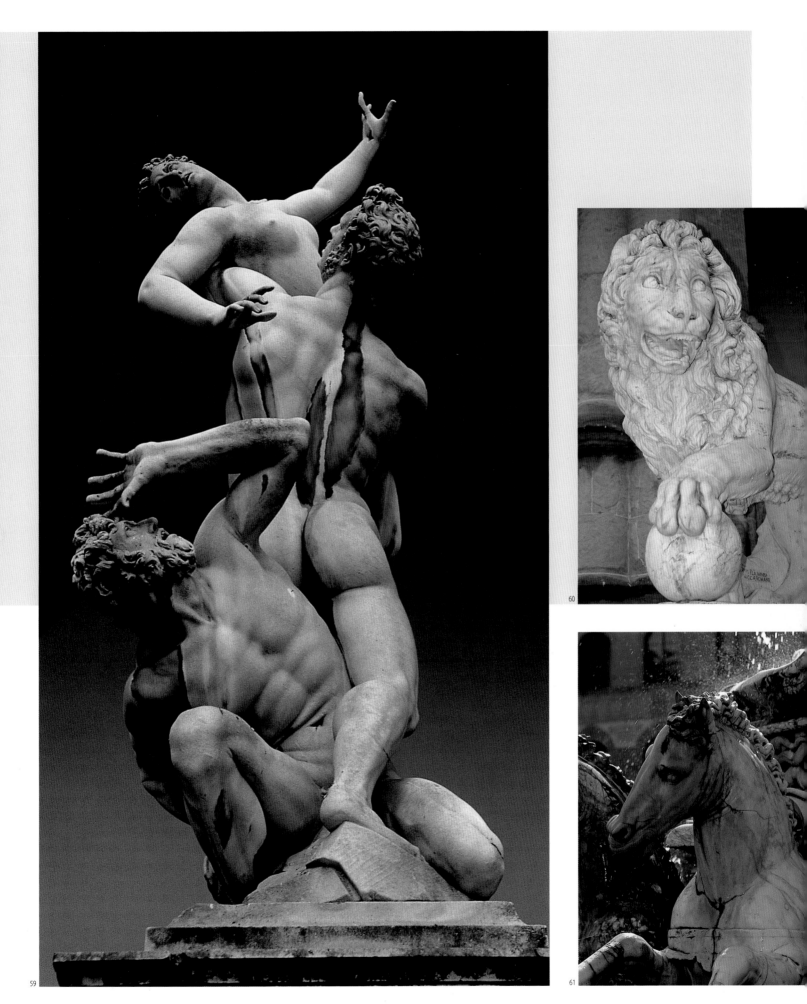

59

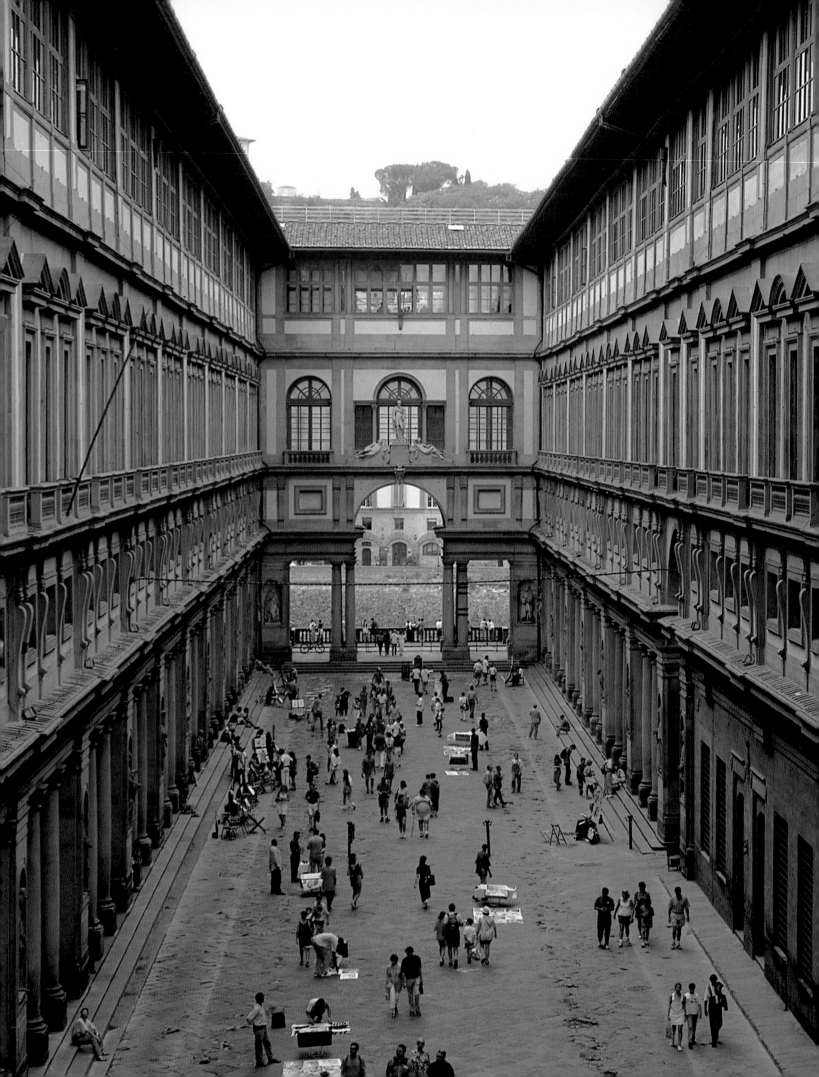

A universal symbol of the art and culture of Florence, and a priceless treasure house of masterpieces, the Uffizi buildings were designed by Giorgio Vasari for Cosimo I in 1560 as the seat of administrative power. However, the need to provide a home for the large art collections of the Medici family soon prevailed, and today the Uffizi is one of the most important museums in the world. Alongside: one of the museum's oldest and finest paintings, Duccio's Madonna and Child, which is in the same room as paintings on the same subject by Cimabue and Giotto.

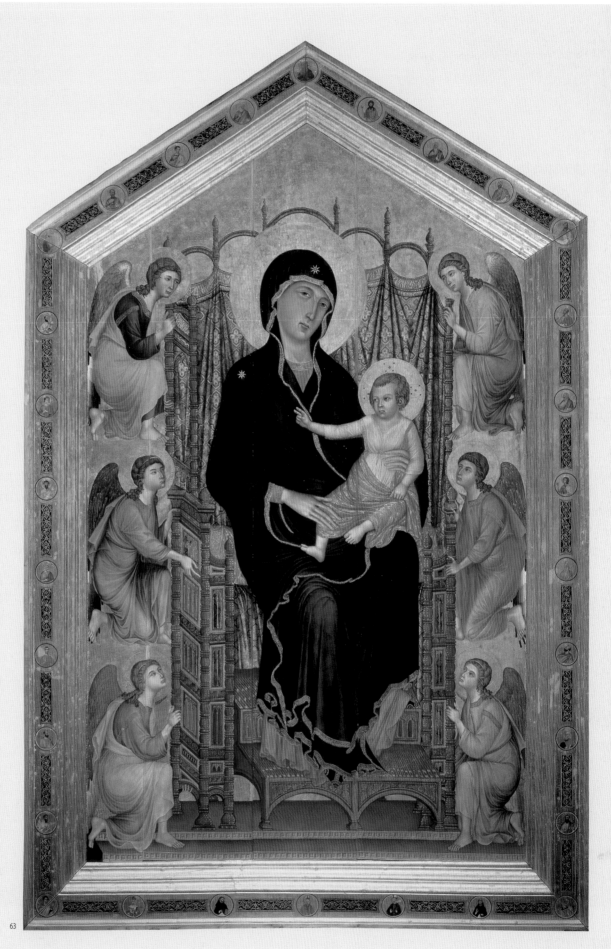

63

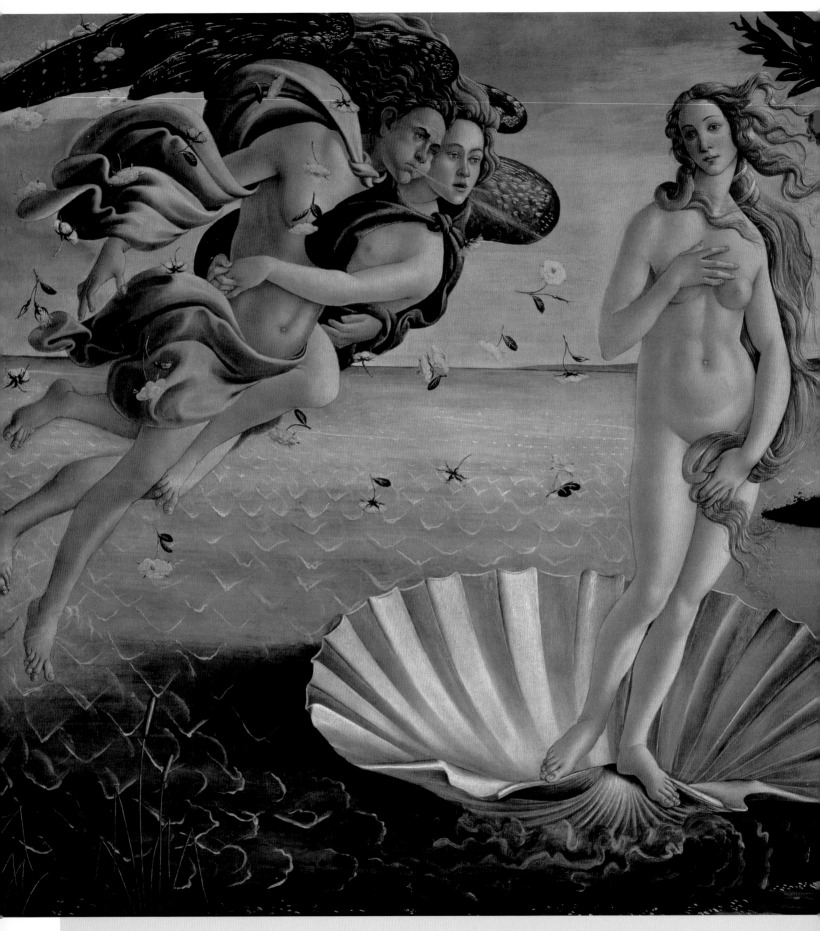

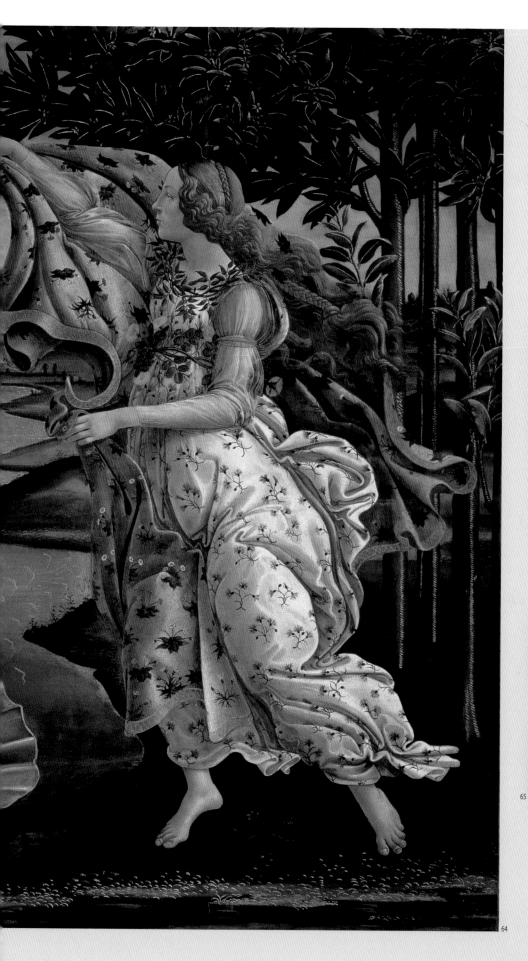

*Two emblematic examples of Tuscan Renaissance art in the Uffizi: Botticelli's Birth of Venus (c. 1485) and the Portrait of Federico da Montefeltro by Piero della Francesca (part of a diptych that also portrays his wife Battista Sforza) painted in 1465. Humanism at its most authentic and original: the 'rebirth of the gods' celebrated in the culturally refined circle of Lorenzo il Magnifico and the synthesis of light, space and colour in the work of Piero.*

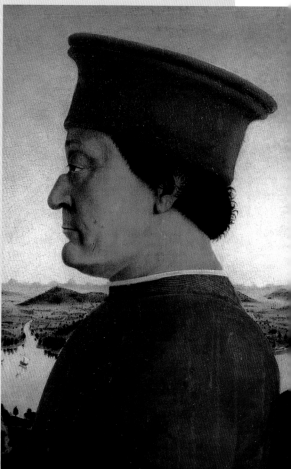

64

65

45

Only a small part of Leonardo's prodigious work can be appreciated in Florence, the city where he trained. He worked on this fine Annunciation when he was twenty years of age, together with other artists in the bottega of Verrocchio, where he did his apprenticeship. Despite some defects in perspective and anatomical proportions, which reveal a youthful uncertainty, the unmistakable hand of the artist heralded a new sensibility that went beyond the design on which the Florentine conception of painting was based. In particular, the faces of the angel

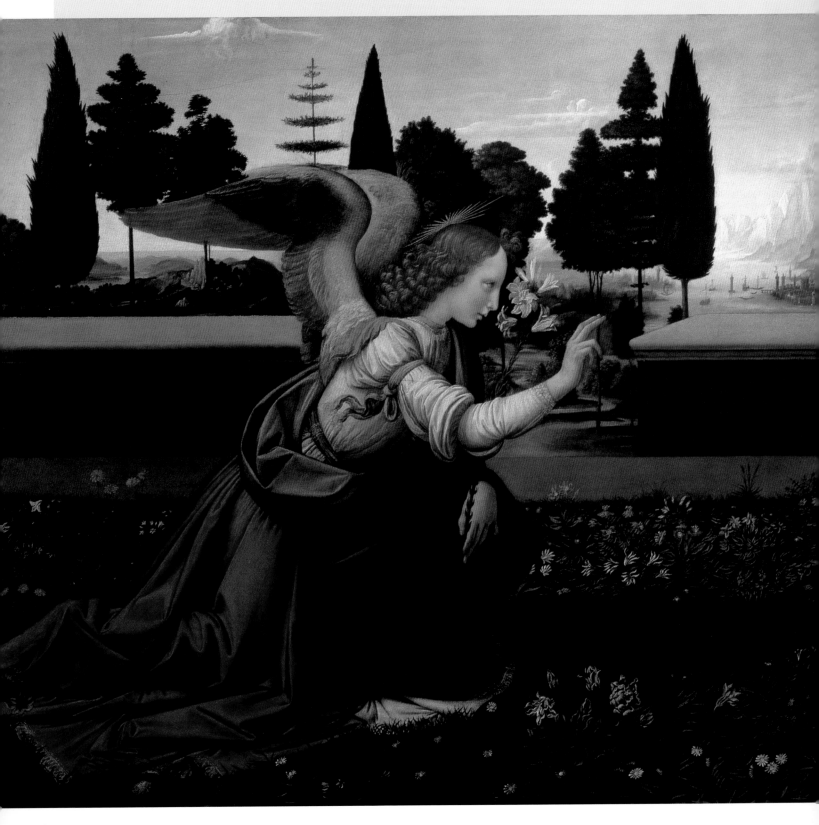

and the Virgin, suffused with grace, are already 'Leonardian', as is the landscape in the background. The fineness of detail culminates in the elaborate marble base of the reading desk, which is also an indication of the extremely high level of craftsmanship in the workshops of Florence. In the course of a close examination of the work, scholars noted the fingerprints of the young painter on the leaves of the festoon and on the fingers of the Virgin's right hand, a touch which softened the colour, achieving an effect of exceptional naturalness.

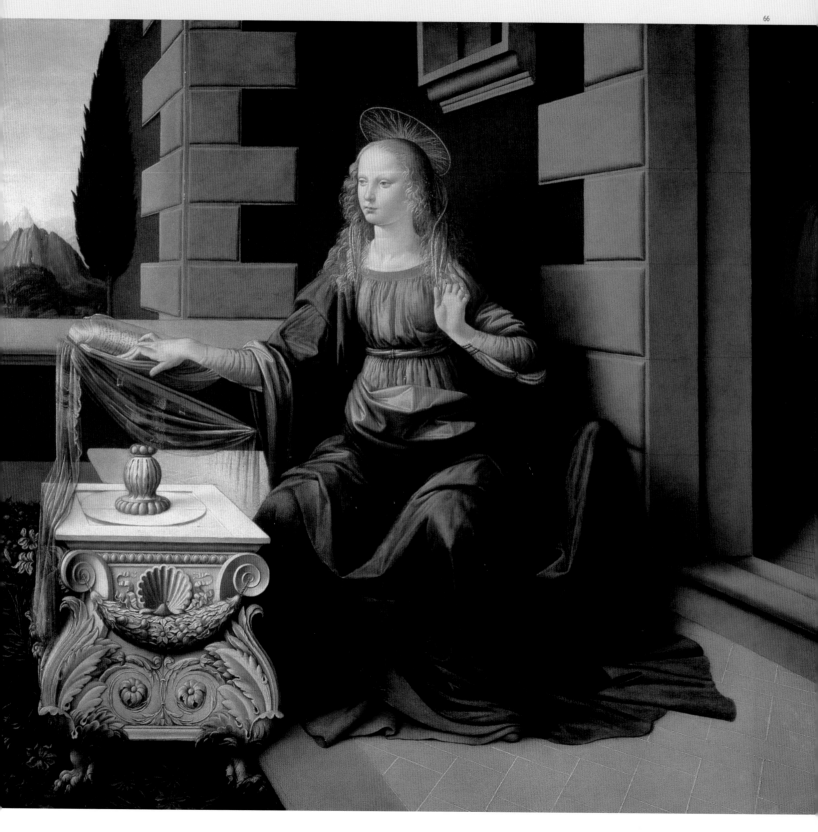

In these restricted spaces, which are nevertheless parallel or tangential to the direction of the sun, built over traces of ancient Roman foundations, it is still possible to enjoy an atmosphere protected from the chaos of the traffic and the invasiveness of hurried, distracted people. Detailed features adorning old residences stand out in the clear Florentine light.

67

68

69

70

71

49

# Along ancient walls

*Crossing the Arno through an avenue of jewellery shops – the full splendour of Medici power – climbing the hill to San Miniato and on to Forte di Belvedere, passing ancient walls partly built by Michelangelo*

Together with the surrounding hills, the Arno is an essential extension of Florence, its appearance and shape indelibly imprinted on the city. The river, which somehow avoids separating the city into two separate parts, imparts light and offers a sense of respite. The river banks, beautiful and rich with history, are linked by the Arno's many elegant bridges. Ponte Vecchio is the best known and perhaps best loved of these bridges. Solid and flood resistant, it has been sitting on the same stone blocks since it was last rebuilt in 1345. The incessant movement along its paved walkway cannot be so very different from how it was centuries ago when Florentines and outsiders alike made purchases from goldsmiths' and jewellers' shops, and, before them, from butchers' shops known as *beccai*, which Grand Duke Ferdinand had closed in 1593 because he could not bear the stench as he walked over the bridge. In the meantime, Vasari, having built the Uffizi – which were government offices before becoming a museum – had the idea of providing the Grand Duke and his family with an aerial walkway, a kind of 'overhead tunnel', which came to be known as the Vasari Corridor. This linked Palazzo Vecchio to the Uffizi, then crossed over the top of Ponte Vecchio and ended at Palazzo Pitti, avoiding ground level and any danger from hostile citizens. The *beccai* were replaced by finer shops and the Medici were able to move with ease to Palazzo Pitti, the new residence of the Grand Duke, which Cosimo I's wife, Eleonora of Toledo, had bought from the bankrupt banker Luca Pitti. They even sat on comfortable little cabs pulled by servants. Should a riot have broken out, the Medici would have been able to leave Palazzo Vecchio without difficulty, reach Palazzo Pitti via the corridor and climb through the Boboli Gardens to the safety of Forte di Belvedere. From there, they could bombard their enemies on the outskirts of the city and their rebellious subjects.

Enlarged and transformed over time from a harmonious Renaissance building into a sumptuous residence fit for a ruler, Palazzo Pitti still houses the valuable private collections of the Grand Dukes, including works by Titian, Raphael and major European artists, and the furnishings and artefacts produced by manufacturing works (successors of the ancient artisan workshops) in that period. There is still little sense of entering a rationally organised museum, rather the house of someone who, out of some sense of munificence and generosity, has decided to open their doors to visitors. To the rear, and covering an area of about three hectares, are the Boboli Gardens, one of the finest examples of the Italian style. The work of the artists of the time, directed by the Grand Dukes, transformed what was once a rough hill into an oasis of calm, where artifice prevailed over nature and in which could be found a subtle interplay of statues and fountains, copses and grottoes, orchards and rare herbs. It was, no doubt, a fitting location for the theatrical performances and grandiose receptions that were held there. Its avenues provide unusual views of Florence and some even climb towards walls fortified by Michelangelo himself; here, in a corner plot of land, the Grand Dukes were the first in Italy to cultivate potatoes brought back from the New World.

The most famous *piazzale* in the world, named after Michelangelo, is unmissable. It was the brilliant and rapidly executed work of the urban planner Giuseppe Poggi, who, more than a century ago, redesigned the whole hill and developed the system of *viali* so that they converge on the *Piazzale*. There is also a copy of Michelangelo's *David* here. Nearby, steps lead up through a cemetery to the Basilica of San Miniato, another miracle of Florentine–Romanesque architecture. It sits there, its facade caught by the rays of the sun, on the hill facing Florence, surrounded by cypresses that are hundreds of years old and which, together with the houses, villas and facades of churches like this one, form an essential part of the geometric patterning of the landscape. As one heads towards Forte di Belvedere and its unrivalled view of Florence, in Via San Leonardo there is a sudden broadening of scale, a stunning sight that helps illuminate the spirit and culture that imbues the city. Via San Leonardo runs between high walls that protect ancient villas, yet still allow one to intuit the existence of the calm and graceful fields and gardens within. Set into some of the walls are inscriptions and small, discreet doors with doorknockers and ironwork that date from another age. Any conversation in this street is, instinctively, conducted in a hushed whisper. The hills, visible in some stretches, have been embroidered by ancient hands, and at the bottom of the street there is a steep downhill stretch leading from Porta San Giorgio to Porta San Niccolò and on past the third circle of walls and a row of ancient olive trees, finally ending in the old stamping ground of the Bardi and Mozzi families in the Oltrarno. Although the medieval streets, with their powerfully forbidding palaces, are very austere, they are redeemed by the outline and light of the low surrounding hills.

*'Di qua e di là d'Arno'* – this side and that side of the Arno. It is a phrase that can still be heard nowadays, but it is said with much less pride and sense of belonging to a neighbourhood than was the case until just a few decades ago. Today's visitor might cross the river several times a day without noting at all any sense of a frontier or division. Besides, the many bridges linking the two bodies of the city in a long embrace help create this sensation of unbroken continuity.

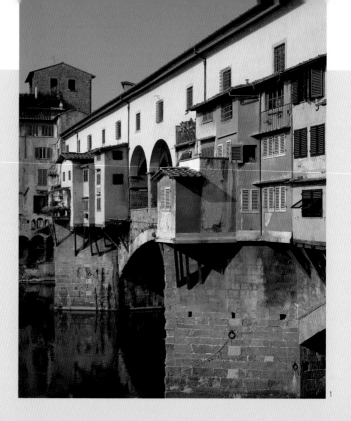

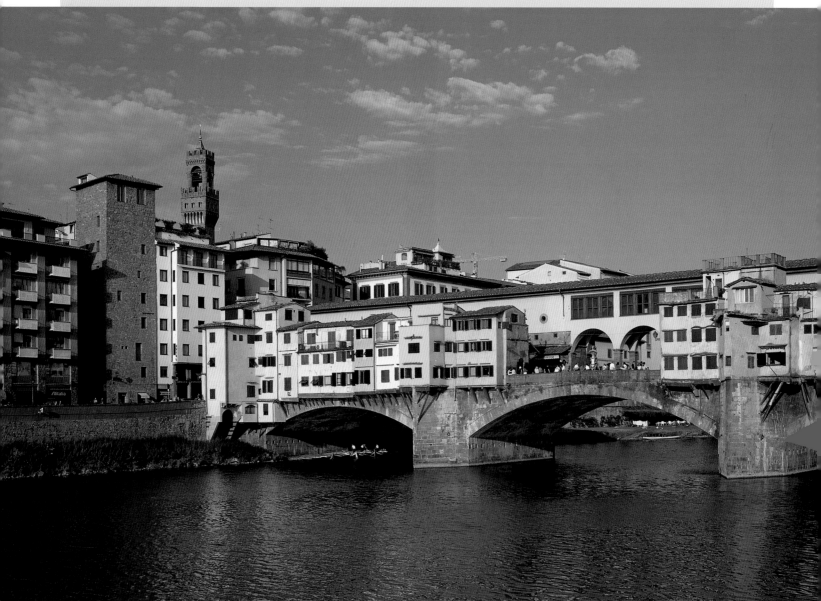

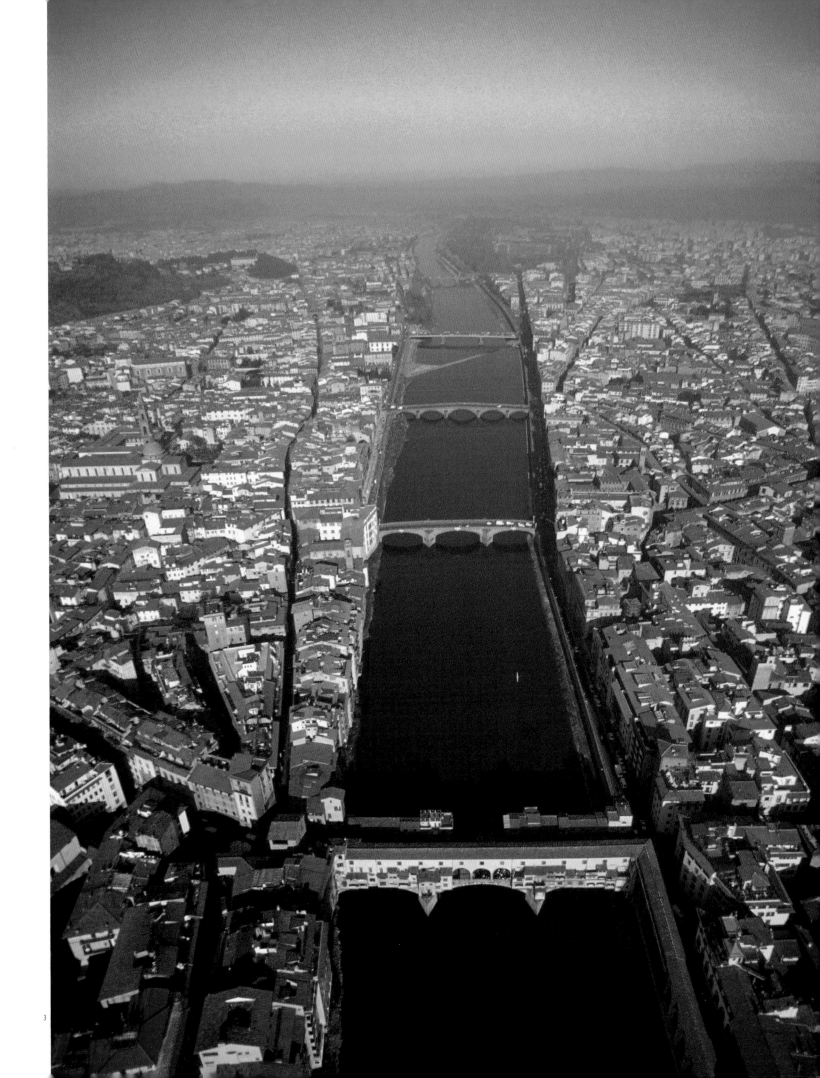

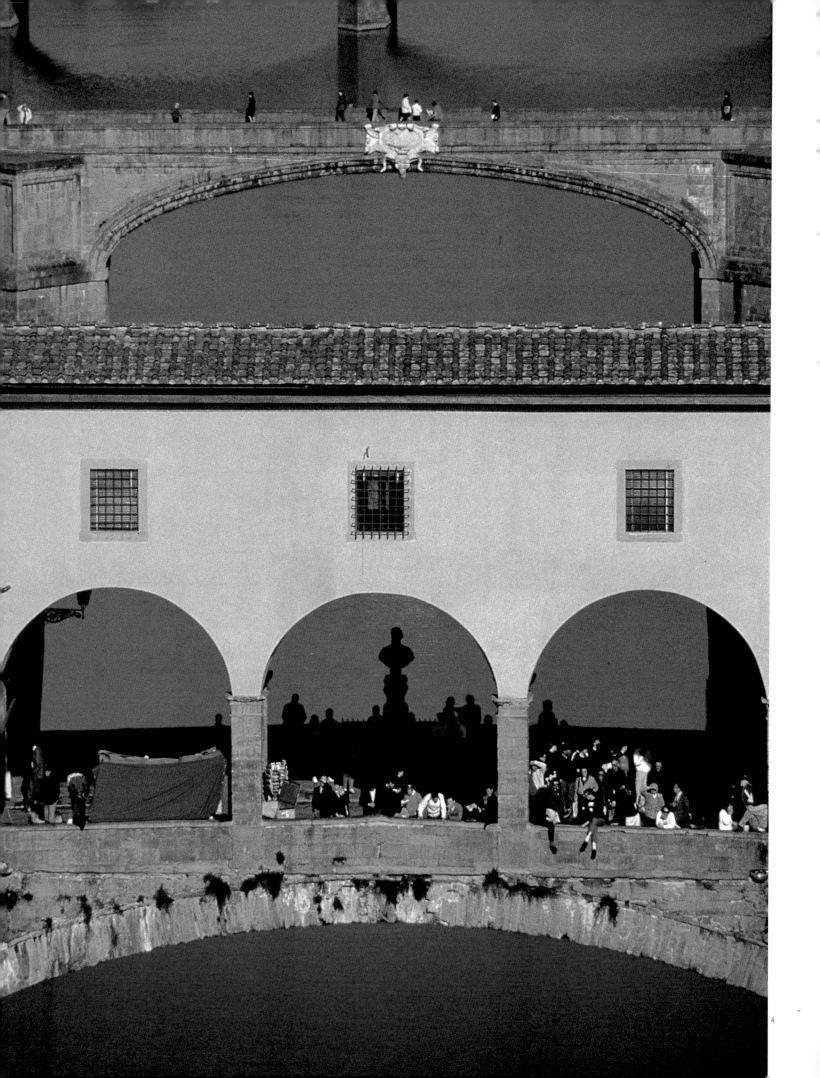

6

5

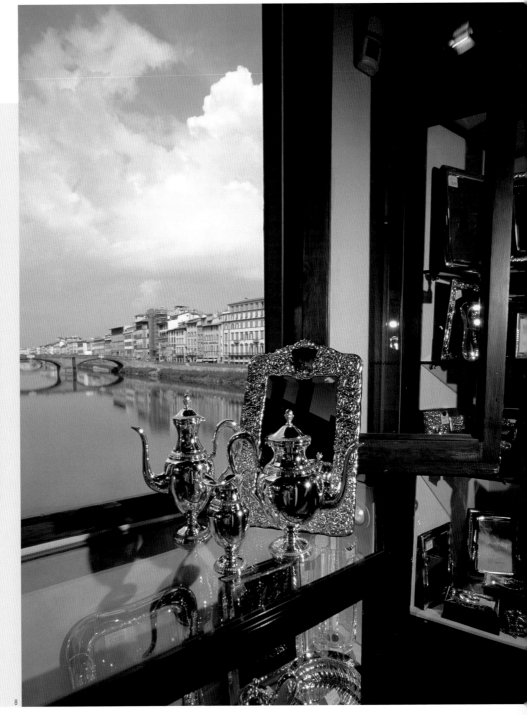

7

8

The aerial photograph passes through and brings closer the two jewels of the Arno, Ponte Vecchio and Ponte Santa Trinita, while the bust of Cellini, one of the most celebrated goldsmith-sculptors of the Renaissance, seems to have been positioned there to protect the goldsmiths' *botteghe*, whose work he still inspires.

9   10

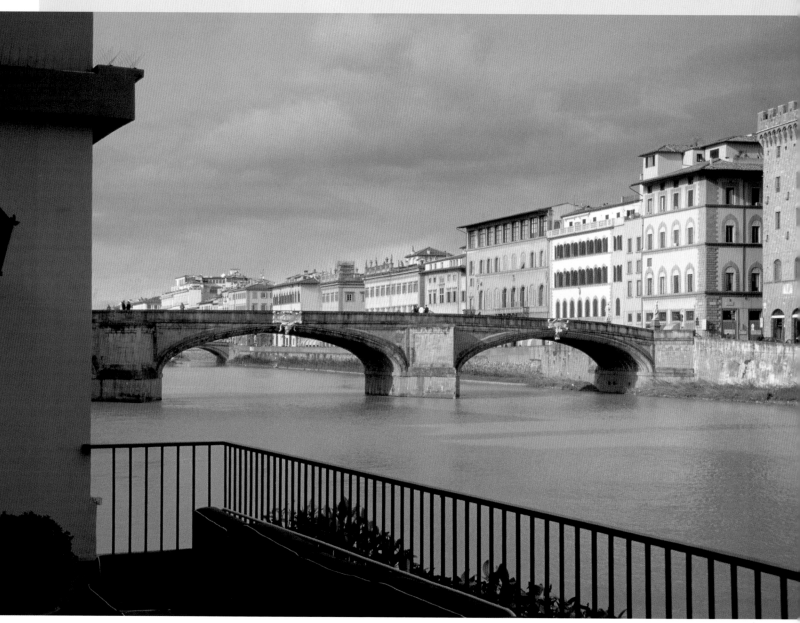

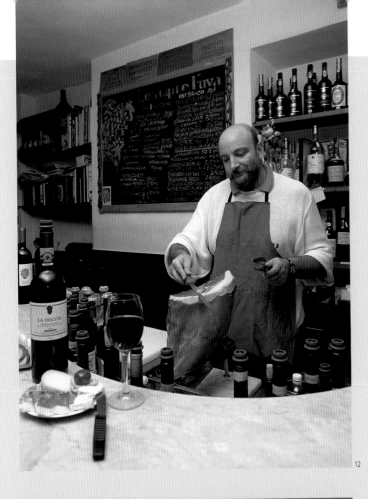

As soon as one steps into the neighbourhood of Santo Spirito, one begins to glimpse a more authentic and atmospheric Florence – an ancient street sign, a vinaio, and the elegant, discreet comfort of a hotel in Borgo San Jacopo with its 'rooms with a view' over the gleaming ribbon of the river…

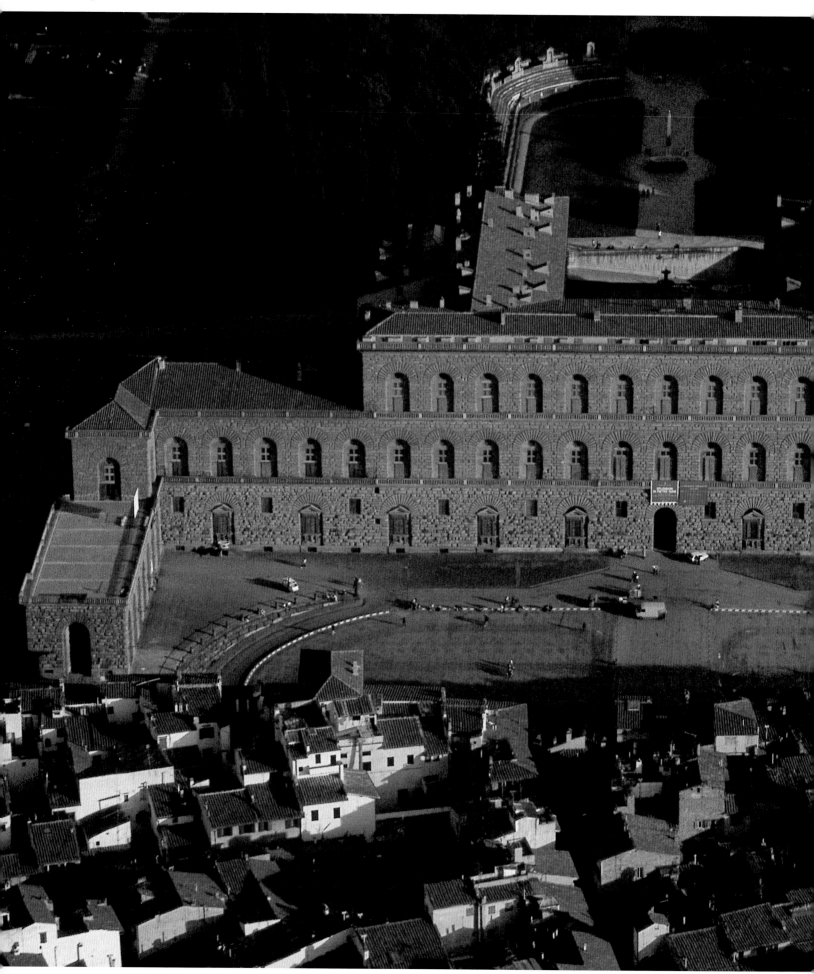

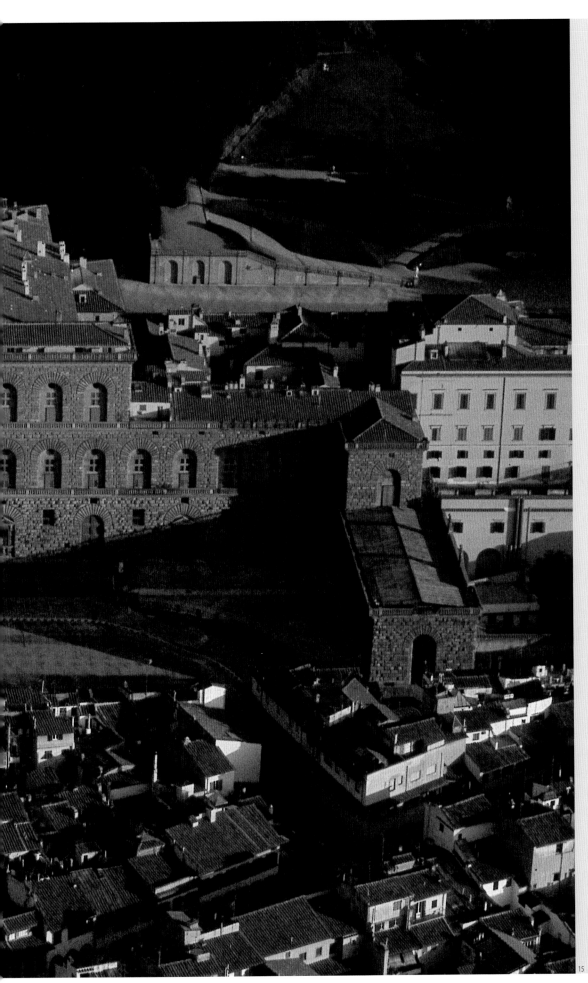

Possibly designed by Brunelleschi, begun in 1447 and enlarged a number of times in the course of the next three centuries, the residence of the wealthy banker Luca Pitti was acquired in 1549 by Eleonora of Toledo, wife of Grand Duke Cosimo I. It became 'the resplendent and prototypic palace which her Spanish opulence required...Cosimo acquiesced to his wife's plan, perceiving the emblematic value of that private, Medicean microcosm...' (Ludovico Zorzi, 1977).

'...huge, like some ghost of a sample of a ruder Babylon...Generations of Medici have stood at these closed windows, embroidered and brocaded according to their period, and held fêtes champêtres and floral games on the greensward, beneath the mouldering hemicycle'. This was Henry James's view of the immense and disquieting mass of Palazzo Pitti as described in Italian Hours, written in 1909. Today, the Palazzo Pitti houses important museums such as the Galleria Palatina, the Museo degli Argenti (Silver Museum) and the Galleria d'Arte Moderna.

15

*The 'marvels' collected by the avid curiosity
and frenzied taste for collecting of the
Grand Dukes: cameos, marbles, glass items,
amber and jade stones, but also stuffed
crocodiles, shells and mandrakes – a taste
for the bizarre and surprising, which
animated the Baroque spaces of Palazzo
Pitti, furnished with ebony and bronze
caskets and frescoed with illusionistic
effects. But here, also, are the masterpieces
of Raphael, Titian, Rubens, Correggio in
the Galleria Palatina.*

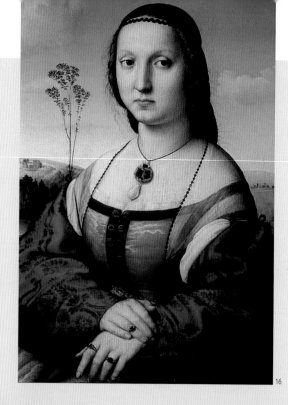

16

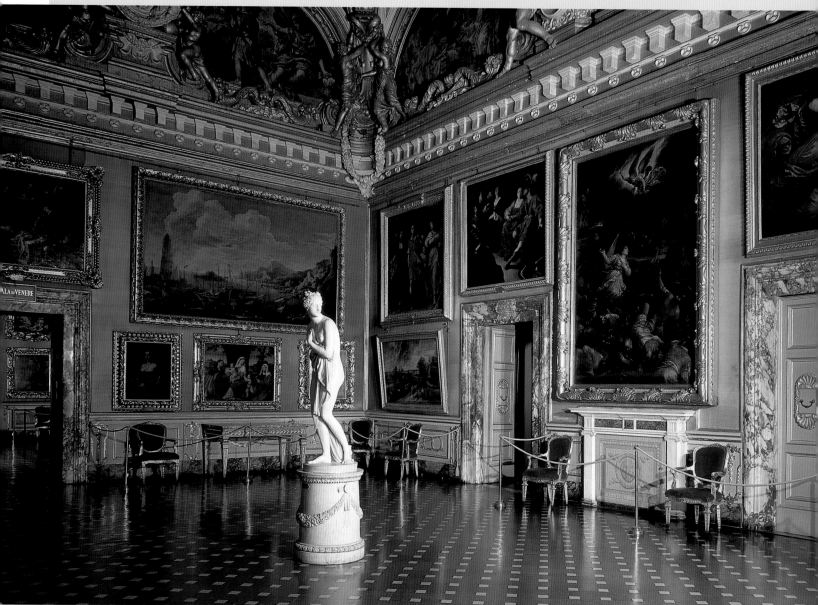

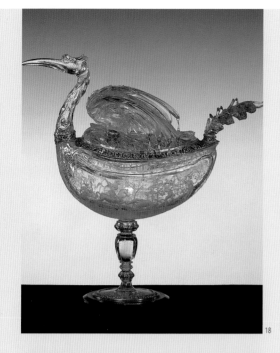

18

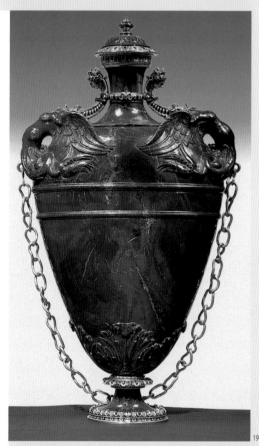

19

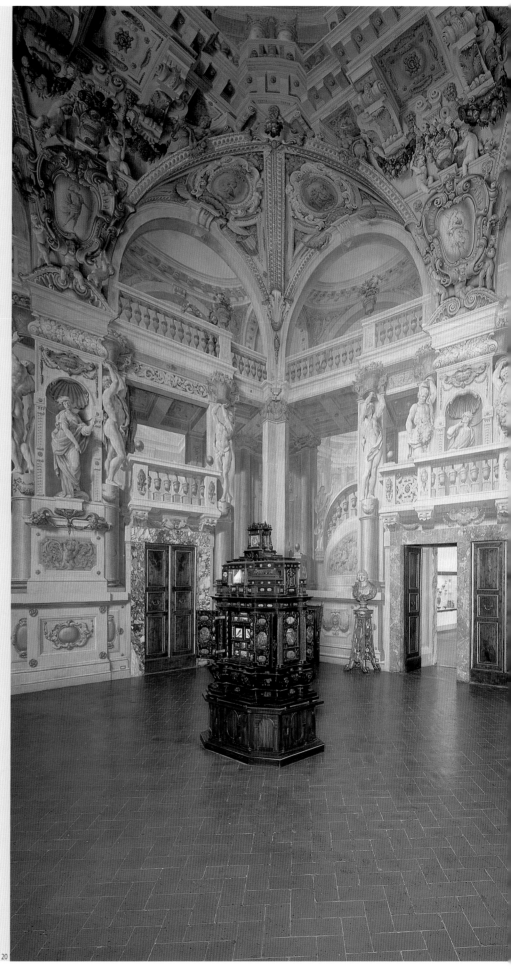

20

'Time has devoured the doers and their doings, but there still hangs about some effect of their passage.' This is how Henry James, an assiduous visitor to the renowned garden of Boboli that stretches out behind Palazzo Pitti, concludes his reflective meditation on the Medici generations, whom he imagines appearing at the windows of the palace. The vast courtyards and the gardens severely shaped by the ars topiaria of the Medici gardeners were also the venue for dazzling scenographic invention and sophisticated theatrical and musical shows.

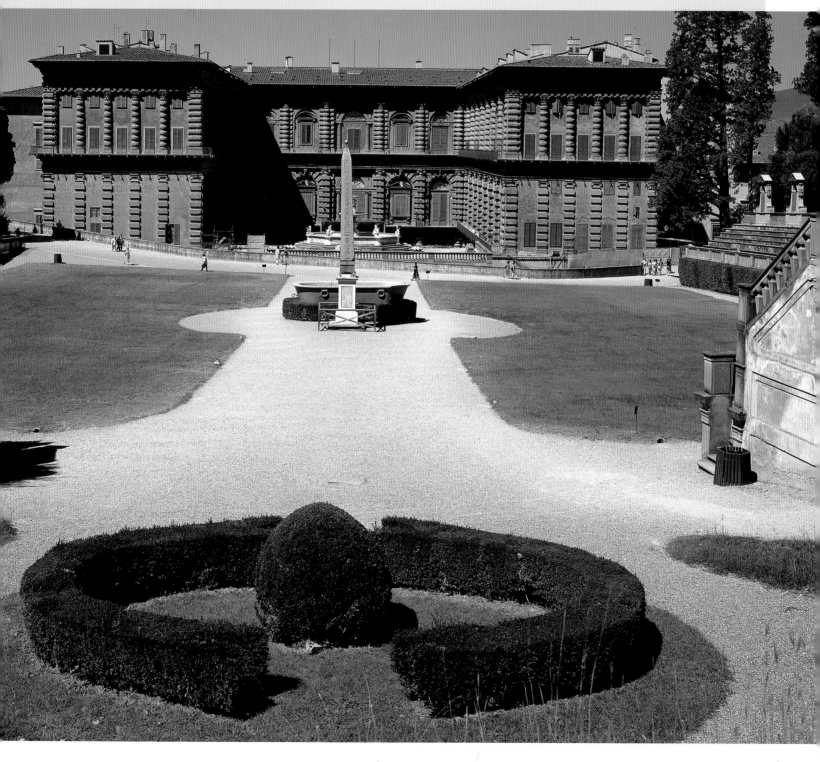

'The Boboli Gardens are not large – you wonder how compact
little Florence finds room for them within her walls…You may
cultivate in them the fancy of their solemn and haunted
character, of something faint and dim and even, if you like,
tragic…' The words, once again, of Henry James as he explored
Boboli at the beginning of the twentieth century.

24

25

26

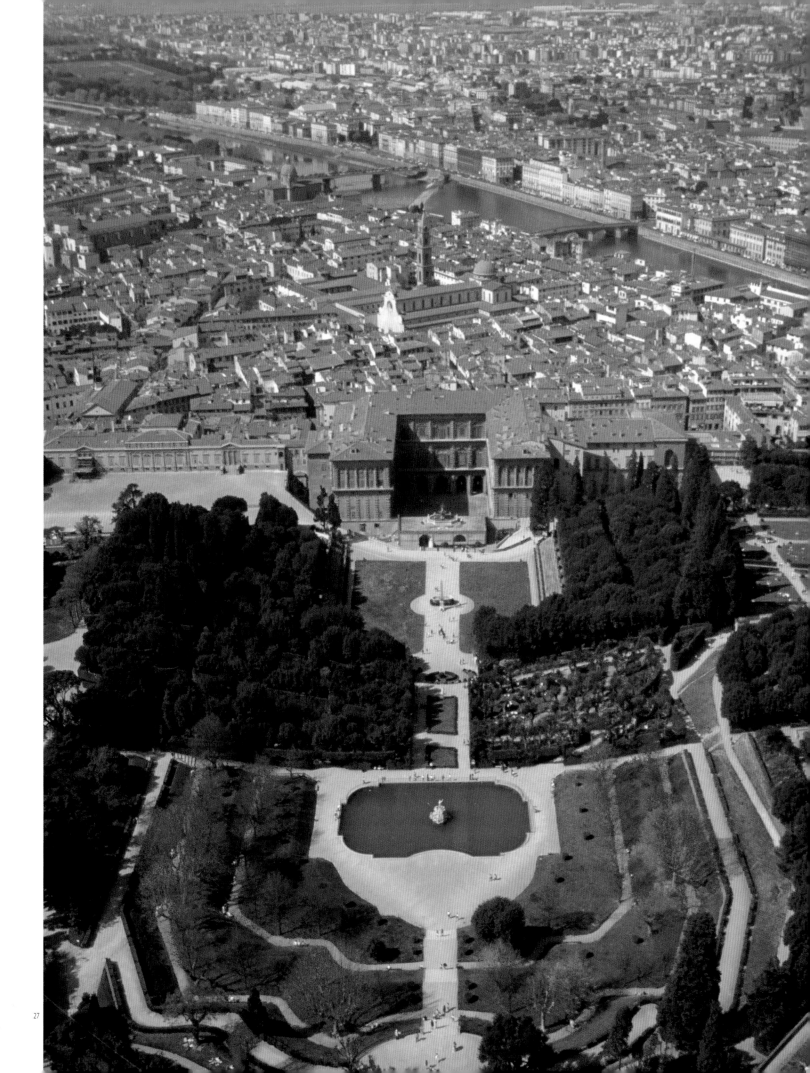

*The enchantment of the Boboli Gardens is the result of a fusion between art and nature. Fountains, exedrae and statues fit elegantly into the scenery of Mediterranean and exotic plants. One of the most widespread and popular botanical species in Florence were citrus fruits, in particular lemons, which were grown in large terracotta pots and kept in the cold winter months in special rooms called* limonaie.

29

28

30

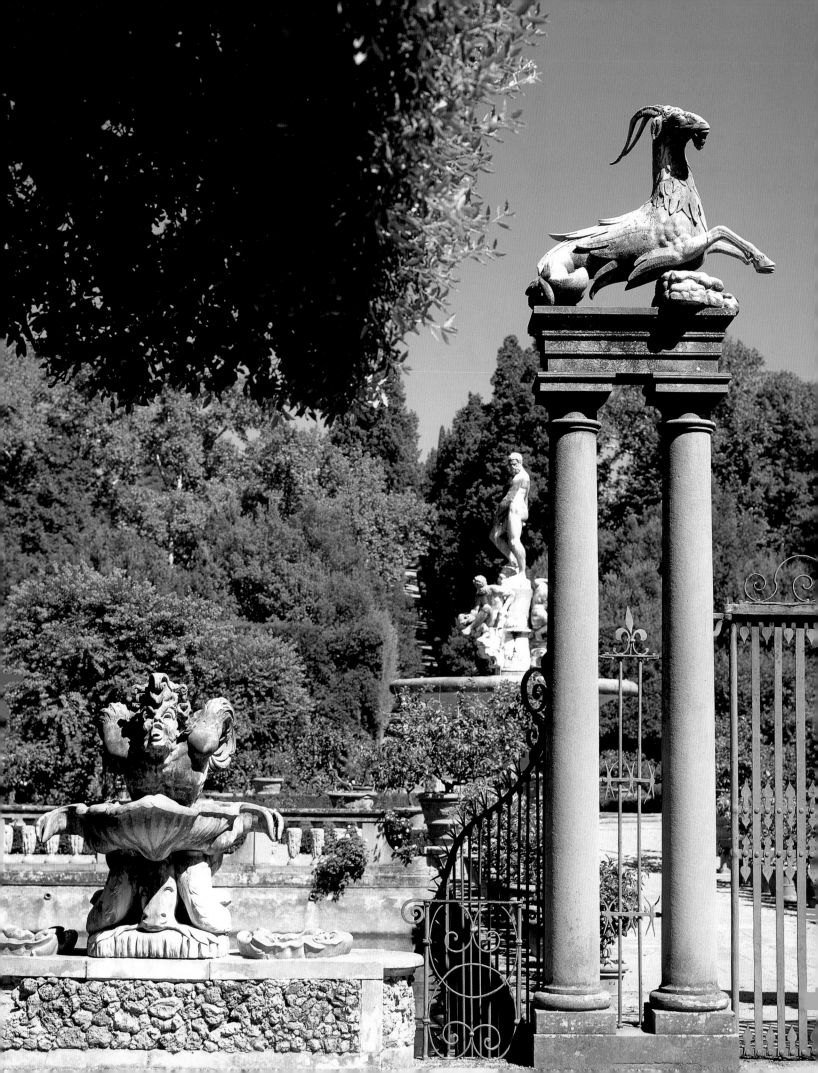

'A softly beautiful addition of Florentine Romanesque to the pure Tuscan countryside' (O. Lelli, G. Pampaloni, 1986): San Miniato al Monte, surmounted by the eagle of the Arte di Calimala, is one of the supreme examples of twelfth- and thirteenth-century Florentine architecture, and has retained its calm beauty and its atmosphere of ecstatic contemplation. Inside there are works from the twelfth to the fifteenth centuries, ranging from the marble pulpit to the frescoes of Spinello Aretino and from the Cappella di Piero de'Medici by Michelozzo to the tomb of the Cardinal of Portugal by Antonio Rossellino.

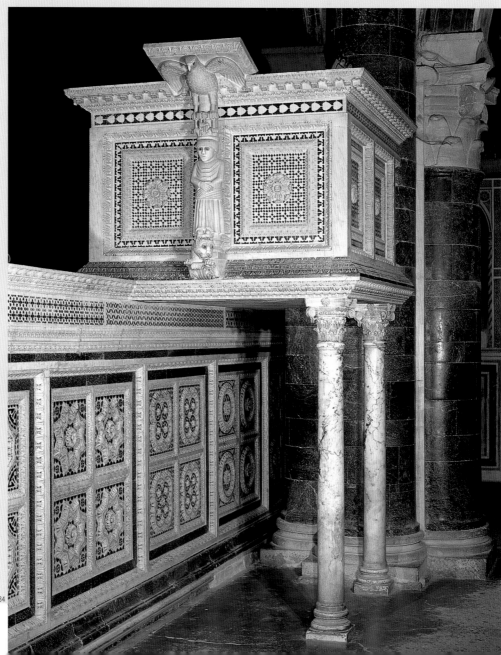

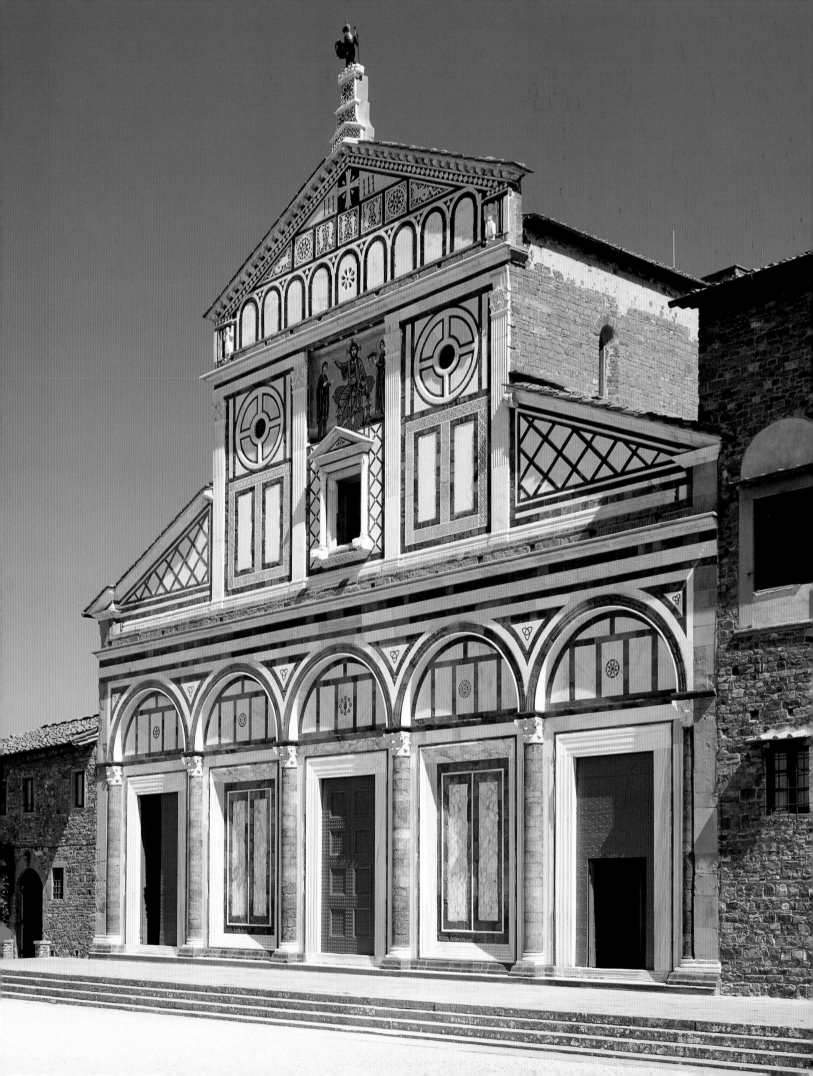

*Florence is not only known for its art, but also for its great literature and scientific advances. Here are statues of Dante and Galileo, finally brought together by the illusionistic effect of the telephoto lens trained on the niches of the Biblioteca Nazionale. The father of the Italian language and the founder of modern science preside over the largest library collection in Italy, their gaze turned towards the hills of Piazzale Michelangelo.*

36

37

38

39

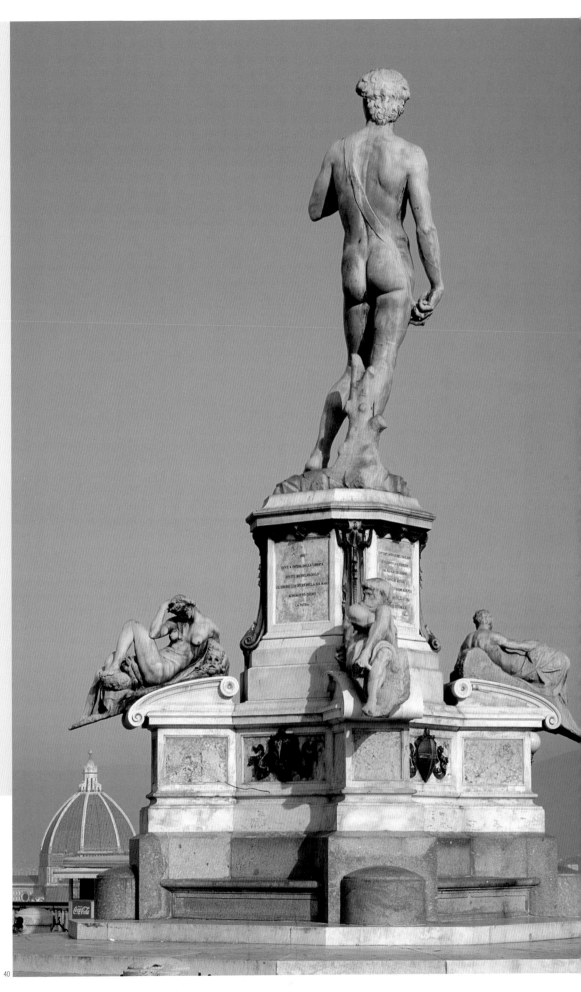

40

41

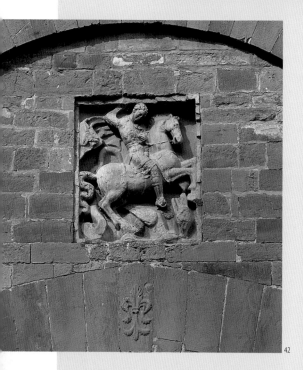

42

St George is the defensive emblem of the most ancient gate in Florence, on the hill of Belvedere where the ancient circle of walls converge. Michelangelo is also depicted here, in a painting housed in the Casa Buonarroti, while he outlines plans to reinforce the powerful bastions before the siege of 1530, which brought to an end the period of the Florentine Republic. Sixty years later, Ferdinando de'Medici had the Forte di Belvedere built opposite but outside the walls, together with the pleasant villa at its centre.

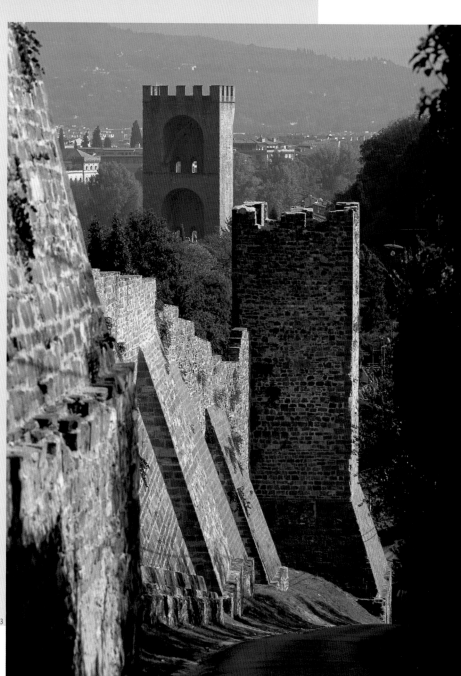

43

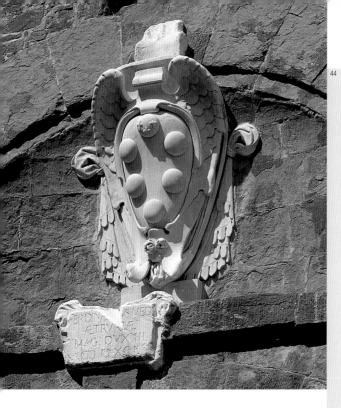

44

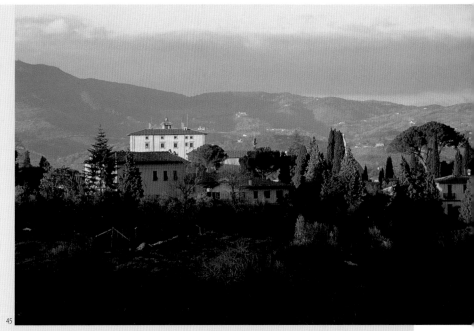

45

46

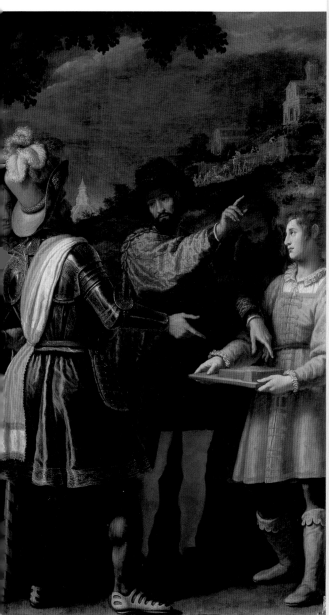

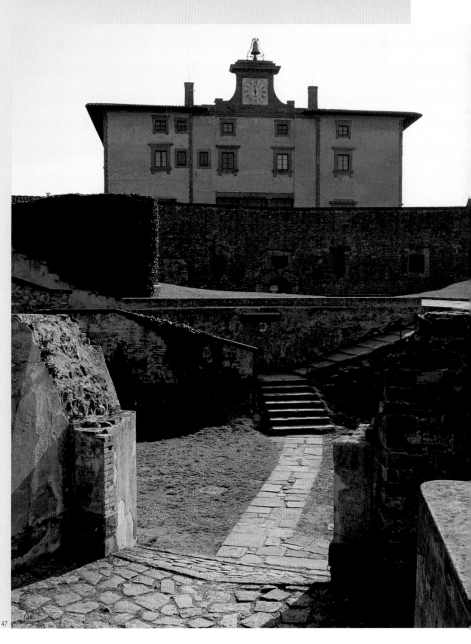

47

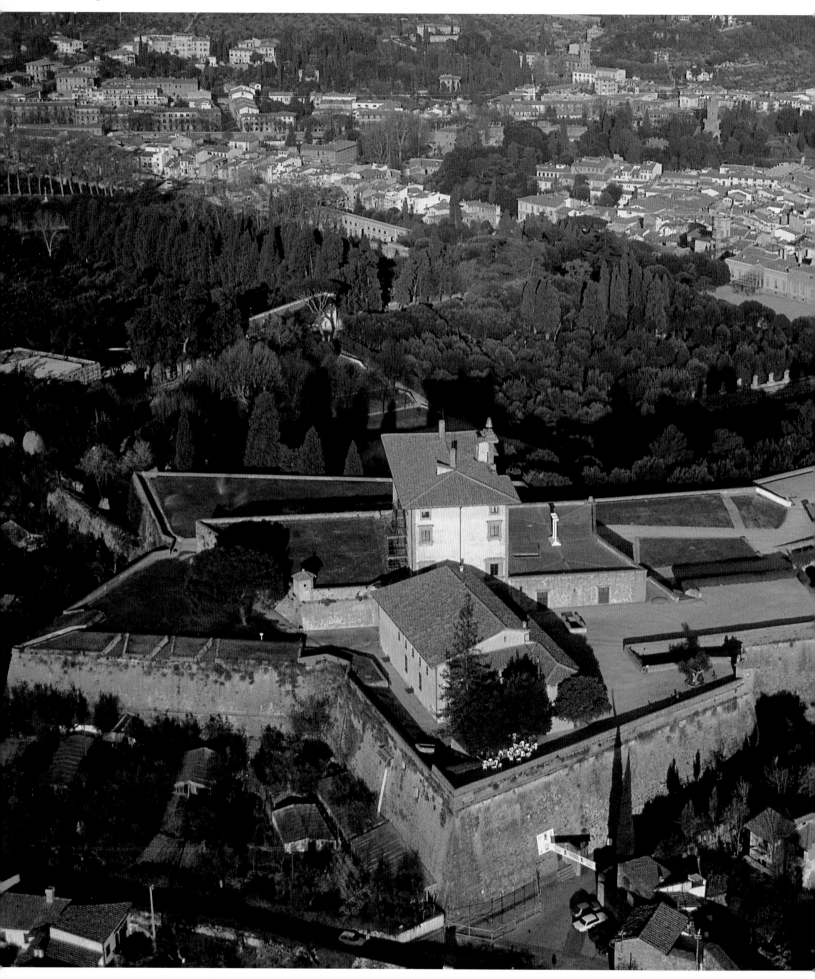

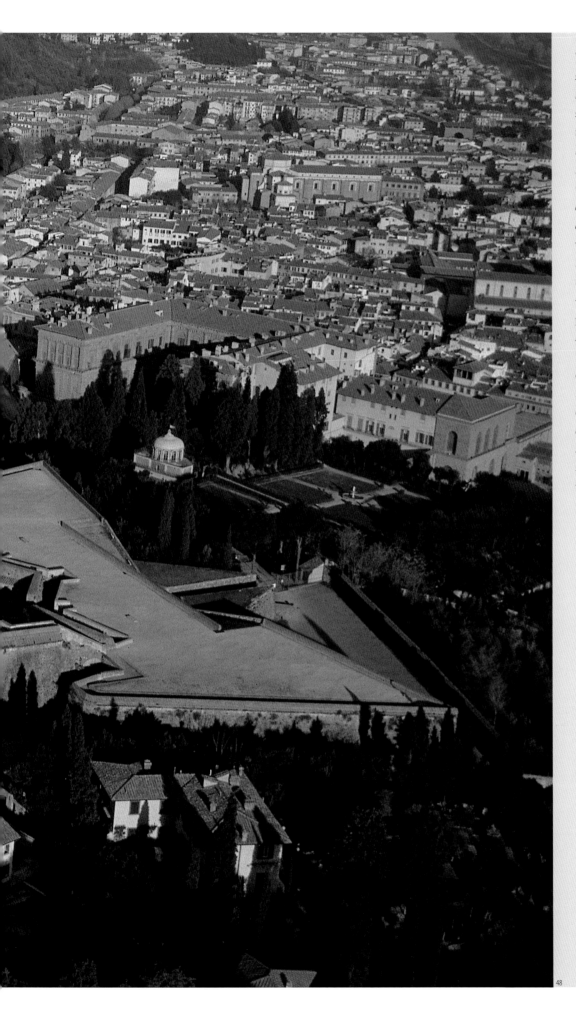

The full power of the star-shaped Forte di Belvedere can be seen in this picture. In a single sweeping view, one can take in the Boboli Gardens below, the eighteenth-century Kaffeehaus, built to satisfy Grand Duke Peter Leopold, and the stretch of the city lying at the foot of the hill. Together with the Fortezza da Basso, the Forte di Belvedere provided – thanks also to modern firearms – a defensive system for the power of the Grand Dukes. After 1859, when the last Grand Duke left Florence, the cannons were removed to the Fortezza da Basso. Just one cannon remained, which until a few decades ago fired a single shot precisely on midday to signal to Florentines that it was time to go and eat.

48

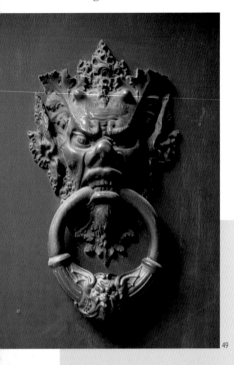

49

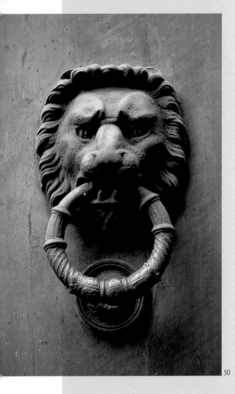

50

51

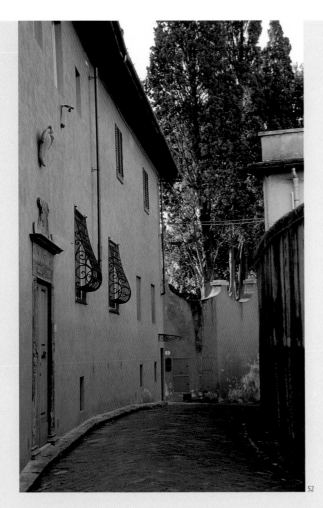

*Via della Scala, Via dei Benci, Via Schiapparelli, Via San Leonardo: glimpses of details of a city that never ceases to yield up fresh discoveries. And in its streets and lanes, in stone- and bronze-framed doors, in the walls that hide houses and gardens that have not become museums or silent reliquaries, the ancient city endures and lives on.*

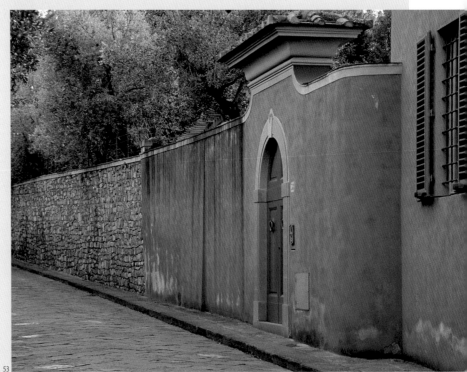

52

53

54

55

56

57

58

59

PIAZZA
DEL TIRATOIO

60  61

62

*Minute and modest features of daily living in Florence: door bells, street signs, ironwork protecting walls from passing carts, time-worn paving, windows, air vents, letter boxes…urban furnishings, one might call them today. But what grace and history there is surrounding us as one walks through these ancient streets…*

63

64

In a nineteenth-century palace at the foot of the hill of Belvedere, the antiquarian Stefano Bardini gathered together his extraordinary collection of works and art objects, which he donated to the city in 1923. Stone and wooden sculptures, frescoes and drawings, chests and cabinets, are all laid out as in an actual home: a Florentine house imagined (and imitated) by millions of Tuscany-lovers round the world.

66

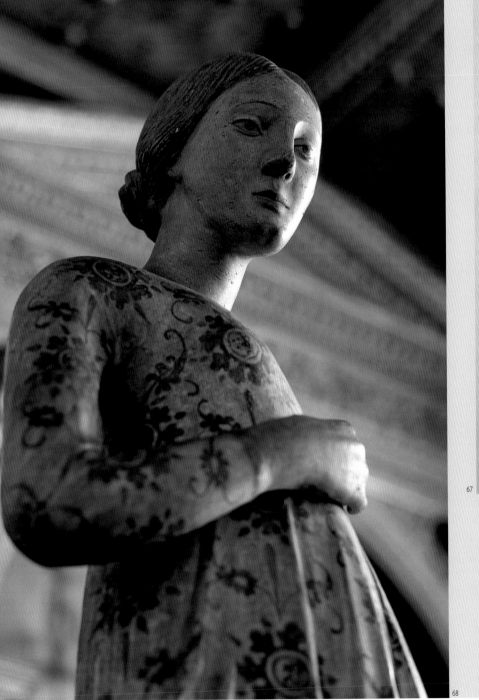

68

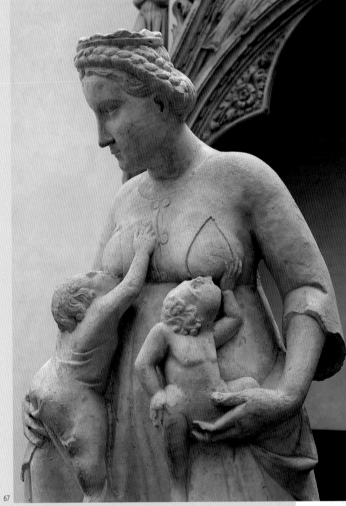

67

# Weathering the flood

The streets of Santa Croce and the silence of the basilica – Giotto and
the geometry of Brunelleschi – the noisy bustle of markets and the products
of artisan creativity

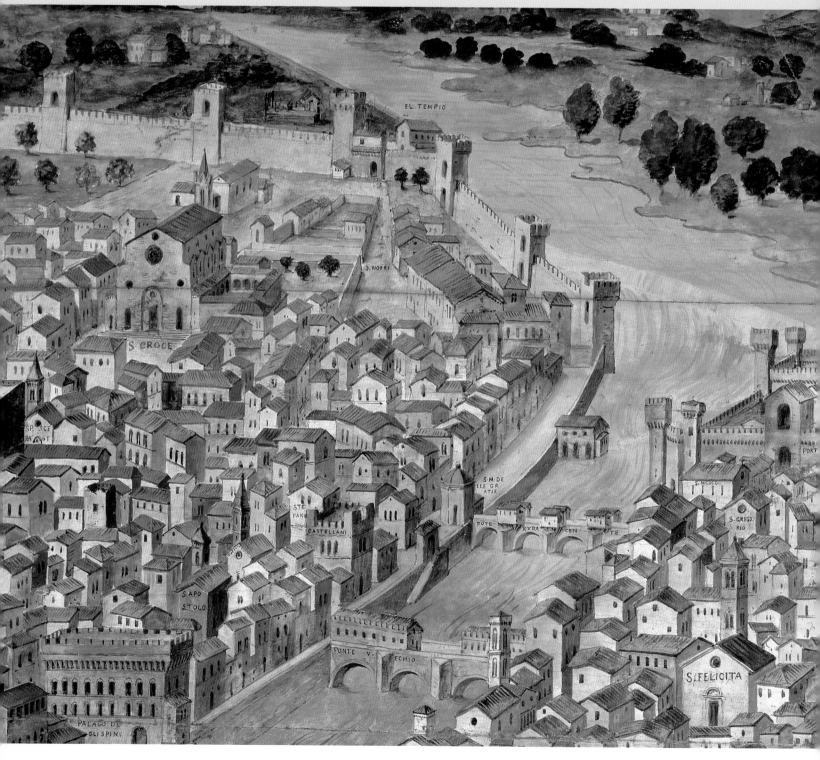

The neighbourhood of Santa Croce starts behind Palazzo Vecchio; 2000 years ago, there was a Roman amphitheatre here, traces of which are still visible in the curves of the medieval streets. The broad, sunny rectangle of the piazza appears suddenly and is dominated by the Franciscan basilica of Santa Croce. The work of Arnolfo and Brunelleschi – the two builders who, separated by more than a century, left such an indelible mark on the city – coexist in this church. Arnolfo laid the foundation stone of the present structure in 1294, on the site of a small Franciscan building on the edge of the city, almost in the countryside. And although there is no conclusive documentary evidence, it is known for certain that, in the 1530s, the adjacent Cappella de' Pazzi was designed by Brunelleschi. Using circle, square, cube, sphere and rectangle, he designed, as always, space, and 'with space, light, which enters his buildings in calculated quantities, contributing to that supreme plainness and unprecedented clearness which is the origin and at the same time the essence of the work, the articulation of a mental law in stone' (P. F. Listri, 1999). Brunelleschi seemed to be striving through this geometric exactness to establish the relationship of Renaissance Man with the divine harmony of the universe.

The Arno struck the Santa Croce neighbourhood hard on 4 November 1966. The river broke its banks, submerging the piazza and the surrounding streets in almost five metres of muddy water, sweeping away Cimabue's *Crucifix* and valuable collections of books from the nearby Biblioteca Nazionale. Swirling torrents broke through the doors of poor homes and wealthy palaces alike, and engulfed goods and equipment in the local workshops. Radio and television broadcasts transmitted the terrible news of a catastrophic flood that threatened to devastate Florence. That did not happen. The city picked itself up – young people rushed to save the treasures of the Biblioteca Nazionale, the local citizens rolled up their sleeves without complaint and the neighbourhood of Santa Croce, the most badly affected area, slowly returned to life and began to repair the damage. Soon, it was once again possible for visitors to admire Giotto's frescoes, Donatello's *Annunciation*, Cimabue's *Crucifix* (painstakingly, but only partially, restored) and the harmonious spaces of Brunelleschi. The neighbourhood, one of the largest working-class areas of the city, was obviously no longer the same. The flood forced many people to abandon houses that had always been unhealthy and squalid, as the houses of the poor often are in historic city centres. So powerful was the destructive force of the muddy waters that the houses would have been uninhabitable for a long time. The *popolo minuto* was in part replaced, but certainly there is no longer that sorry mass of humanity that the great twentieth-century Florentine writer Vasco Pratolini had so effectively depicted in his novel *Il Quartiere*: 'Clothes hanging from windows, scantily dressed women. But also poverty borne proudly and loved ones defended tooth and claw. Workers, or to be more precise, carpenters, cobblers, horseshoers, mechanics, mosaicists. And smoke-filled taverns and shops…' Nowadays, the large monuments are increasingly crowded with tourist groups, but not far from Piazza Santa Croce it is the local people who throng the stalls of the Sant'Ambrogio market and only a few outsiders wander around the antique market in Piazza de' Ciompi, which almost seems to lean against Vasari's Loggia del Pesce. The roots of the neighbourhood are almost intact here.

Piazza Santissima Annunziata is a short walk away: 'the first piazza in Florence to be conceived of in a unitary fashion and to be planned by a single mind' (G. Fanelli, 1980). That mind was Brunelleschi's, who was commissioned by the Arte dei Setaioli (Silkworkers' Guild) in the early decades of the fifteenth century to build the Spedale degli Innocenti. His innovative classicism is evident yet again in the arches and columns, in the steps that seem to lead to a place of worship but which instead are the prelude to an extremely elegant building whose purpose – a mark of a great social consciousness – was to offer protection to abandoned children. And what a piazza, constructed as it is with those porticoes. The Della Robbia *putti*, tightly wrapped in swaddling, look down on us without rancour from the facade but nonetheless remind us of the misery of humankind, soliciting acts of loving charity. The basilica of Santissima Annunziata, much cherished by Florentines, is an ancient oratory devoted to the veneration of the Virgin Mary. It has been rebuilt a number of times, and the Chiostro dei Voti houses frescoes by Pontormo, Andrea del Sarto, Rosso Fiorentino (a new 'manner' of painting), while inside Leon Battista Alberti again expressed, in the motif of the circular choir (of Brunelleschian inspiration), the theme of the centrality of Man. A short distance away, in the Accademia, Michelangelo made his secular response with the virile beauty and libertarian strength of his *David*.

'Di qua d'Arno', on the edge of the Santa Croce quarter and in front of the thirteenth-century tower-house of Alberti, is another museum that has been donated to the Italian state by an affluent art collector and scholar, the Englishman H. P. Horne. In its richly furnished fifteenth-century rooms, possibly built by Cronaca, there are fine frescoes and paintings, including some works of superlative value, like Giotto's St Stephen *and a chest painted by Filippino Lippi to a design by Botticelli.*

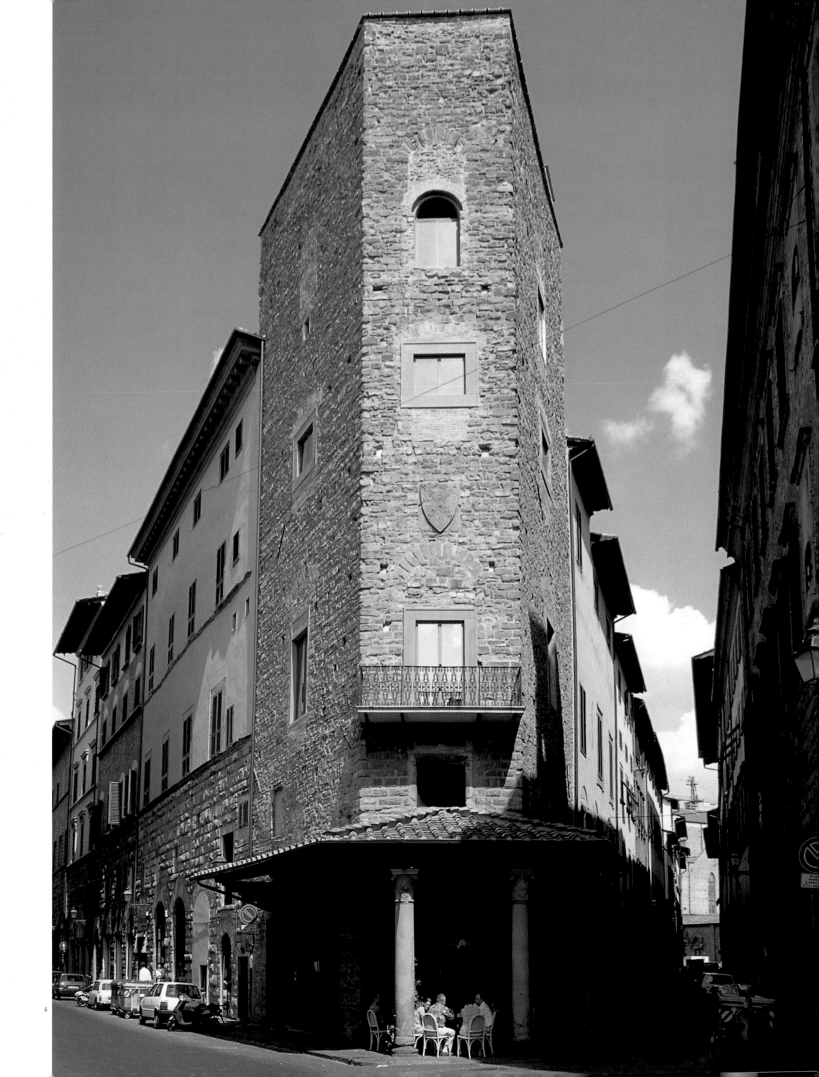

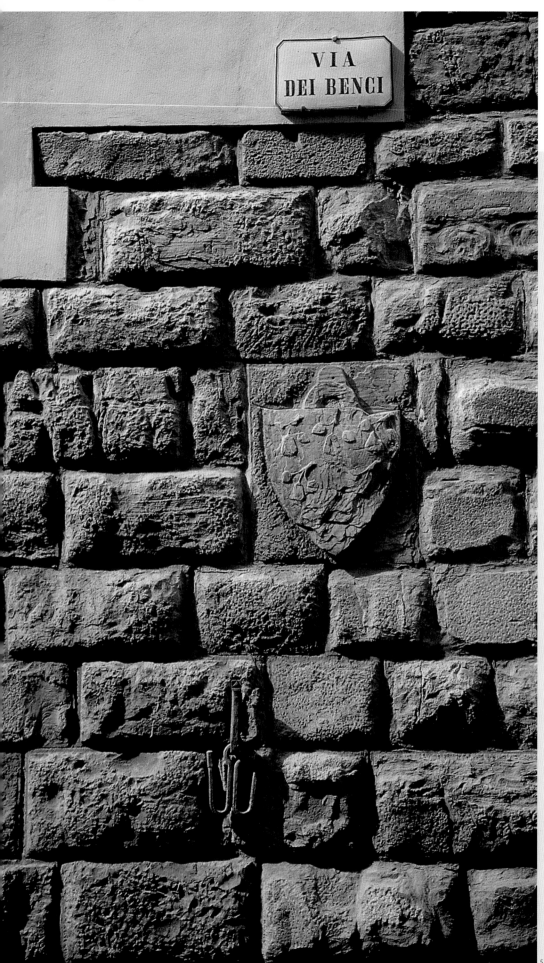

*Via dei Benci: rusticated walls, crests of ancient noble families, cast iron and wood intaglio work. These visible traces of a fine craftsmanship that still exists today are all part of Florence – the past flowing into the present, the finishing touches of an urban vision and echoes of a centuries-old dignity.*

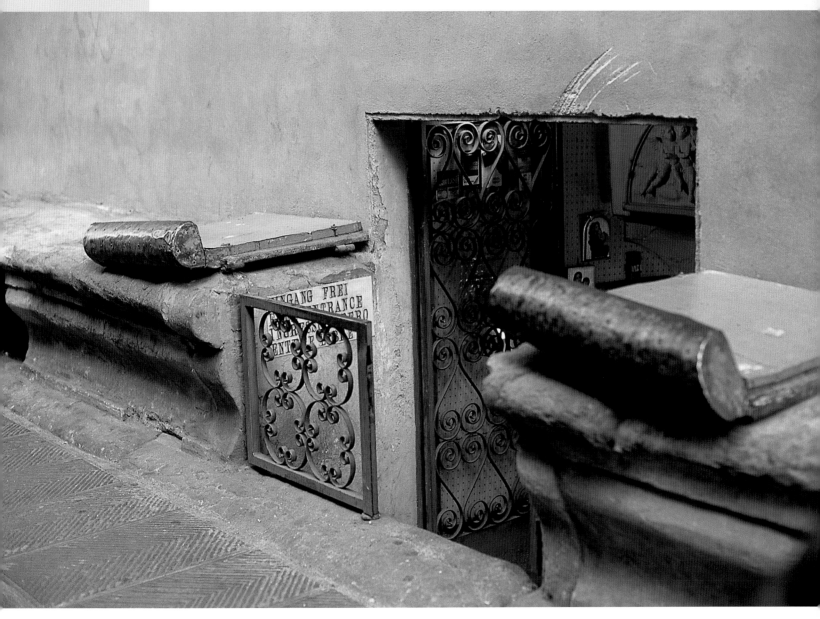

*The Santa Croce quarter, 'one of the best-conserved in Florence, with its medieval palaces, dark alleys and splendid monuments, dominated by the church of Santa Croce, a temple to the Italian people'. This is how Geno Pampaloni and Onorio Lelli described one of the most 'Florentine' areas of Florence in 1986, whose piazza was once a place where Florentines gathered to listen to the sermons of the Franciscans, admire elegant horse-riding and jousting tournaments or enjoy rough games of calcio fiorentino, which is now a major tourist attraction.*

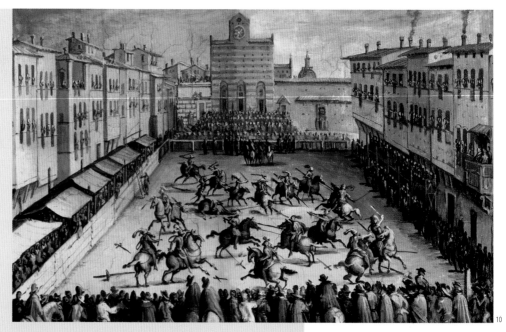

10

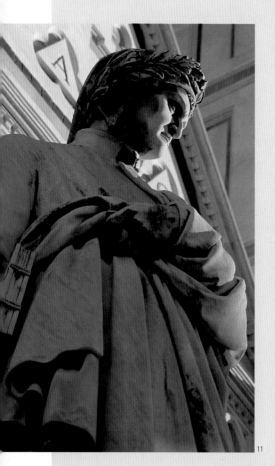

11

12

13

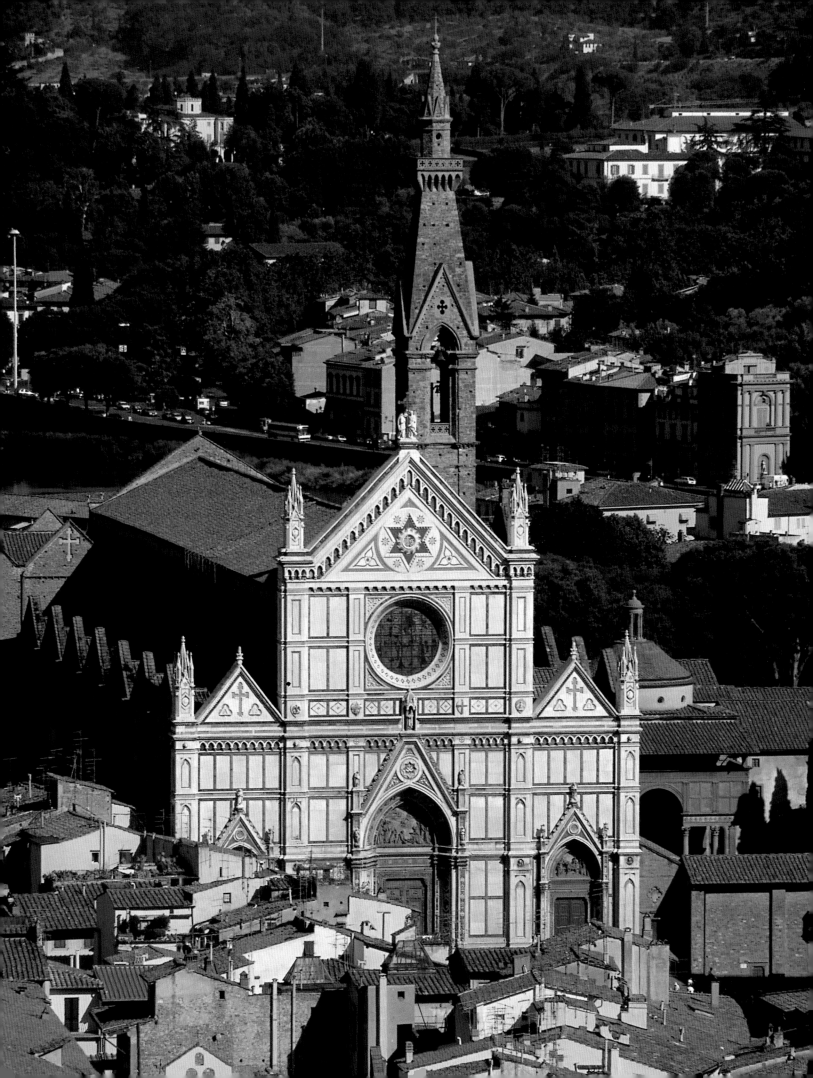

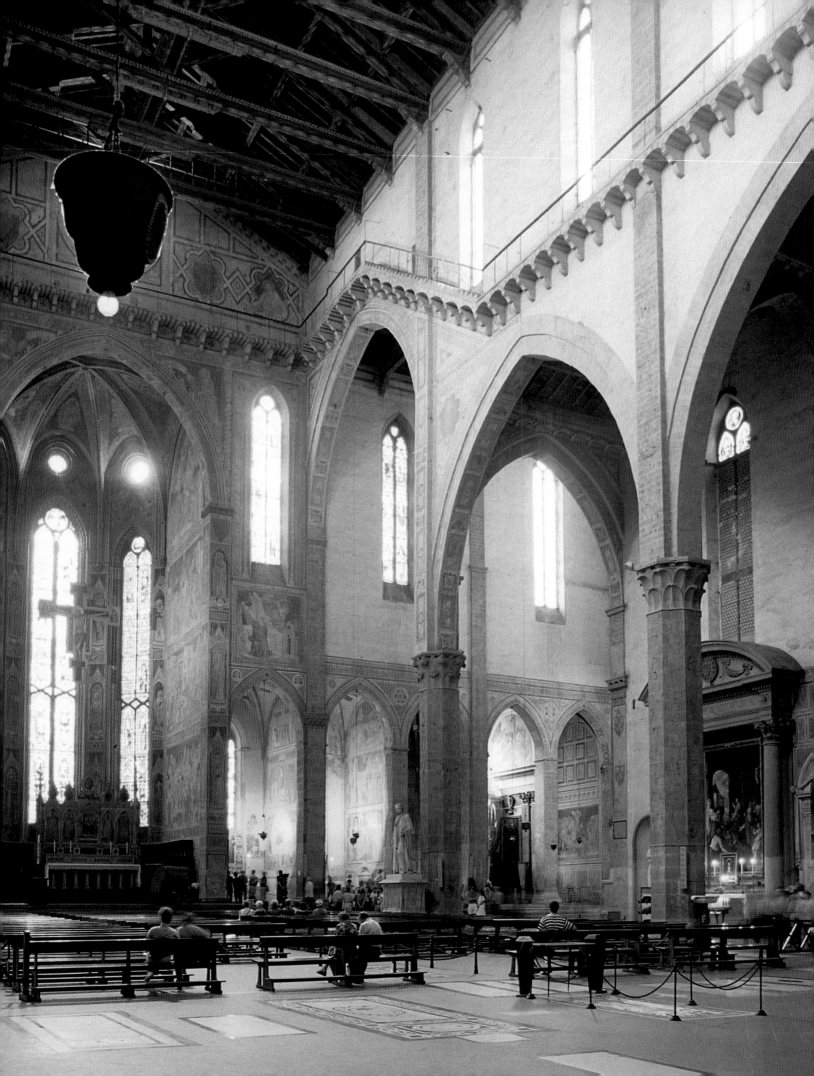

Designed by Arnolfo in 1294 for the Franciscan Order, the austere, Gothic interior of Santa Croce contains artistic and historical masterpieces and commemorative works: frescoes by Orcagna and Giotto, the Crucifix of Cimabue (irreparably damaged in the 1966 flood) and the urne de'forte – tombs of the great – that inspired a celebrated poem by Ugo Foscolo.

15

16

17

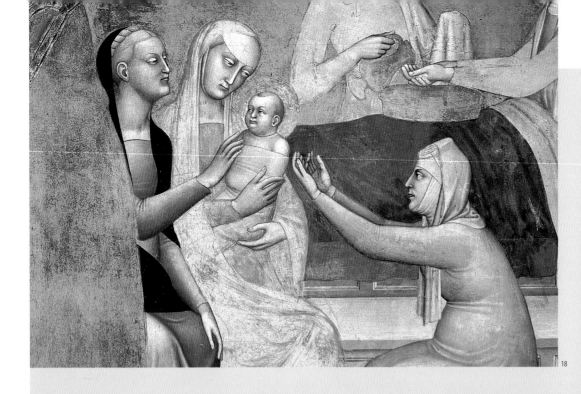

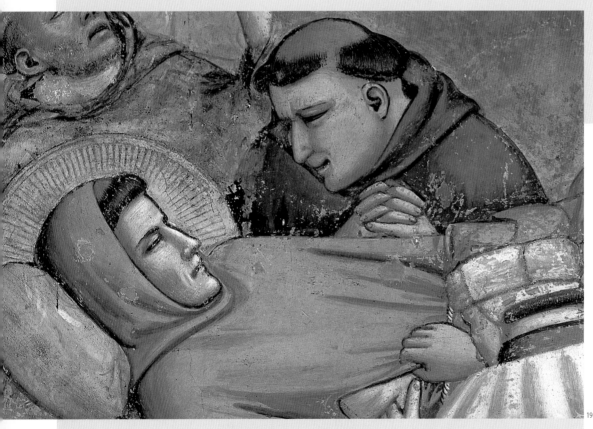

The final legacy of Giotto in the Peruzzi Chapel and the Bardi
Chapel of Santa Croce, respectively the Life of St John the
Evangelist and the Baptist and the Life of St Francis, concluded
in the early fourteenth century the figurative epic of the founder of
Italian and modern painting. 'For Giotto the value of art no longer
lay in the technical execution of the work but in the power and
innovation of the concept' (G. C. Argan, 1968–69).

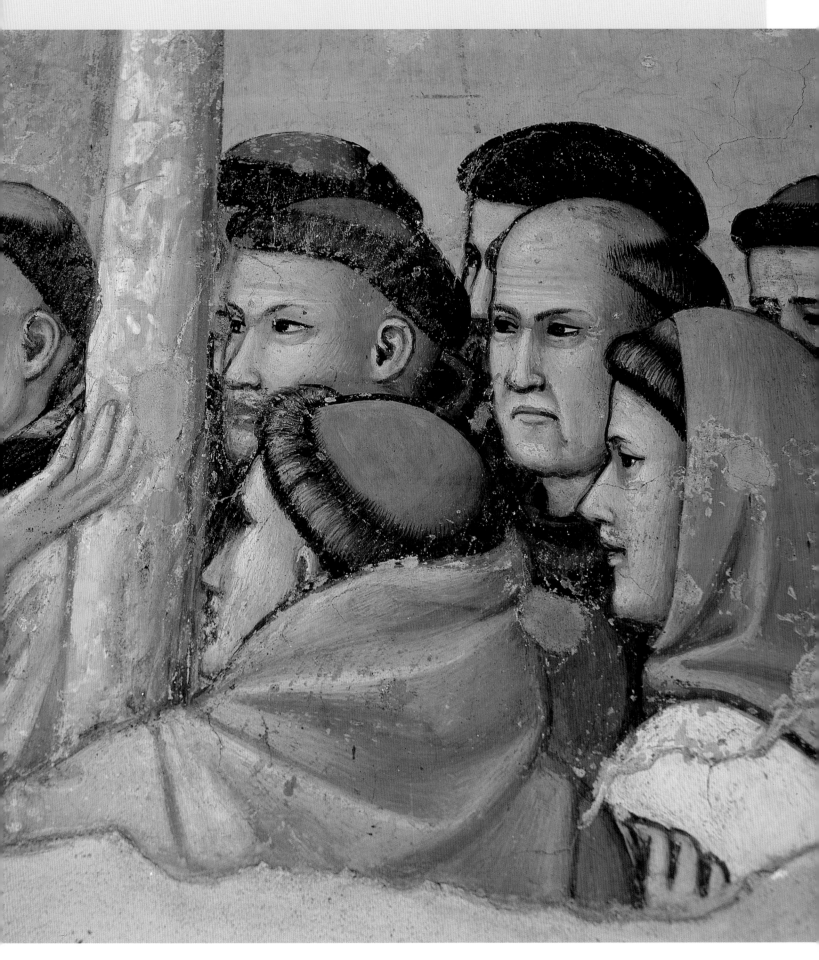

*Filippo Brunelleschi designed the Pazzi Chapel in Santa Croce in 1430; it was a supreme example of Renaissance classicism, with the pronaos on six Corinthian pilasters in pietra serena supporting an attic divided into squares. Above the roof there is a low cylindrical dome. The effect is that of a powerful plastic organism where the stone framework achieves the maximum expressive significance. But here the square shape of the main room, in comparison to his previous work in the Old Sacristy, becomes a rectangle, without however losing the fascination of its geometric harmony.*

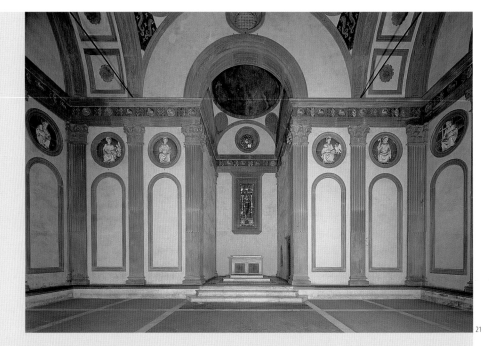

21

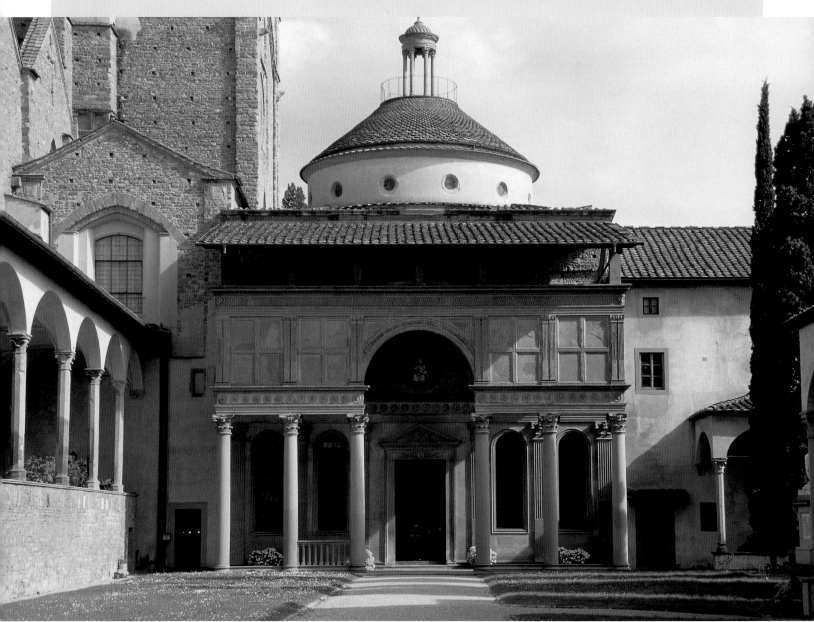

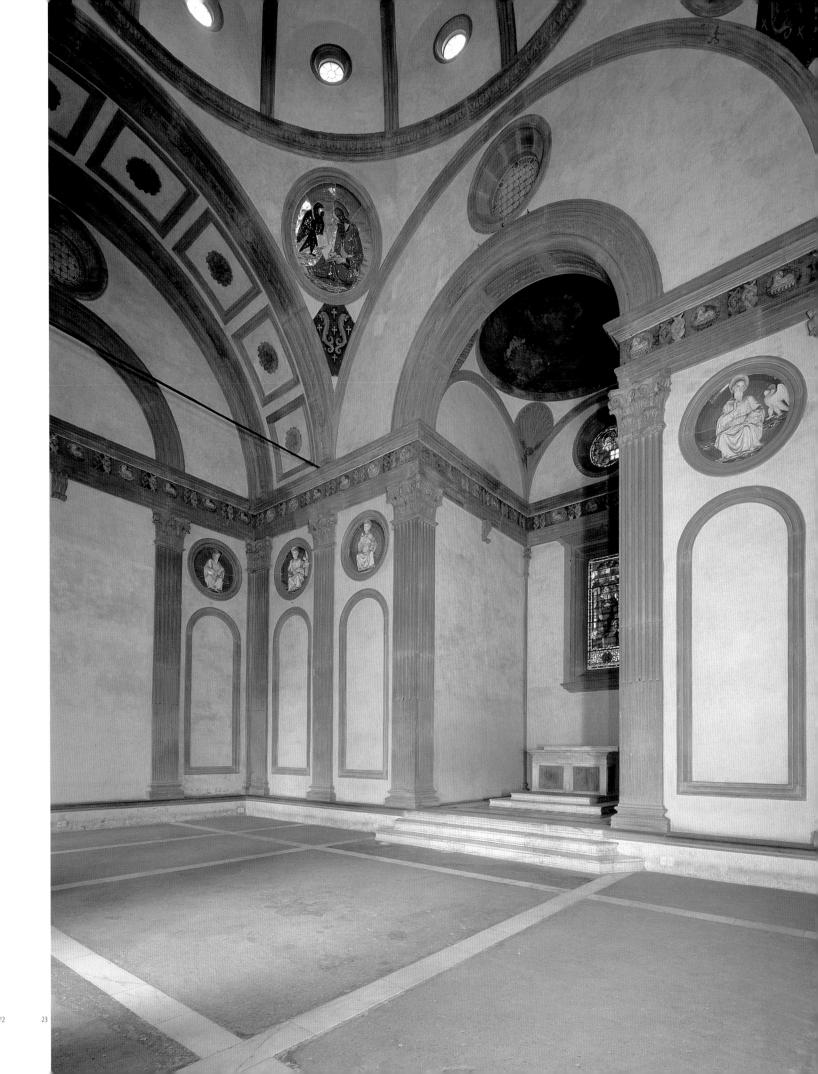

24

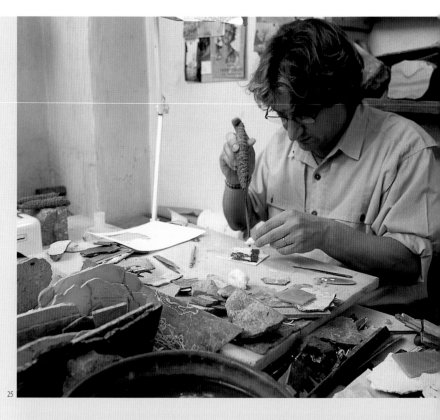

25

26

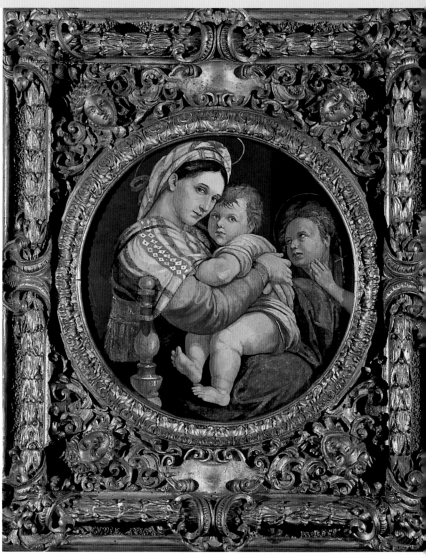

27

The ancient medieval and Renaissance crafts live on in the *botteghe* and skills of master craftspeople. Mosaics (also in the form of reproductions of pictorial masterpieces), marquetry in semiprecious stones, work in bronze and gold, the art of leatherwork – a wealth of skills that are also a major economic resource for Florence.

28

29

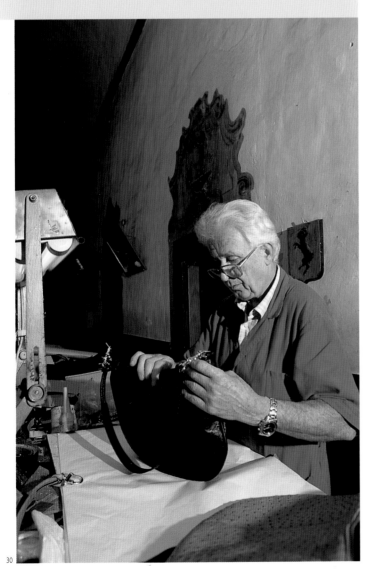

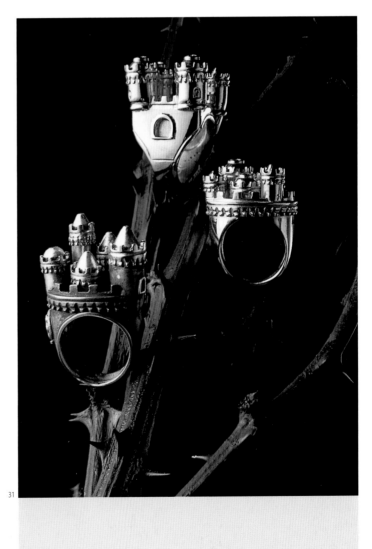

30

31

The detail of a vault in an elegant hotel in the neighbourhood, which seems to recall that of the Loggia del Pesce built by Vasari in 1576 and set up in the Mercato Vecchio. The loggia was dismantled in the nineteenth century to make way for new buildings in the centre, and was re-erected here, between Via Pietrapiana and Piazza de' Ciompi, next to a busy flea market. After the 1966 flood, this piazza was home to the committee that directed and organised reconstruction work in the Santa Croce area.

32

33

34

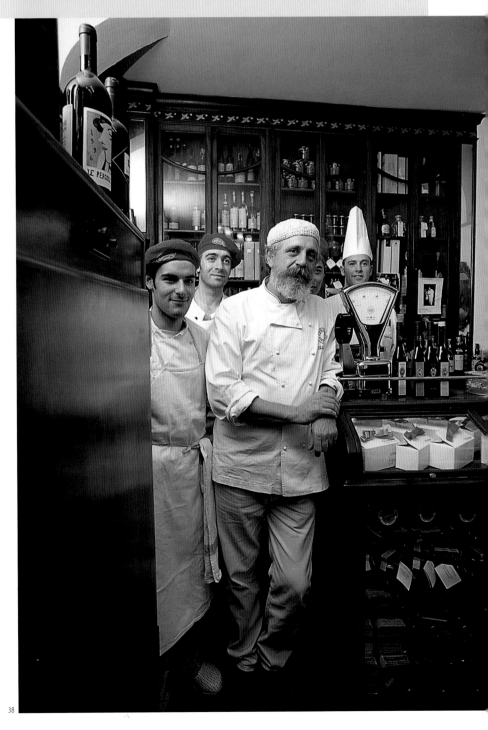

Cereals, pulses and flowering vegetables in
the noisy and lively market of Sant'Ambrogio,
just a stone's throw from the simple elegance
of the celebrated Il Cibreo restaurant.
Featured in the foreground is the proprietor,
Fabio Picchi, who has revisited traditional
Florentine cuisine by opening it up to
flavours and aromas from round the world.

*Piazza della Santissima. Annunziata is one of the high points of humanist Florence, with its Palazzo della Confraternita dei Serviti by Antonio da Sangallo il Vecchio and Baccio d'Agnolo, and above all the Ospedale degli Innocenti, the foundling hospital that Filippo Brunelleschi was commissioned to build in 1419 by the Corporazione dei Setaioli. The result was 'one of the earliest examples of the geometric construction of space' (Klaus Zimmermanns, 1990).*

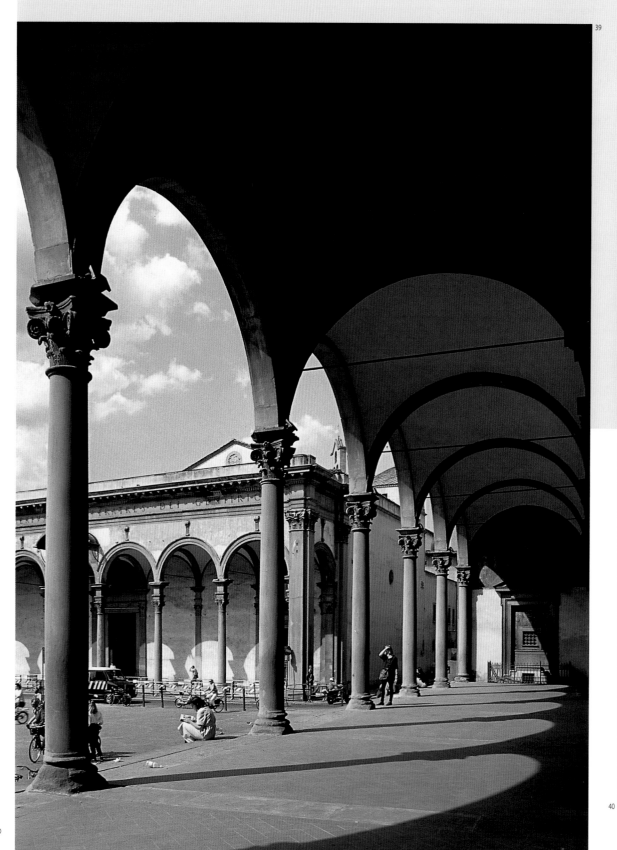

39

40

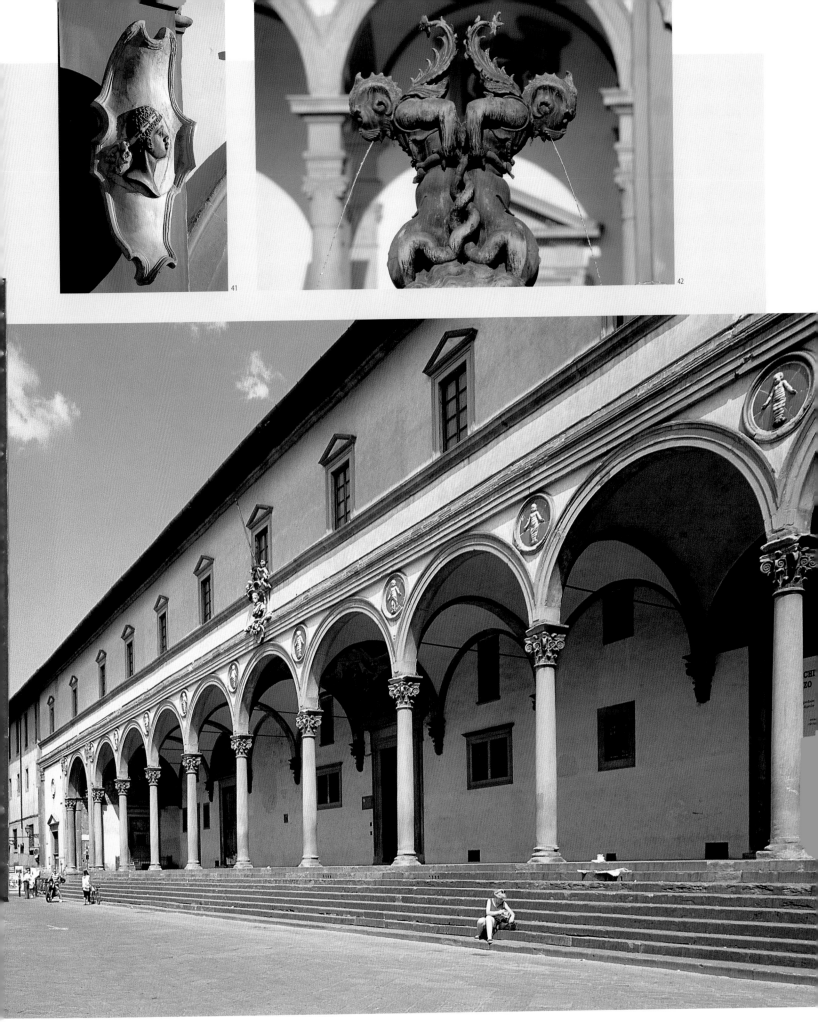

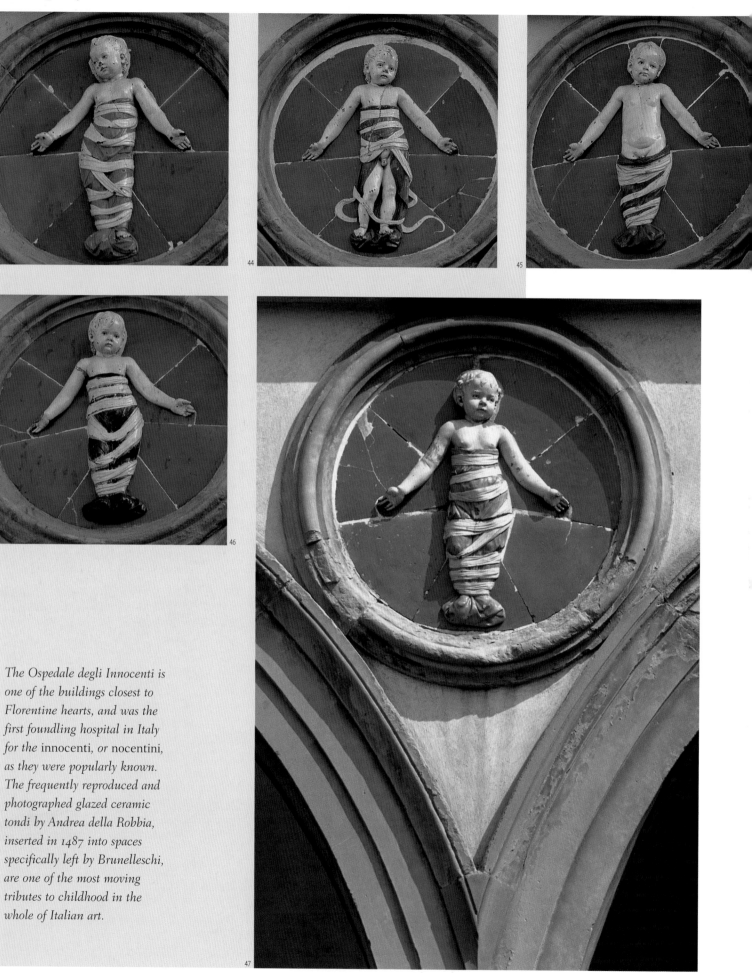

The Ospedale degli Innocenti is one of the buildings closest to Florentine hearts, and was the first foundling hospital in Italy for the innocenti, or nocentini, as they were popularly known. The frequently reproduced and photographed glazed ceramic tondi by Andrea della Robbia, inserted in 1487 into spaces specifically left by Brunelleschi, are one of the most moving tributes to childhood in the whole of Italian art.

*No stay in Florence is complete without a visit to the Galleria dell'Accademia, where, in all its resplendent power and beauty, there stands one of the universal emblems of art and sculpture: Michelangelo's David. In one of his many studies of the Renaissance, Bernard Berenson observes succinctly that Michelanagelo's passion was the nude, and his ideal was force. This is clearly embodied in David, a young giant of a man, the symbol and image of the new-born Florentine Republic, which was already being threatened by hostile powers in Italy and Europe. An unarmed giant, nude and implacable, 'distinguished by the youthful beauty of his body and a frightening will-power...there is hardly any trace of the weight of the stone, nor of a struggle with the material. There has been a shift away from the tension between spirituality and unformed matter towards a conflict between a will which tends to express itself and the self-absorbed beauty of the body...'*
*(Klaus Zimmermanns, 1990).*

*Nearby, almost as if to underline the striking freedom of the massive figure, are the four* Prisoners *or* Slaves *struggling to free themselves from the block of marble imprisoning and enslaving them.*

49

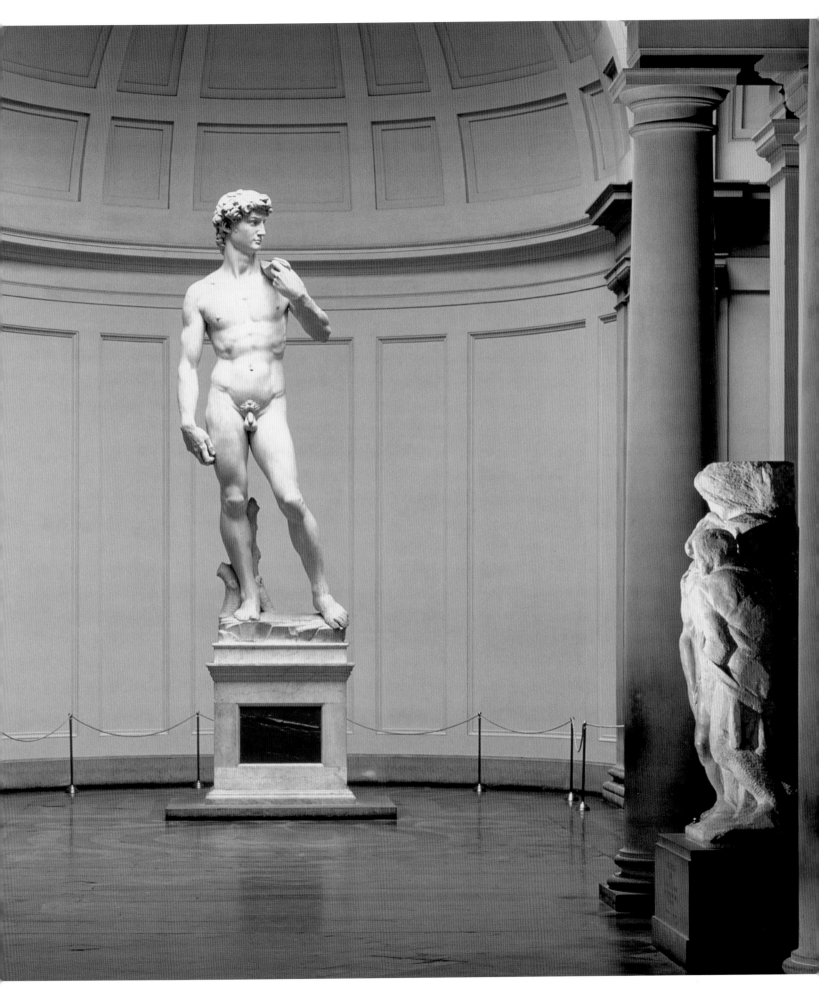

# Perfect proportion

*The peace of San Marco and the frescoes of Beato Angelico, where the Medici established their power – the rooms of the palace in Via Larga and the glory of San Lorenzo*

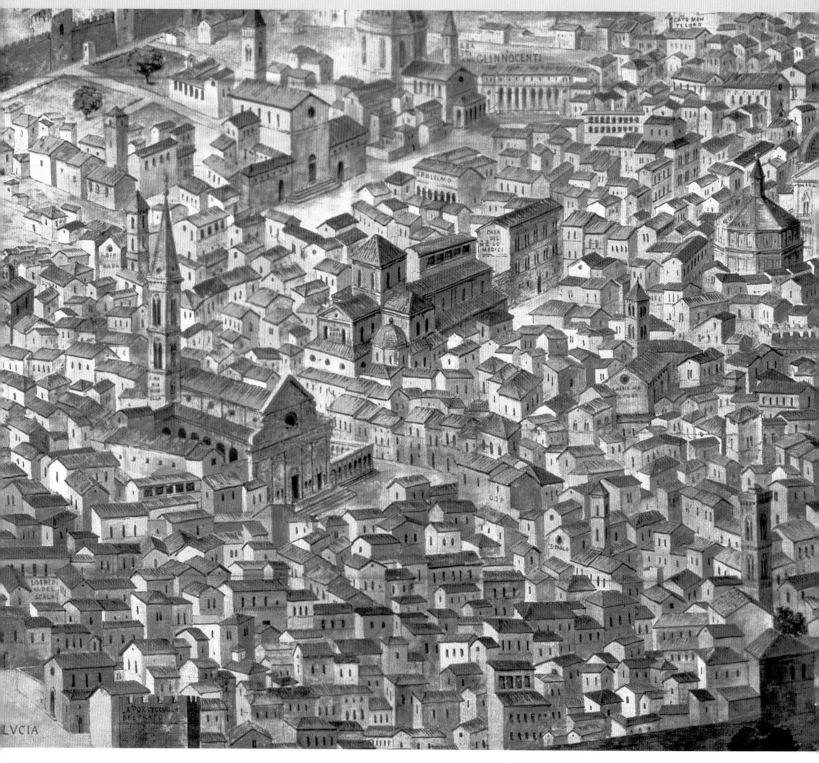

In these streets and piazzas, with their Medici palaces and churches, there is an unstoppable tide of traffic, a flow of tourists, a noisy bustle around the central market (a fine example of nineteenth-century ironwork architecture) amidst the stalls of the San Lorenzo market, still stocked today with the goods they have always sold. This is where the Medici family became the 'shadow' government of republican Florence, exercising the power bestowed on them by wealth and intelligence. Unostentatiously, they dominated the political and financial scene, consolidating and promoting the culture and art of the Renaissance more than any other great patron of the time. Their favoured architect was Michelozzo, and it was he who erected Palazzo Medici, the family home and business centre, and reconstructed the convent of San Marco under the guidance of Cosimo, who later became known as Cosimo il Vecchio. This all took place around the first half of the fifteenth century, continuing a tradition of patronage that had been started by Cosimo's father, Giovanni di Bicci. The Old Sacristy of San Lorenzo was paid for by this enlightened founder of the Medici dynasty, as was the rest of Brunelleschi's restructuring of the church. Brunelleschi erected the cube of the sacristy, framed the white walls with grey-blue pilasters and cornices and built the hemispherical, umbrella-segmented vault, drawing visitors to admire its innovative harmonious geometry even before it was complete. And a hundred years later, the republican-minded Michelangelo, though he had no love for the Medici family, would continue the process of immortalising them with the New Sacristy in a period when the most-loved and most-hated family in Florence were prepared, if necessary, to exercise their power with the force of arms. The sober style of the Medici would definitively disappear with the showy Cappella dei Principi, but Michelangelo also managed to complete another miracle of architecture and decoration, the Laurentian Library, which provided a home for the Medici library, some 600 works donated by Cosimo over half a century previously to the convent of San Marco. This masterpiece of Michelangelo, which has gradually been enriched with codices and manuscripts, incunabula and rare books, still houses the cultural foundations of the Classical age. The convent and gardens of San Marco were in fact the place where neo-Platonic culture, the new humanism and the impulse for the arts had developed, and where the naturalistic and scientific experimentation of the laboratories and of the Giardino dei Semplici would subsequently take place. Yet, ironically, it was also in this Dominican convent, which Cosimo had protected so much, that aversion to certain dangers evident in the new-born *Signoria* took root. The prior of the convent, Antonino, who later became bishop of Florence, opposed Cosimo's manipulation of the democratic laws of the city; and several decades later, Savonarola was hostile towards Lorenzo il Magnifico's support of 'pagan' culture. In the meantime, the convent cells were being painted, one by one, by Fra Giovanni da Fiesole, later known as Beato Angelico, who left the world masterpieces of perfect pictorial simplicity and clearly defined colours.

Cosimo loved San Marco and often slept there in his double cell, where Beato Angelico, with the help of Benozzo Gozzoli, had painted the *Adoration of the Magi*. It is curious that the habit amongst members of government to sleep in the convent lasted a long time: Giorgio La Pira, the celebrated mayor of Florence in the middle of the twentieth century, also slept there and used it as a base when preparing his meetings with international leaders in his efforts for world peace.

On leaving the Medici quarter and heading in the direction of the station, one is struck, simultaneously, by the sight of the apse of the oldest Dominican church, built at the end of the thirteenth century, and by the linear, rational facade of the railway station of Santa Maria Novella. Though built centuries apart, the two monuments seem to speak the same language: the stone of the apse, together with the adjoining horizontal convent, engage in a dialogue with the *pietre forti* used to face the front of the station, with the rigour imposed in the 1930s by Giovanni Michelucci and his group of young anti-academic architects. It was one of the finest architectural works of the period. And the church, which has Orcagna's frescoes (inspired by Dante's *Divine Comedy*), Masaccio's Brunelleschian *Trinity*, Giotto's *Crucifix*, the narrative paintings of Ghirlandaio, the fantastic visions of Paolo Uccello, the grandiose pictorial construction of the Spanish Chapel and the esoteric Renaissance facade of Leon Battista Alberti, is Gothic and yet not Gothic at the same time. Immediately on entering, even though the arches are ogival, there is an all-pervasive sense of harmony and lightness that seems to prefigure the perfect proportions that Brunelleschi would invent more than a century later.

Piazza San Marco. The church and convent was once frequented by Cosimo il Vecchio and his loyal architect Michelozzo, as they planned how to construct an interior and exterior space that would later be of particular importance for the family and would extend along what is now Via Cavour to Palazzo Medici Riccardi and San Lorenzo. However, in the age of Cosimo the heart of the area was undoubtedly the convent, where the undeclared ruler of Florence took refuge from the worries (and perhaps guilt) of his many economic and financial activities.

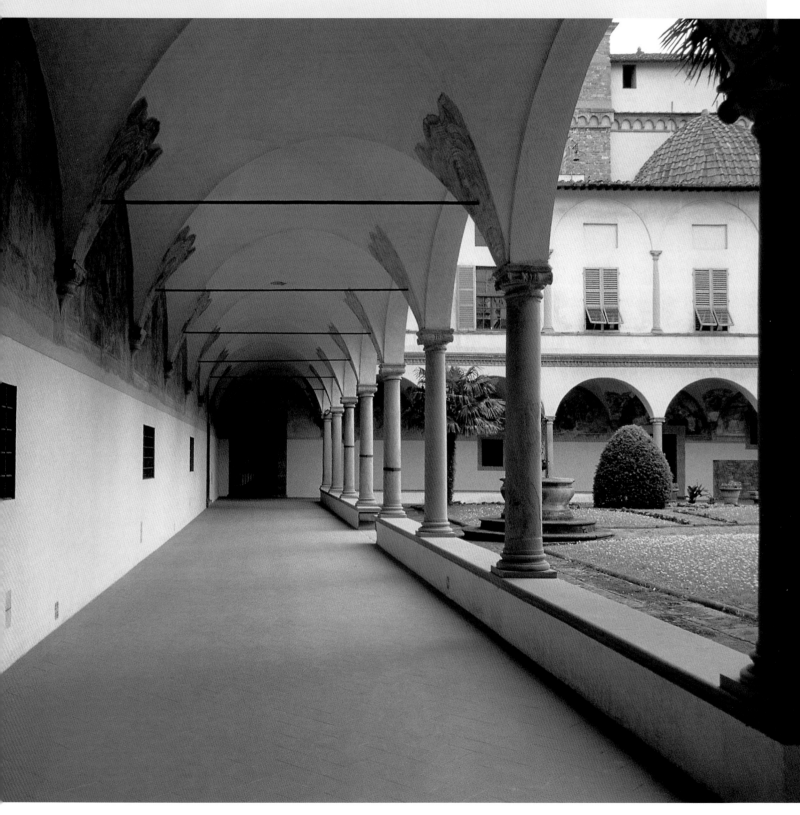

The light and architectural breadth of
the Biblioteca di San Marco, built to house
the texts of a rediscovered Latin and
Greek antiquity that Cosimo was gradually
accumulating (thereby laying the
foundations for the culture of humanism),
greet visitors today as they move from
the mystical space of the cells and of
Angelico's frescoes into the vast patrimony of
medieval and Renaissance knowledge. And
yet this was also the scene of the tragedy of
Savonarola, placed in shackles and
taken to his death at the stake in
Piazza della Signoria.

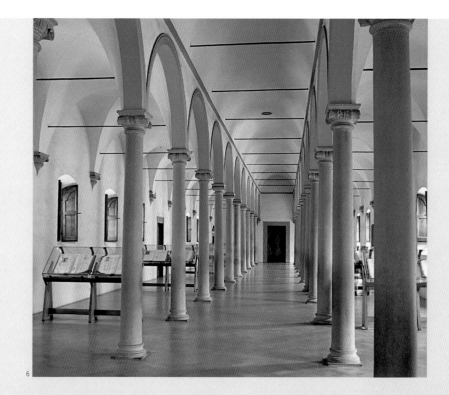

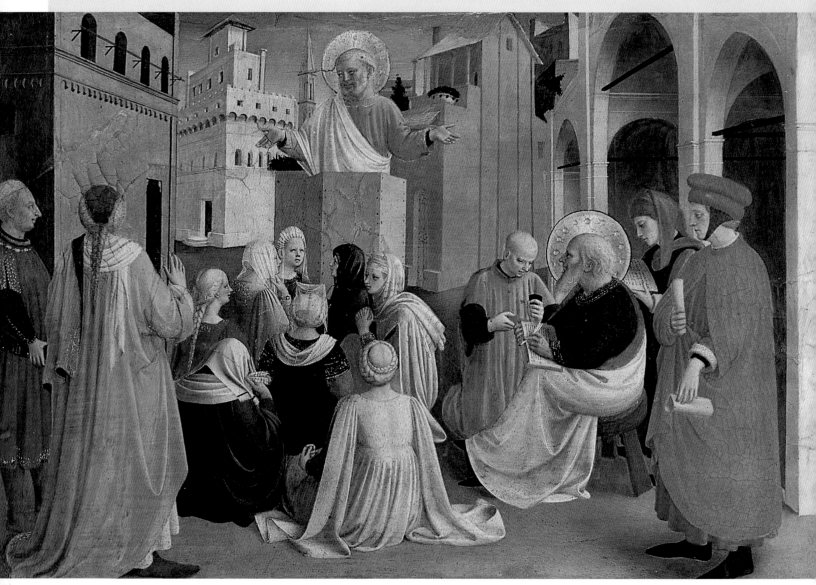

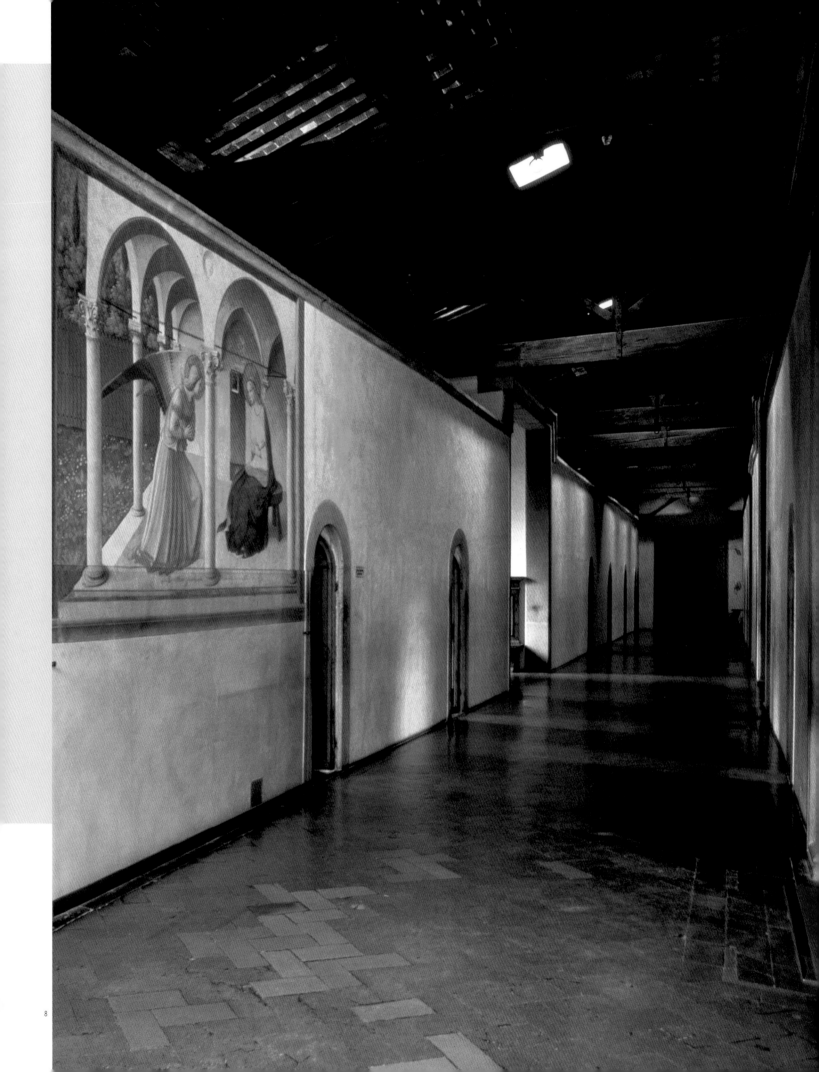

*Via Cavour boasts one of the least well-known masterpieces of sixteenth-century Florence, the Chiostro dello Scalzo belonging to the Confraternity of St John the Baptist, whose cross-bearer made his journey barefoot (scalzo). Here, there are grisaille frescoes by Andrea del Sarto – whose genius was hemmed in by that of Michelangelo and Raphael – marked by shades of an incipient Mannerism but still faithful to the considered monumentality of the most mature Renaissance period.*

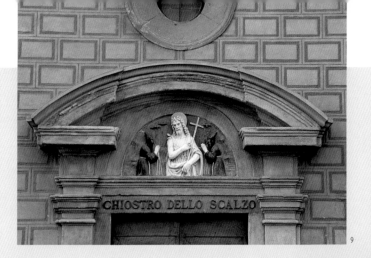

9

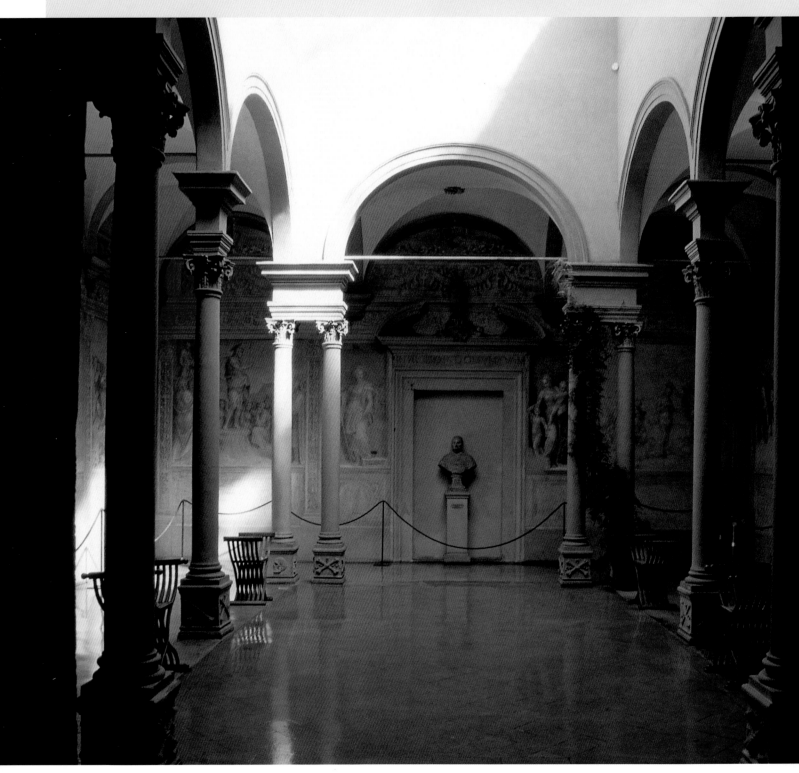

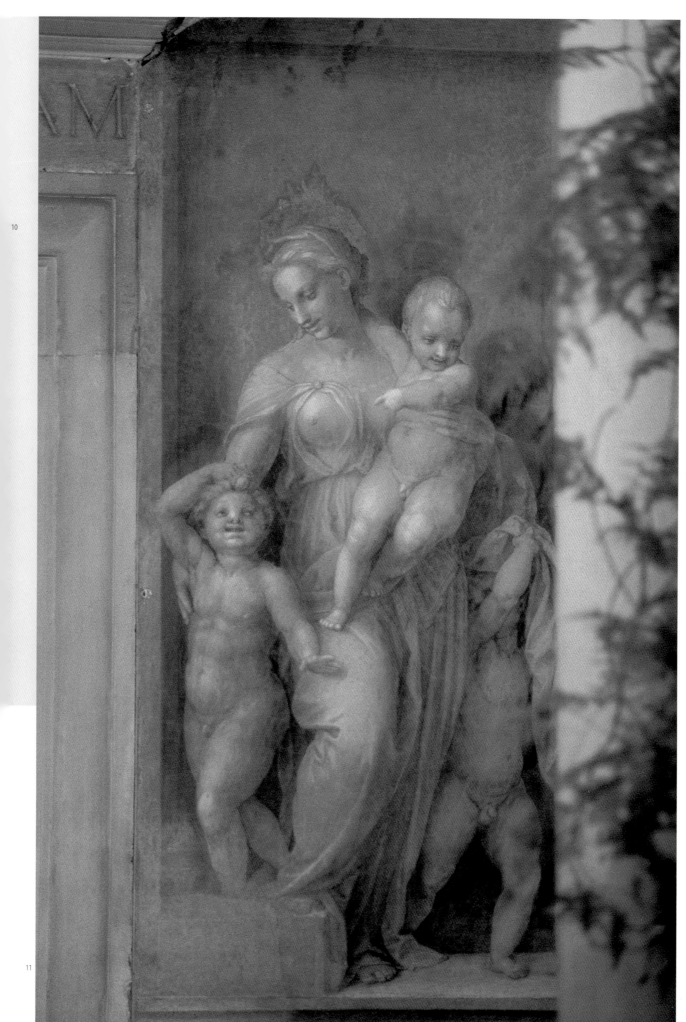

*Palazzo Medici Riccardi, the heart
of Medici fortunes and power. Built
by Michelozzo between 1444 and
1460, the administrative seat of the
bank and commercial office, the
home of Cosimo il Vecchio,
Lorenzo and his successors, in 1494
it received Emperor Charles VIII
and his court in all its pomp.
Though Cosimo I moved to Palazzo
Vecchio in 1540, the imposing
structure continued to be used by
family widows, other women and
younger members of the family
until it was bought in 1655 by
Marchese Riccardi, who modified
the original cubic shape,
lengthening the facade on Via
Cavour with seven extra windows.*

12

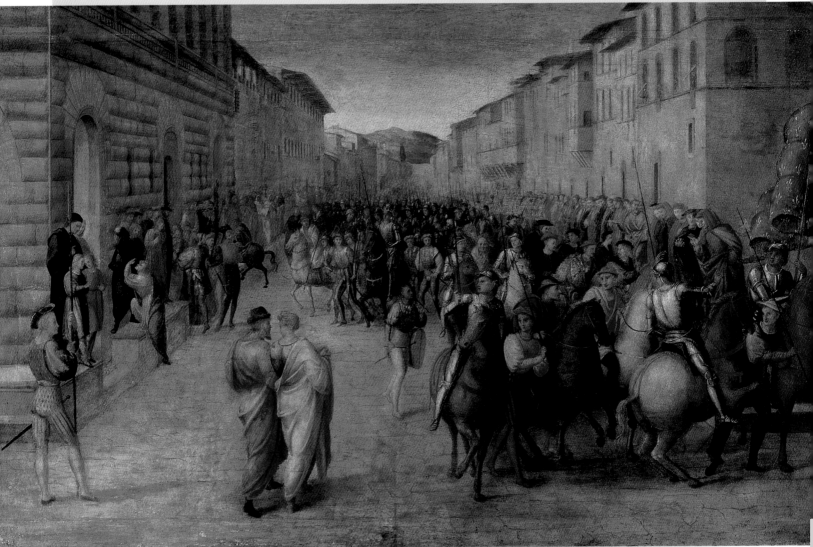

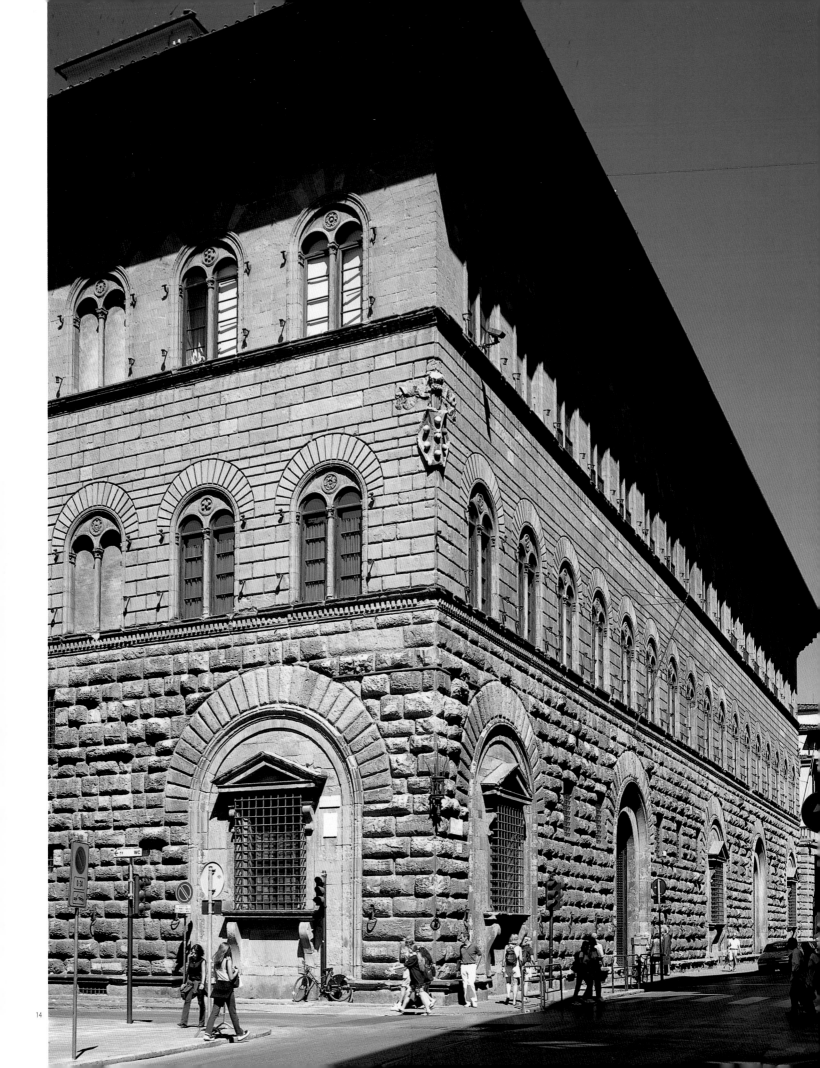

The imposing gravity of the exterior of Palazzo Medici Riccardi is echoed and contrasted by the elegance and airy clarity of the interior, with a cloister-shaped courtyard where the gaze and the mind can rest, shutting out the street noises and soaking up the marvellous art works that have been accumulated in the palace over the centuries – from the frescoes of Benozzo Gozzoli to the Baroque illusionism of Luca Giordano, and the Biblioteca Riccardiana, with its 50,000 volumes, which include many codices and manuscripts.

15

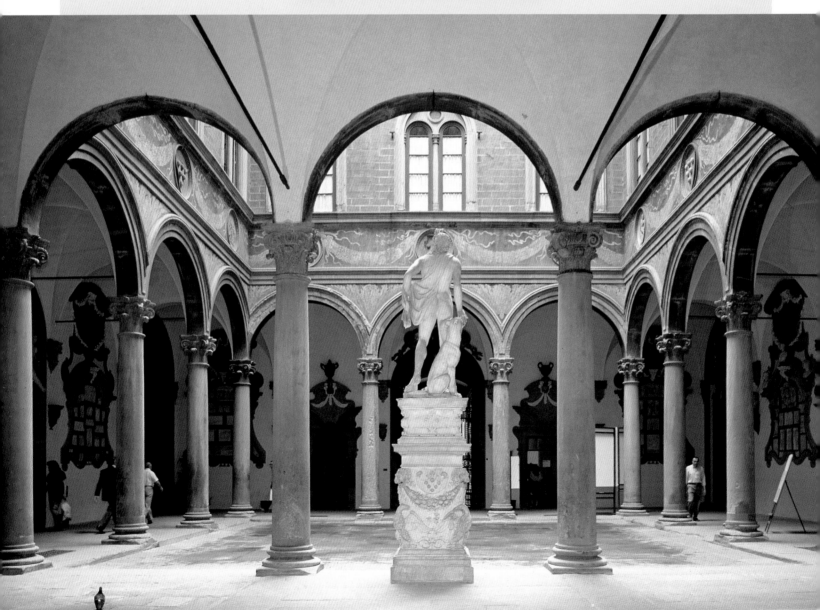

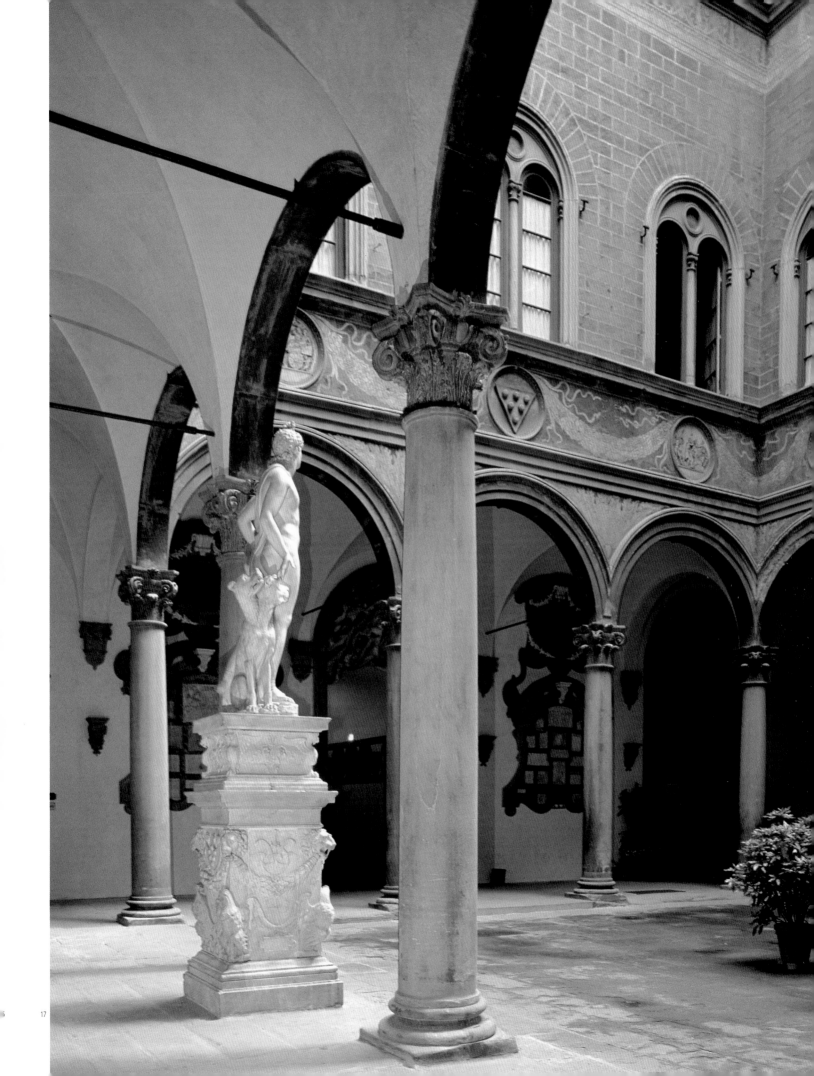

In 1459, twenty years after the Council, of which Cosimo il Vecchio had been one of the most influential patrons, the Medici decided to re-evoke on the walls of their private chapel the splendid procession of prelates and eastern princes that had taken place through the streets of Florence. They commissioned Benozzo Gozzoli to execute the Procession of the Magi, which depicts in a deft and colourful narrative style the faces and costumes of Medicean Florence.

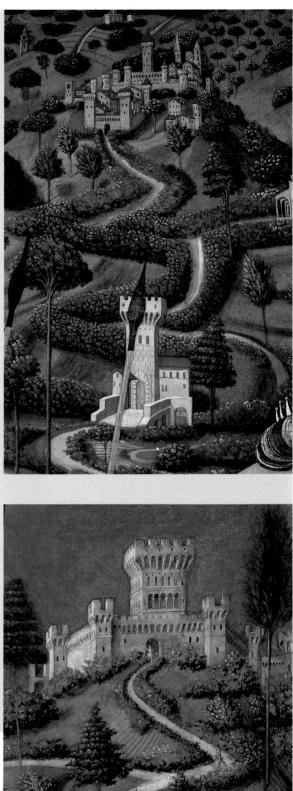

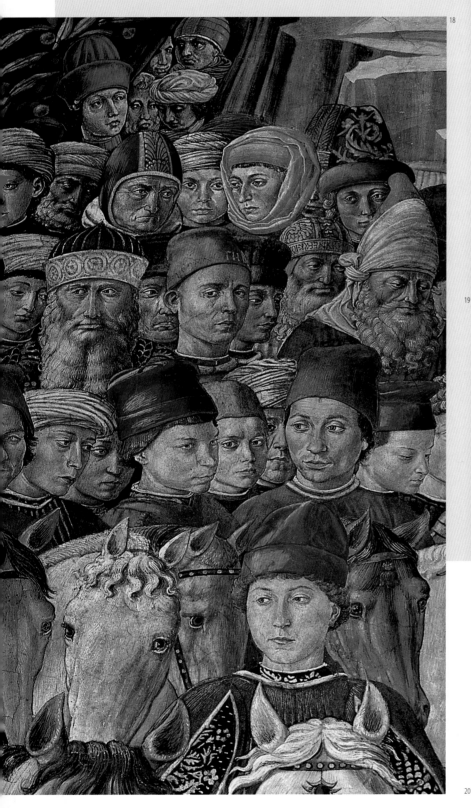

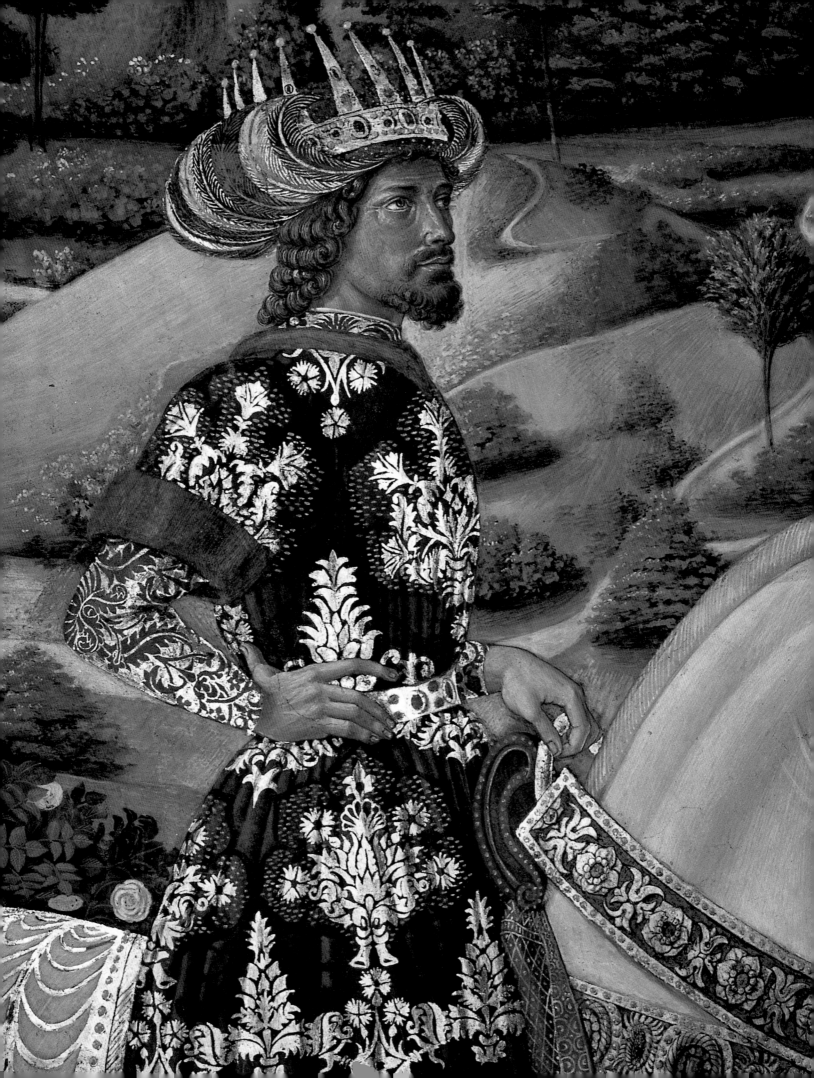

*Redesigned by Brunelleschi and completed by the Medici architect Michelozzo between 1421 and 1469 (though the facade was never completed, notwithstanding the wooden model by Michelangelo), San Lorenzo is the Medici church par excellence. In the Old Sacristy, designed by Brunelleschi with tondi by Donatello, are the tombs of Piero and Giovanni de'Medici; Michelangelo sculpted the monumental Medici tombs in the New Sacristy and, in the seventeenth century, Gaggini executed the opulent scenes in the Cappella dei Principi.*

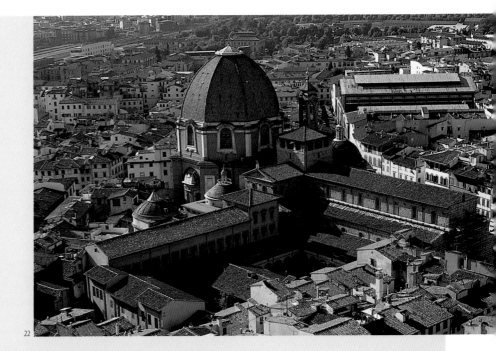

22

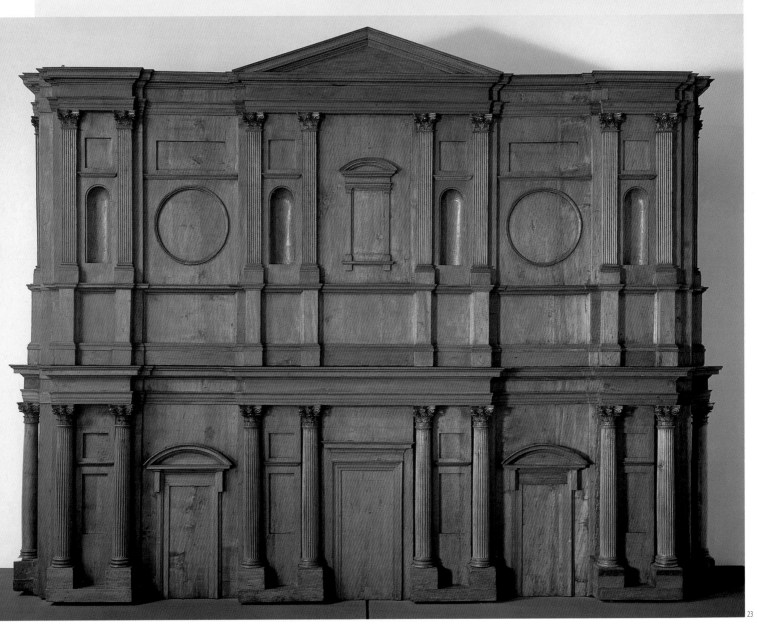

23

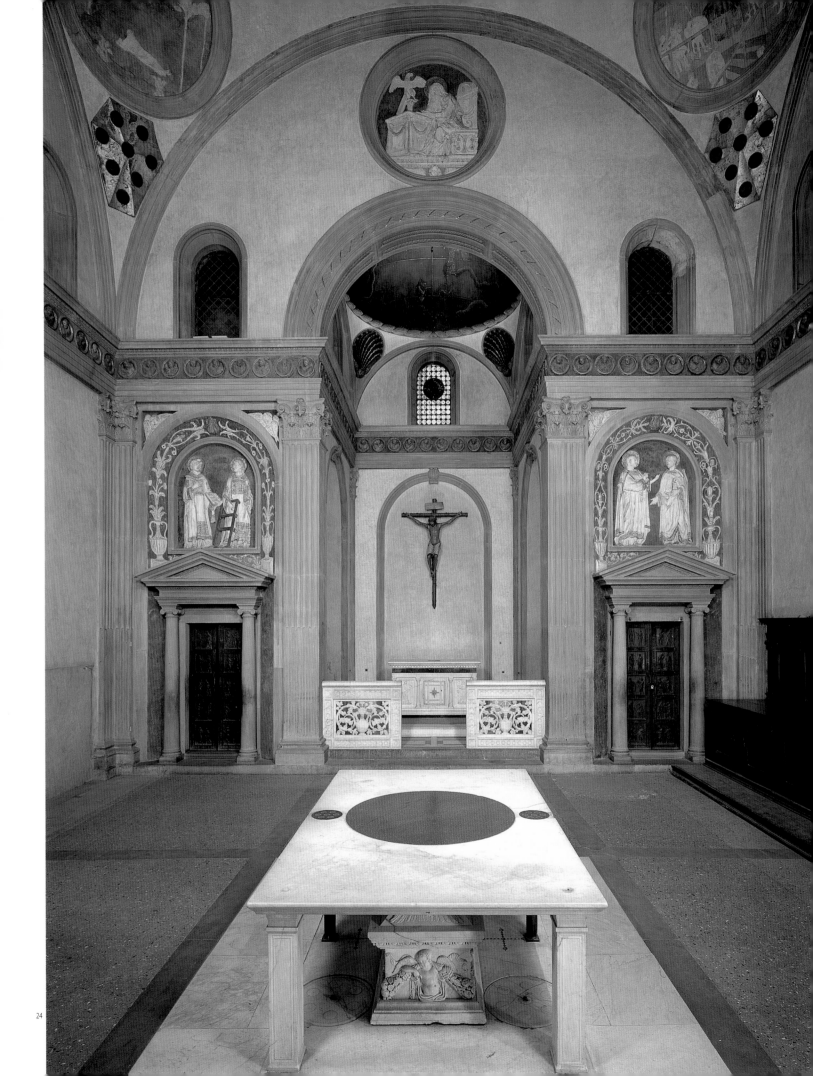

The New Sacristy of San Lorenzo, designed by Michelangelo to house the tombs of Giuliano and Lorenzo, respectively the son and grandson of Lorenzo il Magnifico. Idealised as ancient heroes, and so removed from the real contingencies of uninspiring personalities and lives, the two figures contemplate the celebrated allegories that traditionally allude to the hours of the terrestrial day: Dawn, Day, Dusk *and* Night, *in other words all-consuming* Time, *which reduces everything to dust — even glory and fame.*

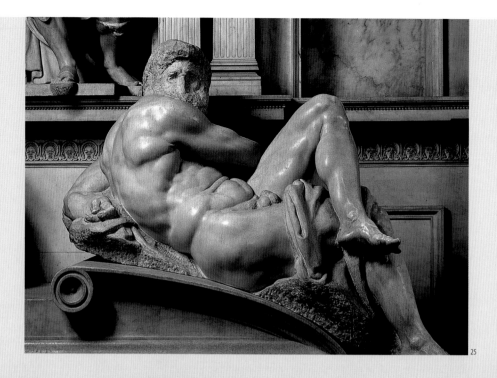

25

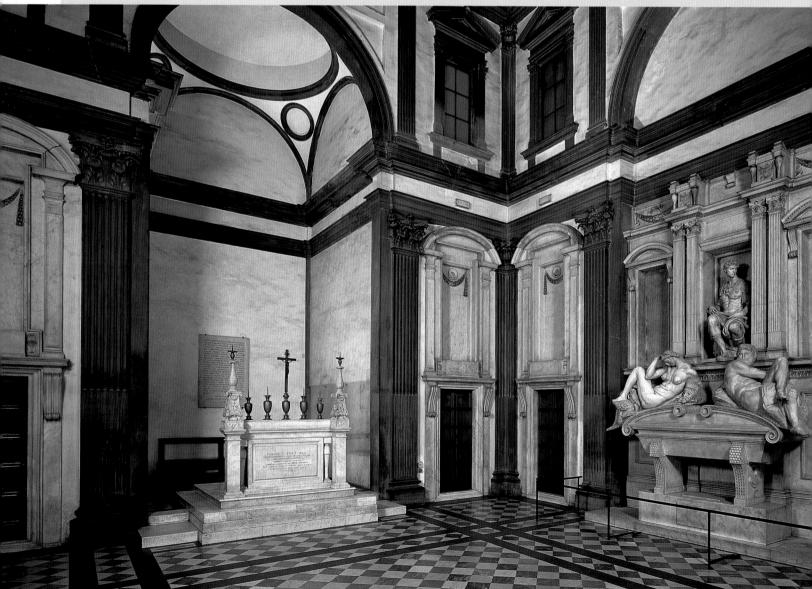

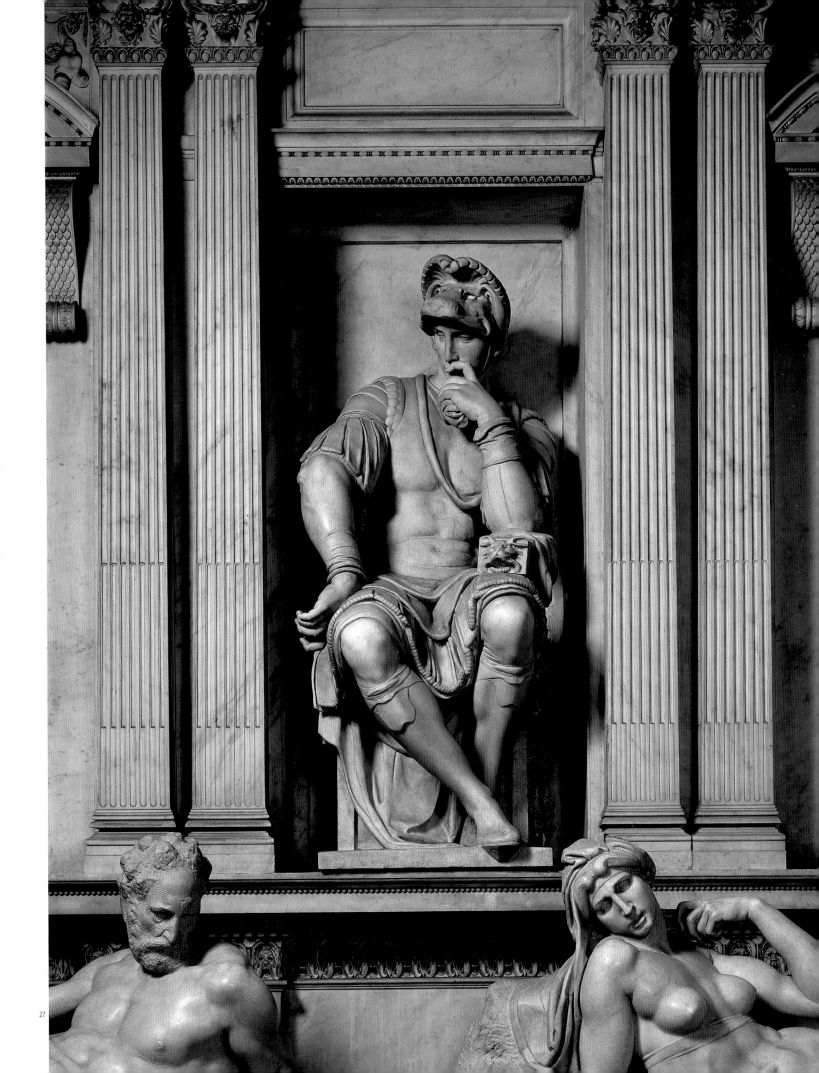

Michelangelo's hand is clearly present throughout the San Lorenzo complex – from a fine marble detail on the base of one of the Medici tombs to the brilliant staircase of the Laurentian Library, which opens onto the cloister of the church.

For the narrow vestibule, Michelangelo designed three ramps of stairs like a broad wave, making them converge on the floor of the long room of the library. He designed the wooden study benches where for centuries, since the library was opened to the public in 1571, scholars from around the world have studied priceless illuminated codices, Egyptian papyri and key manuscripts of the world of classical culture.

28

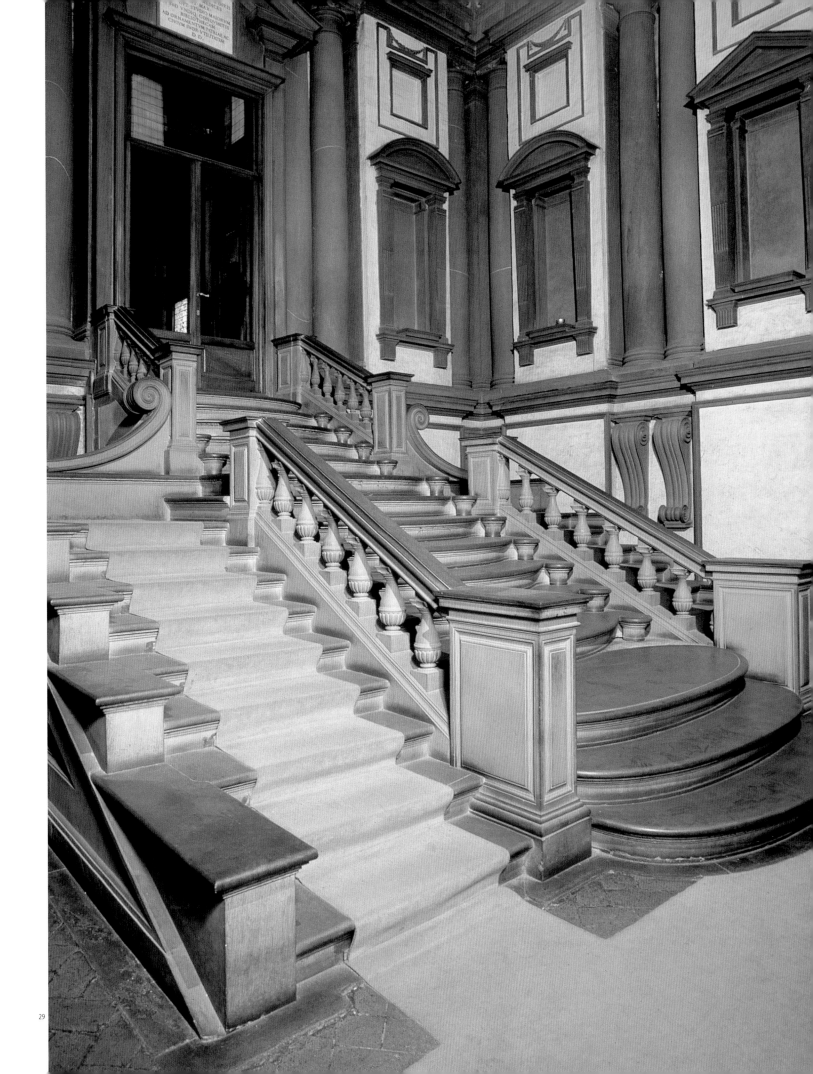

'Nothing pleases me as much as the rows of market stalls heaped with cheap fabrics, maidservants' soaps and bras, clustered around the Medici Chapels', wrote Emilio Cecchi many years ago.

The goods on display nowadays are perhaps not as cheap, but the lively and noisy vitality of the market of San Lorenzo is still intact. Adjoining it is the Mercato Centrale, designed by the Bolognese architect Giuseppe Mengoni (also responsible for the Galleria di Milano) in accordance with the dictates of nineteenth-century ironwork architecture and directly inspired by contemporary Parisian halls.

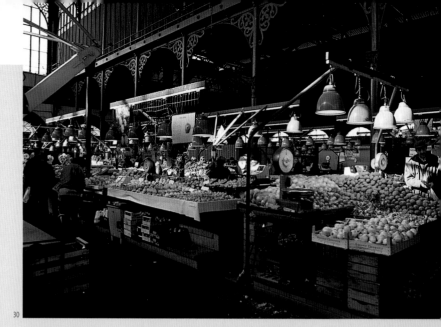

30

31

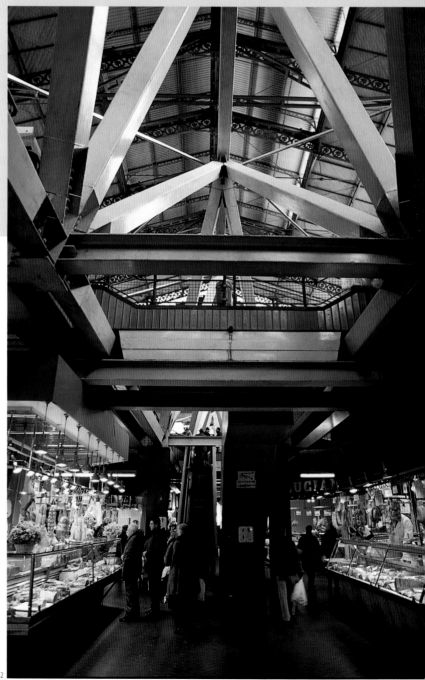

32

In return for granting Alessandro de'Medici the hand of his illegitimate daughter Margherita, the Emperor Charles V demanded that an imposing fortress be erected to protect the court and the stately couple. In 1532, Antonio da Sangallo completed this work with brick bastions, which nonetheless did not save Alessandro from the murderous knife of Lorenzino de'Medici, who subsequently became known as Lorenzaccio. A masterpiece of sixteenth-century military architecture, the Fortezza da Basso has been softened on the northern side by a nineteenth-century garden, and since its restoration in 1965, it has hosted important art, fashion and craft trade events.

34

35

36

37

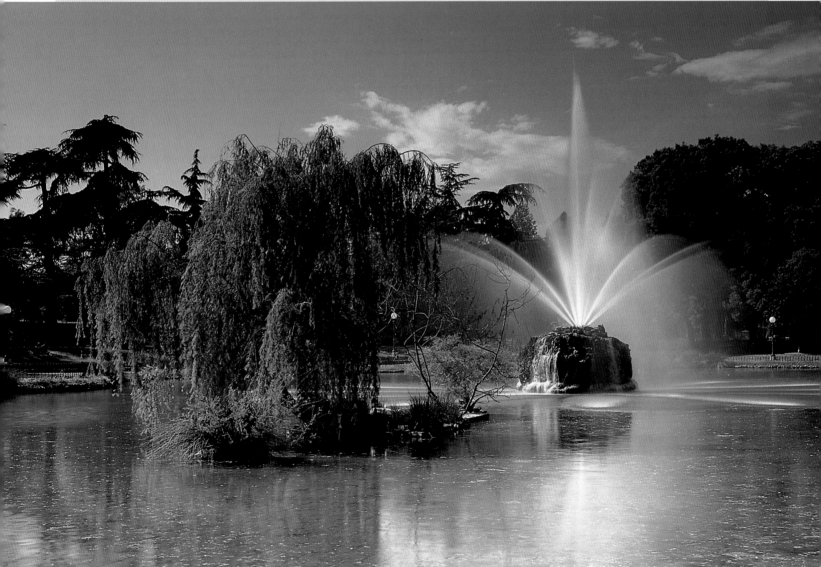

*'They say that the station is a work of rationalist architecture. They are mistaken. It was conceived in utter freedom from the various tendencies and with various contributions...the essential thing was to establish a dialogue between this building and the splendid basilica of Santa Maria Novella. The main solution to this lay in the use of the stone: our marvellous* pietra forte, *the most beautiful there is in Florence. It was the basilica which forced us to be essential.'* This is how Giovanni Michelucci, head of the station project, described it to P. F. Listri, author of a dictionary of Florence. Michelucci won the public competition for the new train station in 1933, and the resulting work still resists the decay and obsolescence that has overtaken many modern buildings.

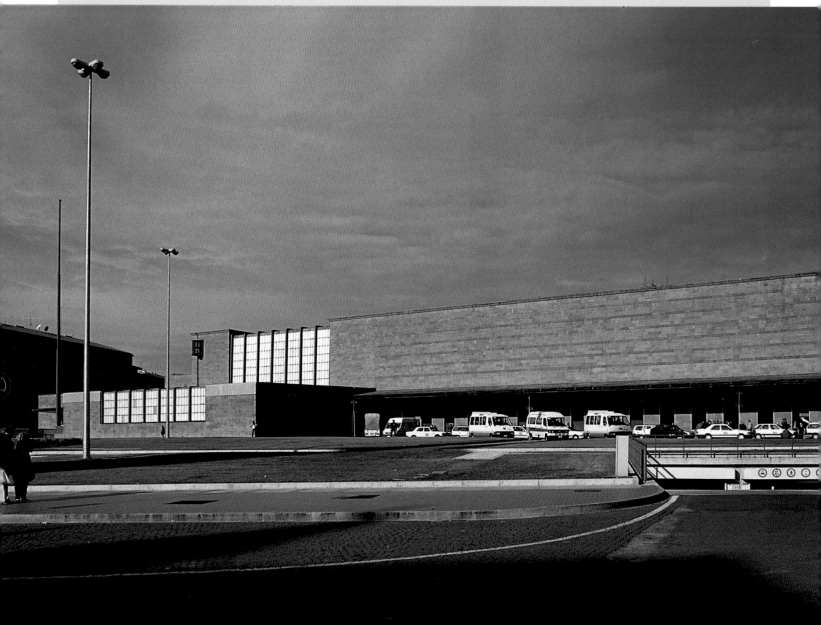

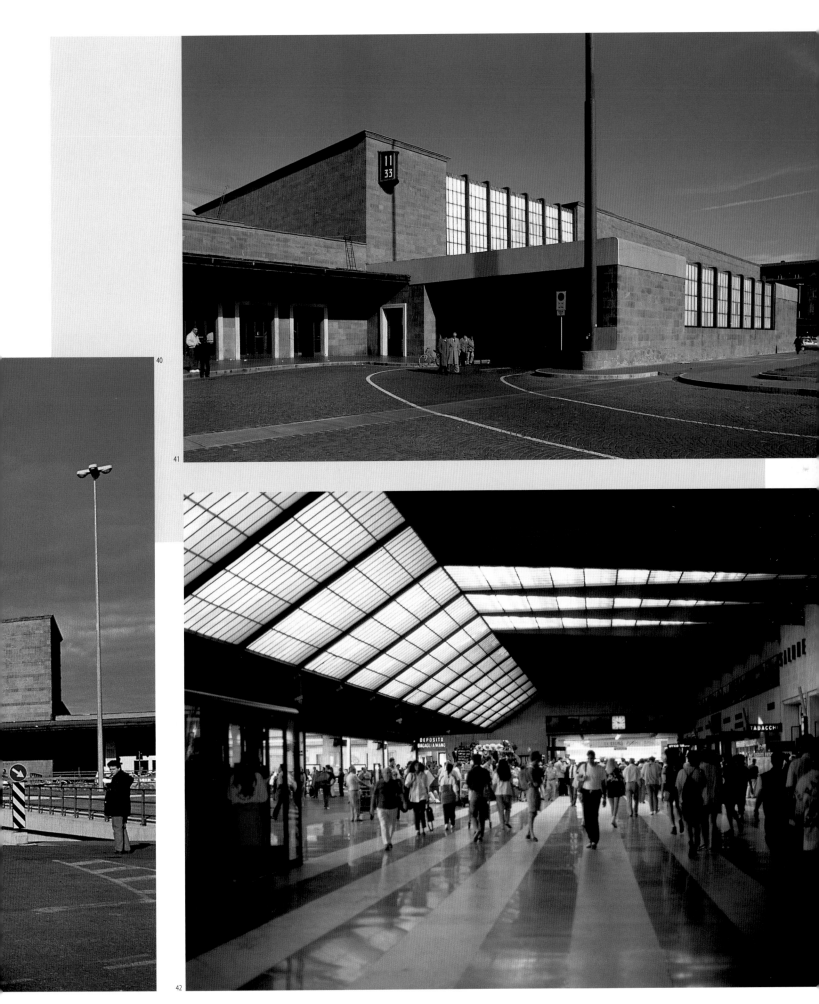

40
41
42

*Santa Maria Novella and its vast piazza, another of the Florentine sites where art, history and city life have gone hand in hand through to the present day. Designed in the Gothic style by the Dominicans in 1246, the architecture of the church was completed two centuries later when Leon Battista Alberti restructured the facade and designed the upper part. Continuing the typically Florentine-Romanesque motif of the geometric tarsia work, he came up with the magnificent spiral scrolls that link the facade to the tympanum and give the whole structure an extraordinary soaring flair.*

44

45

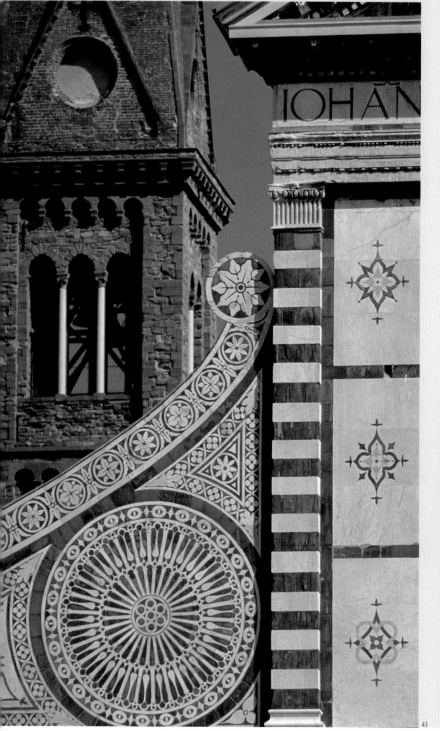

43

46

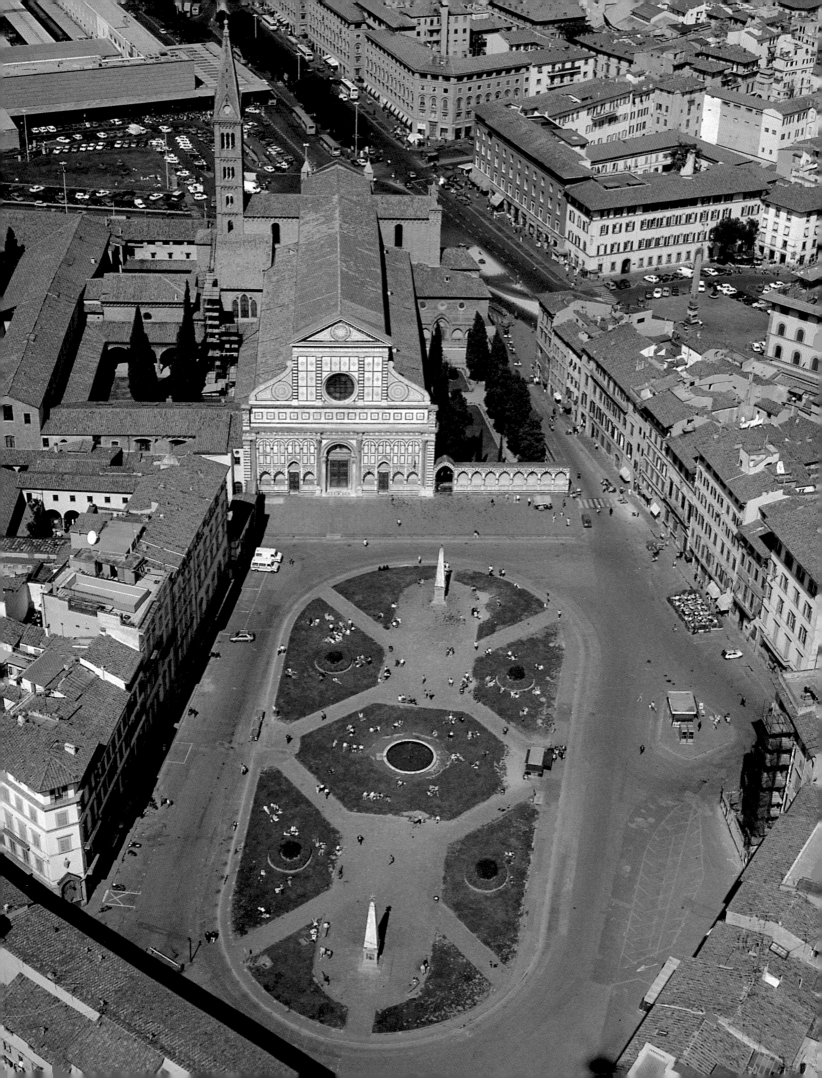

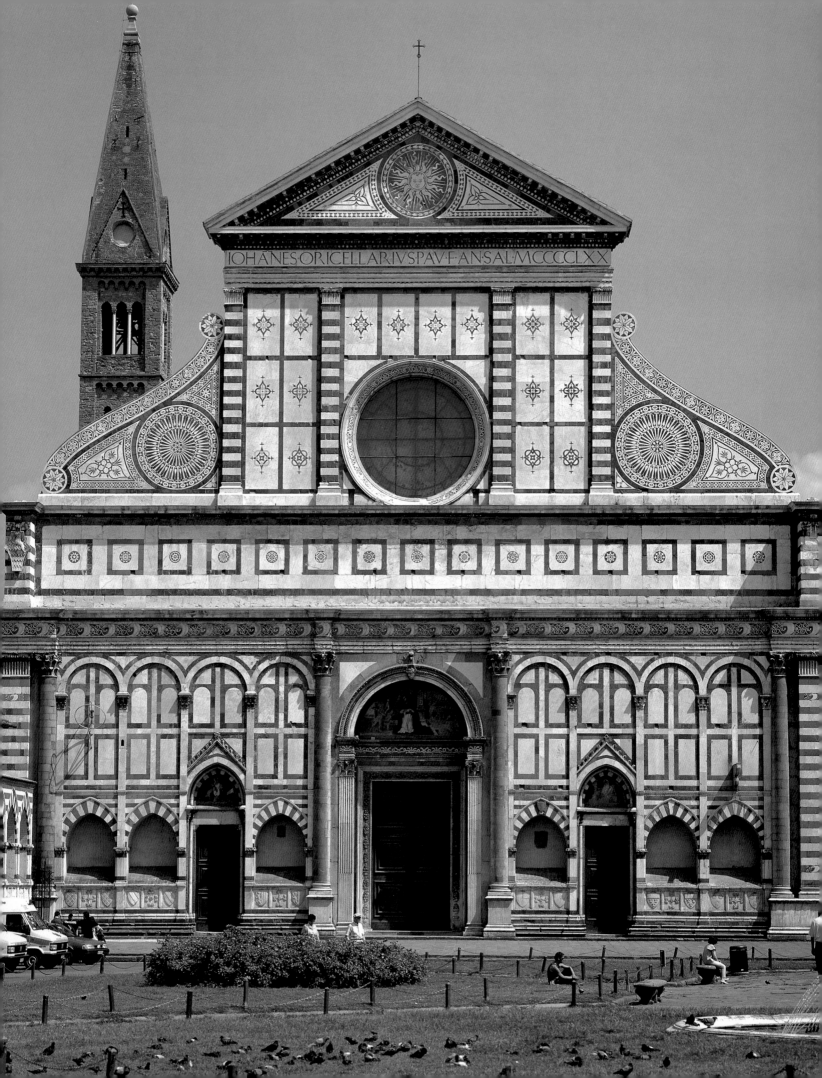

At the top of the Renaissance facade of Santa Maria Novella there is the sun, symbol of the esotericism and neo-Platonic doctrines of Marsilio Ficino, to which Alberti himself adhered. Inside the church, dominating the centre of the nave, is the large suspended Crucifix of Giotto (c. 1290), a youthful work whose realistic humanity contrasted with Byzantine tradition and announced what was to be Giotto's profound renewal of Western painting.

48

49

*In 1425, Paolo Uccello painted his Universal Deluge in the so-called Green Cloister, an extraordinarily expressive work, as Vasari underlined: 'He painted the flood and Noah's Ark; and here, taking great pains and with great care and skill, he reproduced the dead bodies, the tempest, the fury of the wind, the flashes of lightning, the rooting up of trees, and the terror of men, in a manner that defies description.'*

*The whole of Santa Maria Novella is a massive compendium of Florentine art, ranging from Giotto to Masaccio, from Brunelleschi to Ghirlandaio and from Filippino Lippi to Giambologna. It is also the place where the energies of non-Medici patrons made themselves felt. The leading merchant, Giovanni Rucellai, after having commissioned Leon Battista Alberti to design a palace for him, also provided the resources to carry out the work on the facade of the church. This is solemnly announced by the inscription beneath the tympanum and by the Rucellai emblem on the frieze – billowing sails (see previous page).*

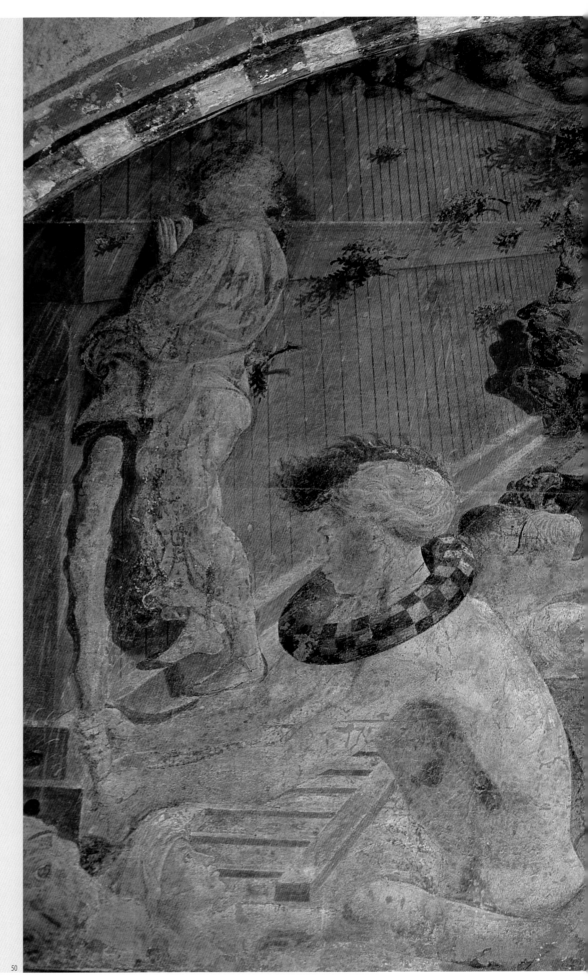

50

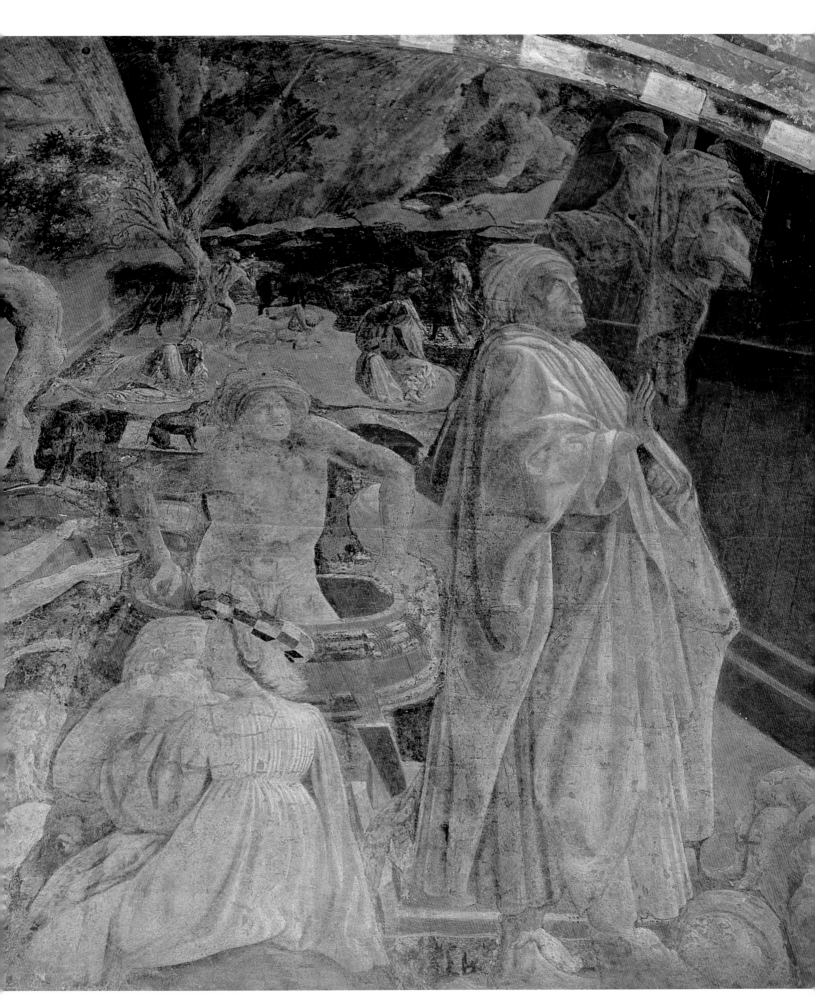

The origins of the Officina Profumo-
Farmaceutica of the convent of Santa Maria
Novella lie in the medical care and assistance
provided by the monks, who by the fourteenth
century had already created a laboratory where
'herbs and roses are distilled'. The highly
renowned pharmacy is still in operation and
has been enlarged over the years (the
alchermes liquor invented by the herbalist
Cosimo Bucelli in the eighteenth century was
particularly sought after). Florentines and
well-informed tourists still make the trip to the
ancient premises in Via della Scala.

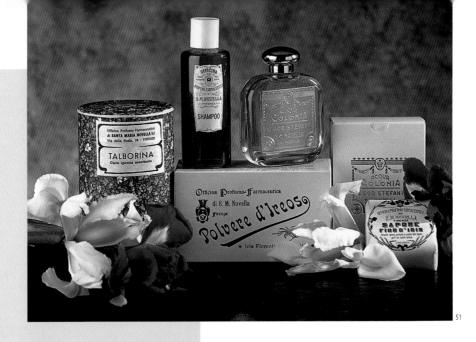

51

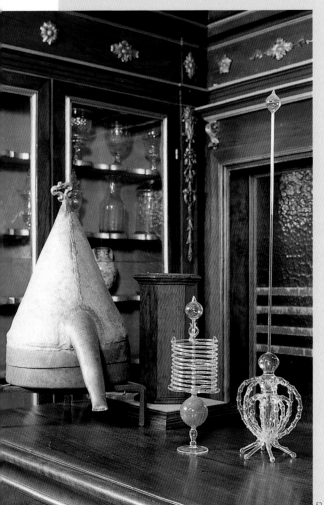

52

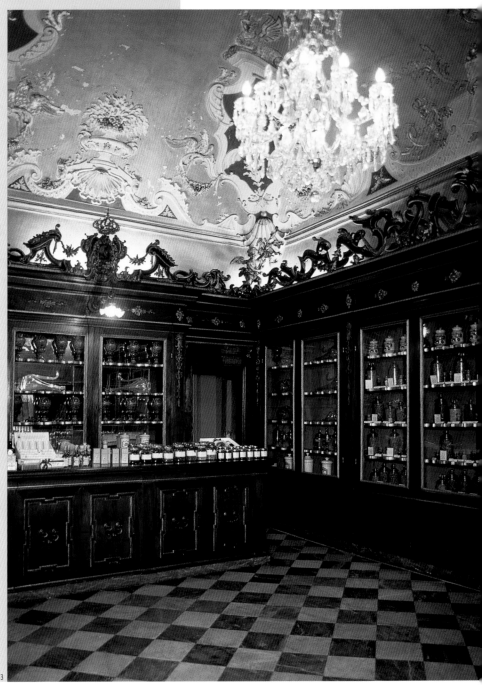

53

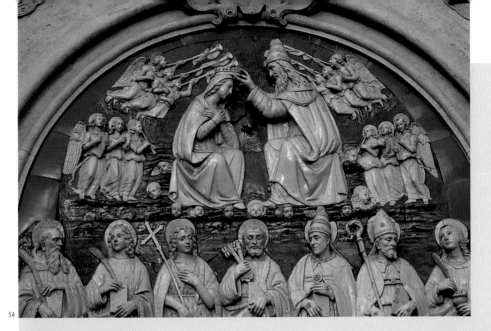

54

The facade of the church of Ognissanti is the first example of Baroque in Florence. Designed by Matteo Nigetti in 1637, it includes a glazed terracotta lunette attributed to Giovanni della Robbia. Inside, and facing each other, there is Botticelli's St Augustine *and* Domenico Ghirlandaio's St Jerome *(pictured here). The latter also painted the extraordinary* Cenacolo (Last Supper) *in the refectory of the convent in 1480 (see next page).*

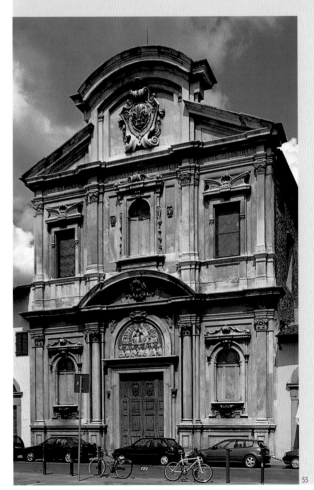

55

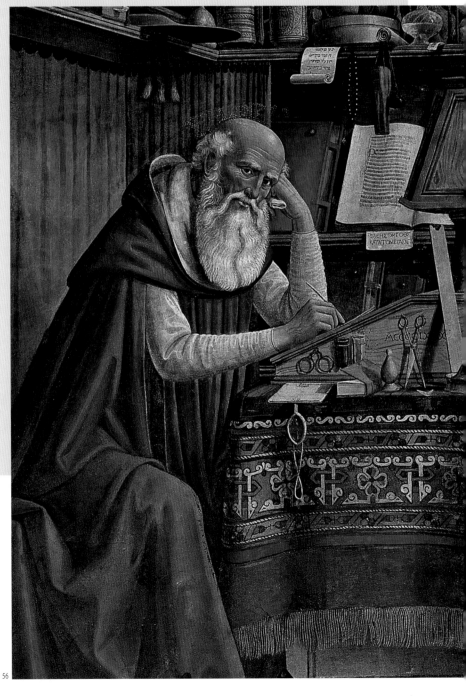

56

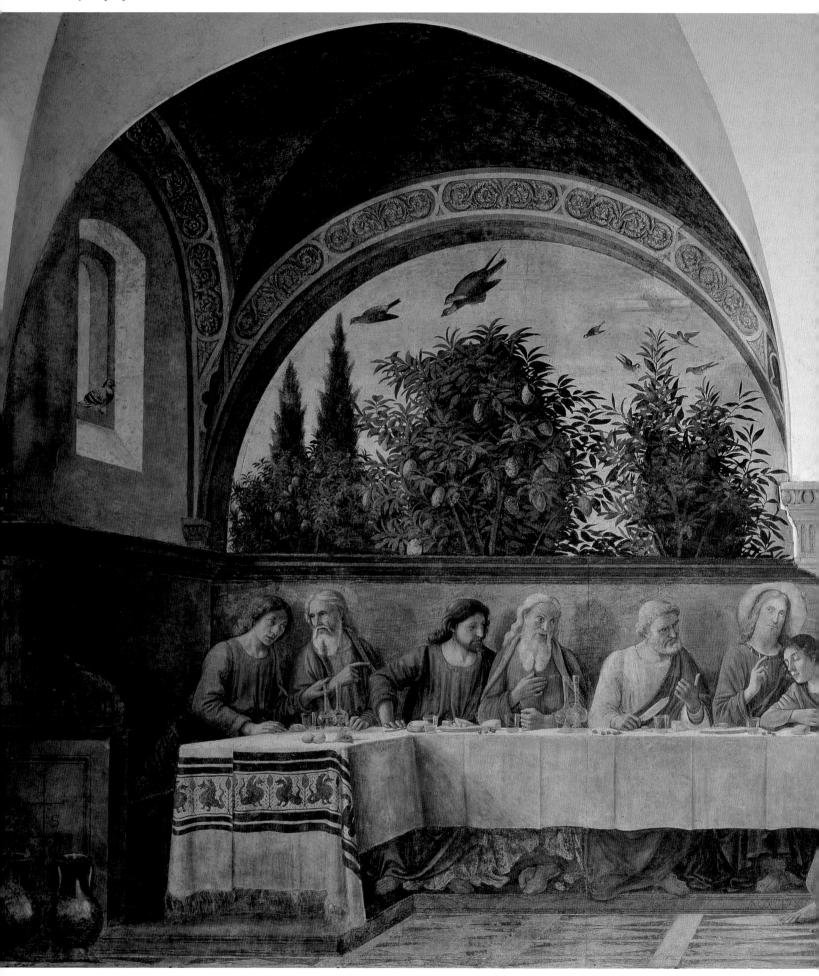

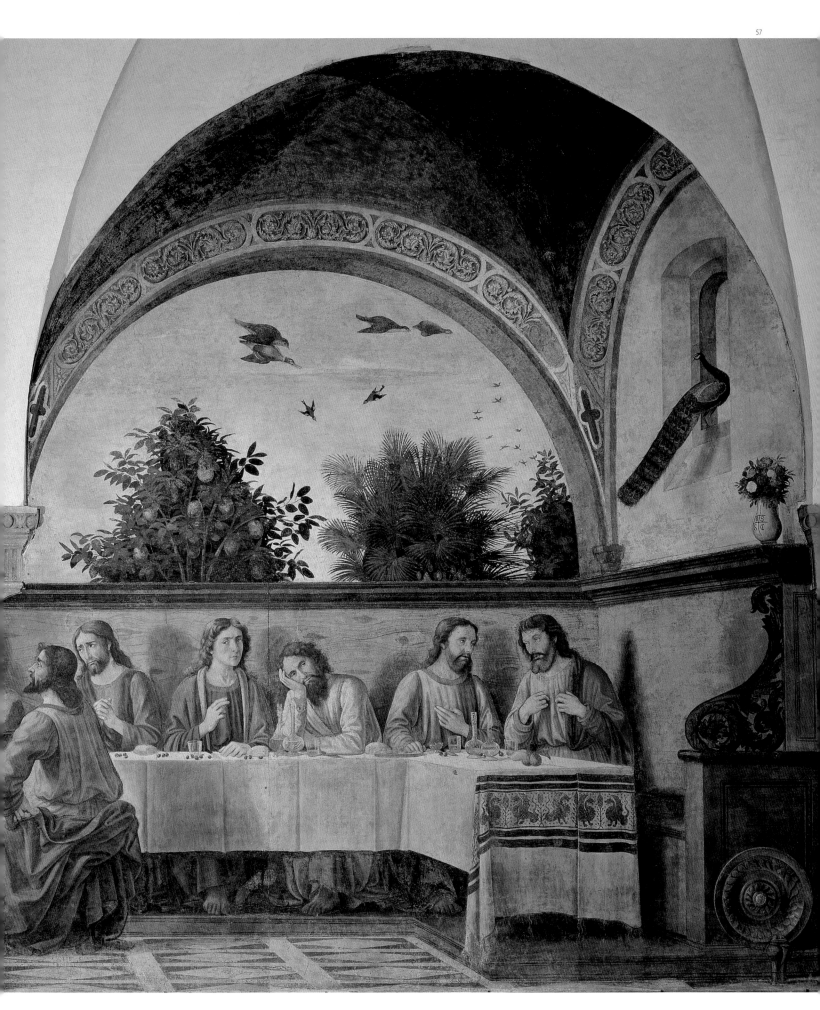

*Of the few examples of Baroque in Florence, one that stands out is Palazzo Corsini in Lungarno Corsini (on the page alongside there is a detail of the broad spiral of the staircase). This imposing structure, topped by a balustraded attic, houses one of the biggest private art collections in the city, open to the public only by prior booking. Every two years it hosts the International Antiques Fair.*

*Large traditional hotels face onto Lungarno Vespucci and Piazza di Ognissanti.*

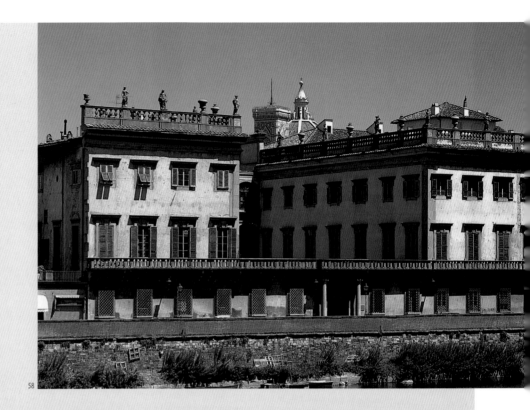

58

59

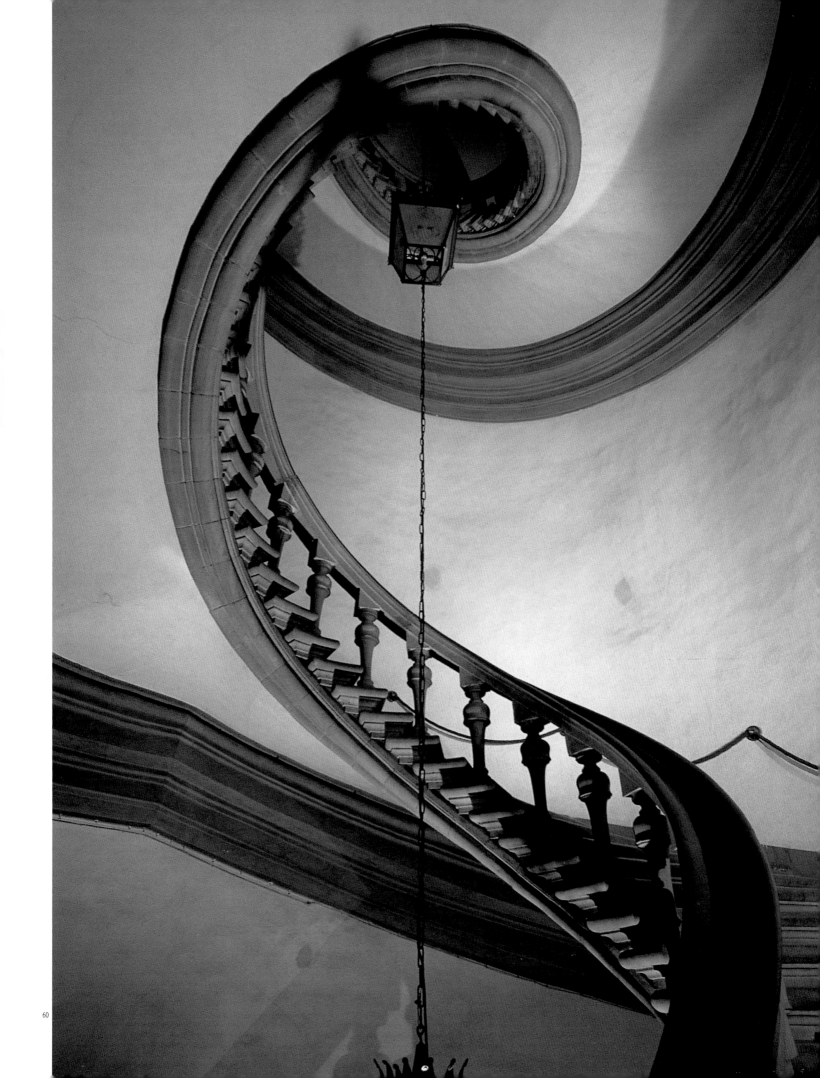

# The two sides of the Arno

*The noble and the working-class quarters of the Oltrarno – the marvels of Masaccio and Brunelleschi – the culture and experience of antiquarians and craftspeople – ancient palaces and celebrated shops*

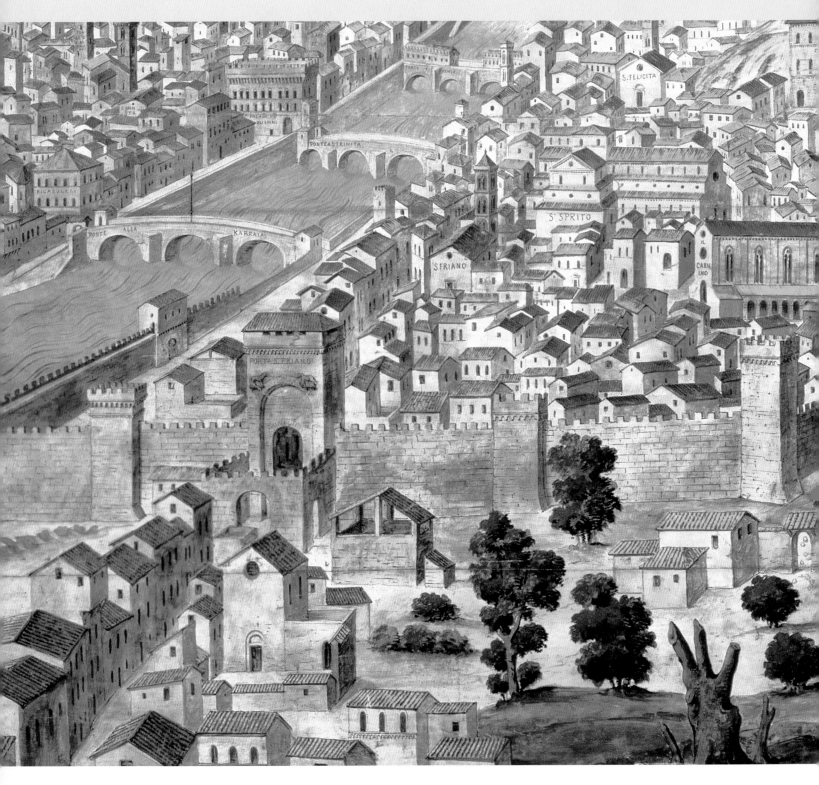

Built at the beginning of the thirteenth century to allow the passage of carts laden with wool that had been worked by the monks of Ognissanti, rebuilt a number of times in the wake of destructive flooding, a venue for street parties and fireworks until little more than a hundred years ago, and reconstructed soon after the Second World War because German mines had destroyed the one designed by Ammannati in the sixteenth century, the bridge of Ponte alla Carraia enters the Santo Spirito quarter and with its extension, Via de' Serragli, divides it in two. This road runs south as far as Porta Romana between magnificent palaces and more ordinary houses. On one side there is the refined elegance of Via Maggio, Palazzo Pitti and the church of Santo Spirito (yet another masterpiece by Brunelleschi); on the other there is the district of San Frediano.

San Frediano is still today the more working-class part of the Santo Spirito neighbourhood. At the end of the 1940s, Vasco Pratolini described it powerfully in his novel *Le ragazze di Sanfrediano*: 'it is the unhealthiest area of the city; at the heart of its maze of streets, populated like ant hills, is the central refuse collection depot, the public dorm and the barracks. Many of its slums house rag collectors and people who cook the innards of cattle to sell them with the resulting broth…' The streets are animated by the 'cheerful, rowdy noise of its inhabitants…by the shopkeepers and ragmen, the workers in the nearby workshops, the lowly clerks, the marble-working artisans, goldsmiths, leather workers…Sanfrediano is the little republic of home-workers: braiders, trouser-makers, ironers, straw weavers…The people of Sanfrediano, the most vulgar and lively of all Florentines, are the only ones to have maintained the authentic spirit of the people, and they are capable of expressing loveliness in their coarseness…The Sanfredians are at the same time sentimental and ruthless, and their idea of justice can be summed up in the sight of the hide of their enemy hanging from a lamp-post'.

Little has changed since then in the outward appearance of the houses and of certain shops between Piazza di Verzaia (next to Porta San Frediano, set in a surviving arm of the ancient walls) and Via di Camaldoli, Via del Leone, Via de' Cardatori, Via dell'Ardiglione, Via dei Tessitori, Via del Drago d'Oro. Almost all the buildings are small, with two to three floors at most, and are in proportion to the narrowness of the streets. But the flats behind those facades are no longer the same. Many of them have been turned into small, almost luxury, flats for the new inhabitants of San Frediano, young professionals, students, artists and foreigners who live together with the last of the original inhabitants of the district, and who in the evenings – or rather, at night – noisily throng the bars of Piazza Piattellina and Piazza del Carmine. Yet, walking through the streets and alleys, one still comes across old trades, art and restoration workshops, and sees the same eyes, hands and faces that Masaccio painted many centuries ago on the walls of the Brancacci Chapel in the church of Santa Maria del Carmine, right in the middle of San Frediano. The church of Cestello is set a little apart, and is more atmospheric when viewed from outside and from the opposite side of the Arno at sunset. The church of Santo Spirito, on the other hand, needs to be entered in order to grasp fully Brunelleschi's architectural language and sense of space. And from the workshops in the heart of the Santo Spirito neighbourhood, in Via delle Caldaie, in Borgo Tegolaio and in the small alleys leading towards the more noble Palazzo Pitti area, there come the sounds of saws and chisels, the pungent smells of treated woods and restoration wax. One can see gleaming gold-leaf work and witness the skilful movements of traditional craft occupations carried out by strong, delicate hands and guided by a deep-rooted spirit.

In the noble palaces of Via Maggio, dozens of major antiques dealers display their treasures in shop windows. There is a kind of continuation of this exclusivity on the other side of the bridge of Santa Trinita (also by Ammannati and the most beautiful and elegant in Florence, some say in the world) in Via Tornabuoni, where there are the elegant shop displays of what some people consider to be the modern art of fashion, and also, in keeping with an old Florentine craft tradition, of exclusive shops selling gold and precious stones. Almost the whole street is a single, uninterrupted shop window. Yet something has been lost over the years – pastry shops and famous tea rooms, bookshops stocked with the latest titles and purveyors of Anglo-Florentine male elegance have been gradually disappearing. However, half way down the street, Palazzo Strozzi, a masterpiece of the Renaissance, seems to interrupt, yet reaffirm, the fascination of Via Tornabuoni, making it impossible to mistake it for any other street of exclusive designer shops.

*The theme, reiterated on an almost daily basis in the skies of Florence, of the symbolic competition between the ribbed cupola and the battlemented tower of Palazzo Vecchio, and the precise disposition of volumes of the other major public buildings, is counterposed by the magmatic fabric of roofs that have agglomerated and solidified over time around these monuments'* (Carlo Cresti, 1985). *Indeed, from the sky above Borgo San Frediano in the Oltrarno, the historic city centre with its big monuments and the presence of the surrounding hills, an inseparable part of the design of the city, offers a complete and satisfying view. The facade and imposing bulk of the Duomo, of Palazzo Vecchio and of Santa Croce soar above the roofs of the city of Arnolfo and Brunelleschi, Giotto and Dante, the Medici and the Lorraine dynasties, the* popolo grasso *and the* popolo minuto, the Arti Maggiori *and the* Arti Minori. *The reddish horizontal line of flat-tiled roofs covers a city of* pietra forte *and* pietra serena, *of grey plaster, of narrow streets and a few, never massive, piazzas. Only the Arno, once a thoroughfare and a source of water for ancient artisan trades, cuts through the compactness of Florence, conferring light and a point of reference. Meanwhile, the Santo Spirito neighbourhood still holds the promise of encountering and discovering deeply rooted arts and ancient crafts.*

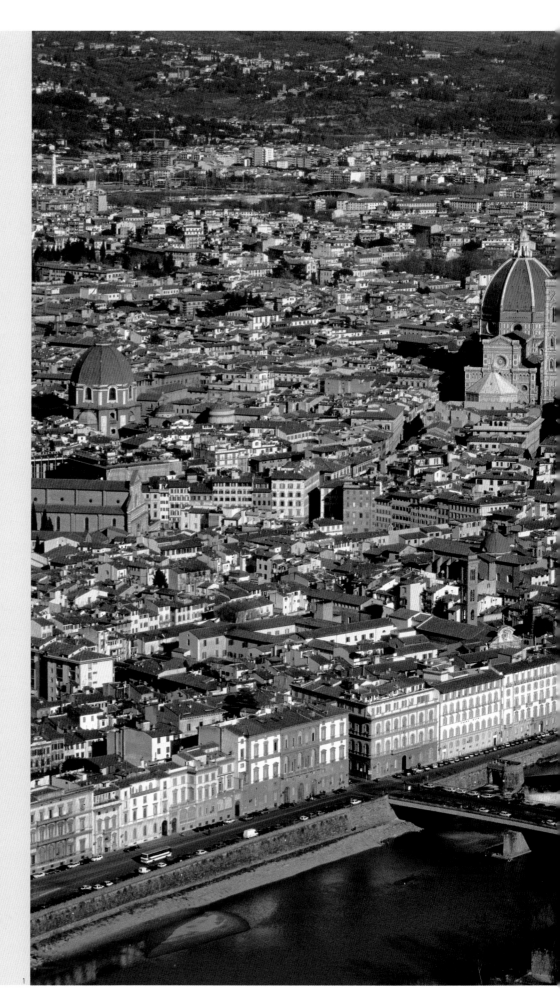

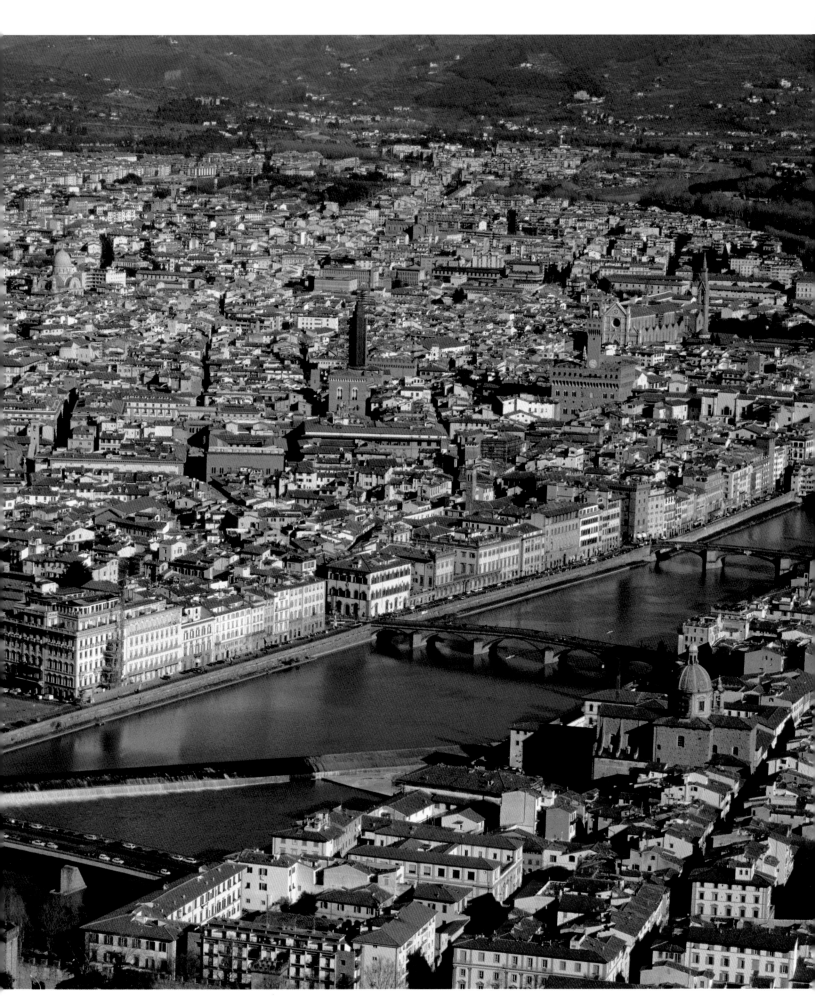

*San Frediano al Cestello, Santo Spirito, Carmine: the Oltrarno quarter is a key area for the art and life of Florentines. Both working class and aristocratic, illuminated by the work of Brunelleschi and Masaccio, it has also been described by Vasco Pratolini, who depicts the popolo minuto of his city with lyrical and civic involvement. Santo Spirito was the mother church of the Augustinians, the most intellectual and culturally advanced of the religious orders, who embraced the bold complexity of Brunelleschi's design. His plan was to have the main door of the church opening in the direction of the river, but he died before the church was complete, and his successors partially betrayed his intentions.*

2

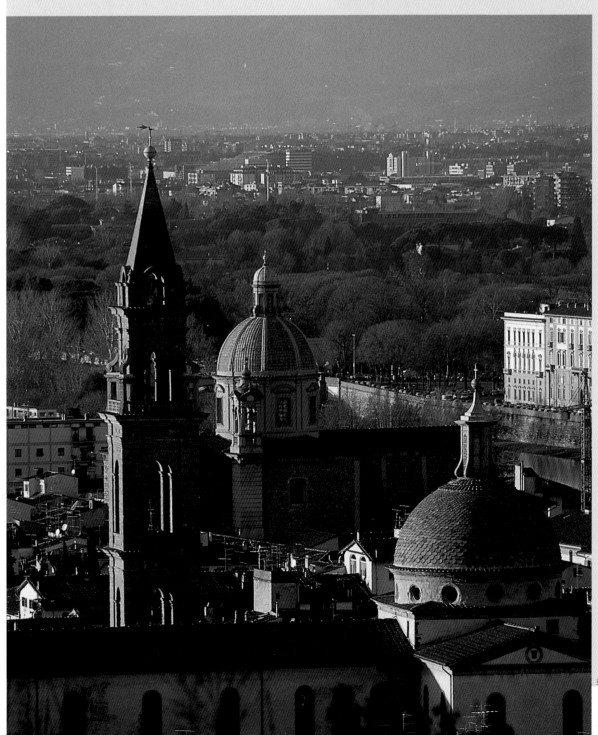

3

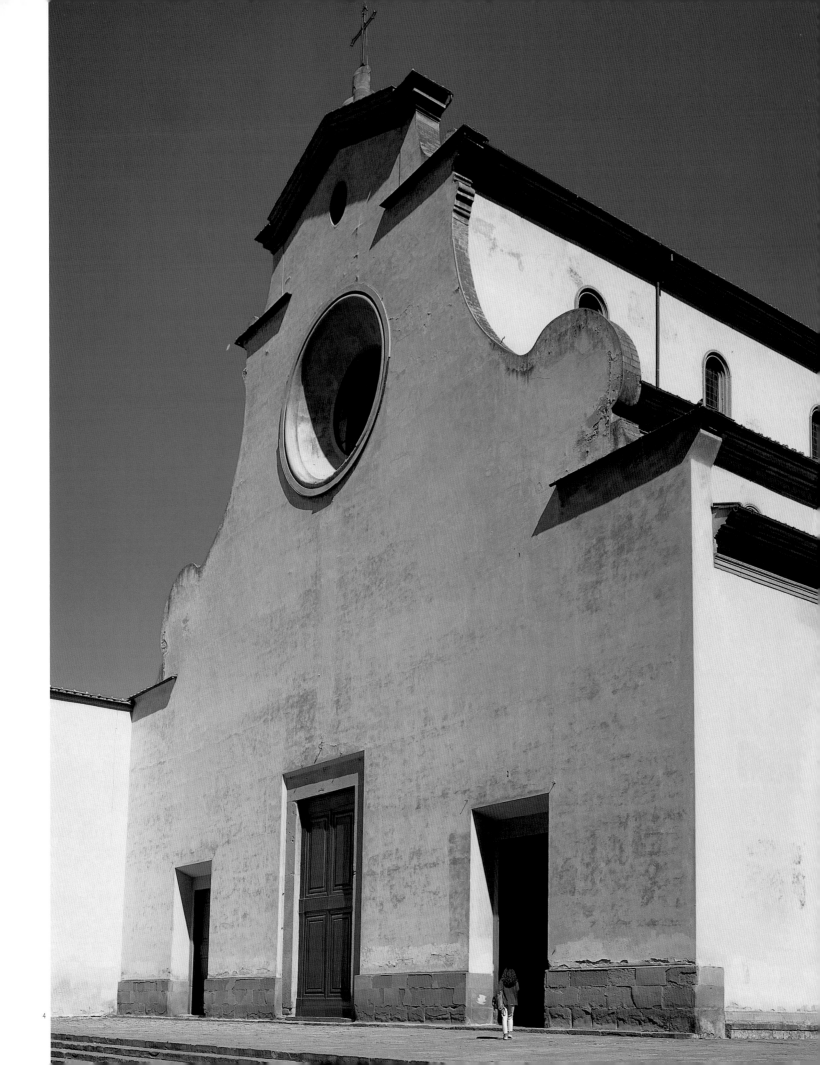

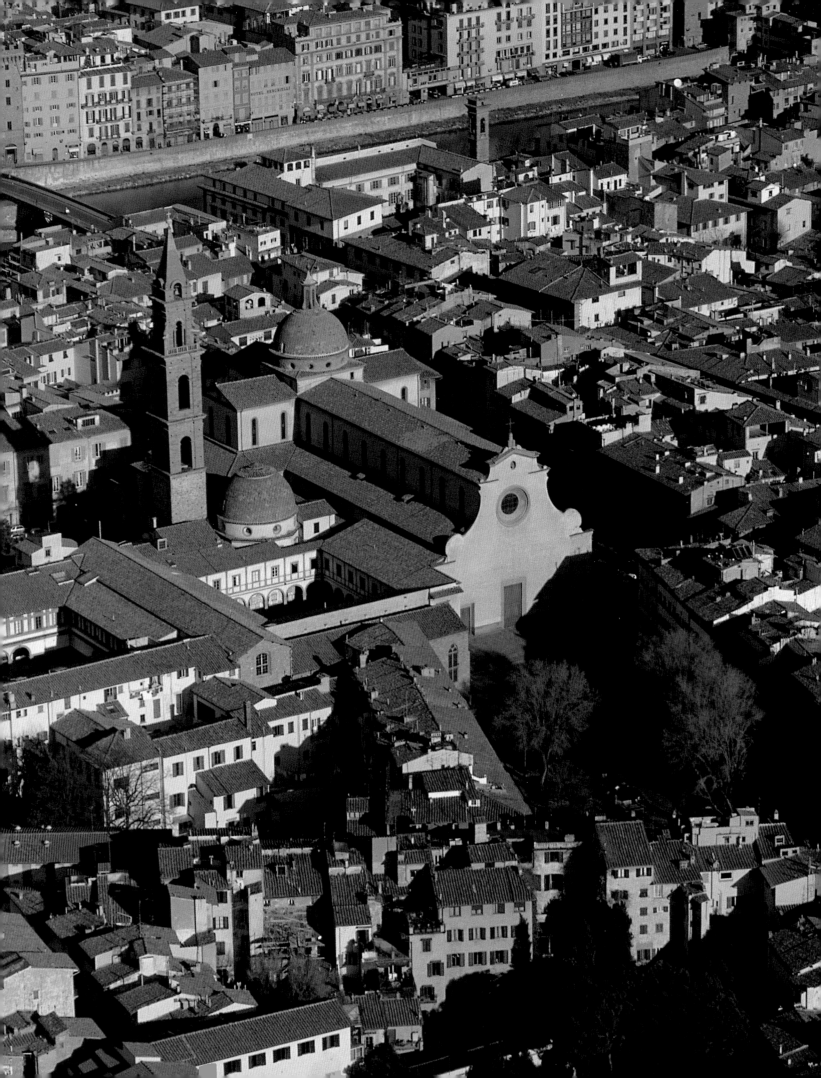

Santo Spirito lies at the heart of a lively and heavily populated area. Still inhabited by artisans who have preserved traditional skills, the area is socially varied: intellectuals, academics, students, tourists and people from all over the world contribute to make this part of the Arno a kind of Florentine *rive gauche*.
Yet there is still – and this is one of the extraordinary features of Santo Spirito – the original medieval and Renaissance imprint in the streets, alleys, piazzas and houses.

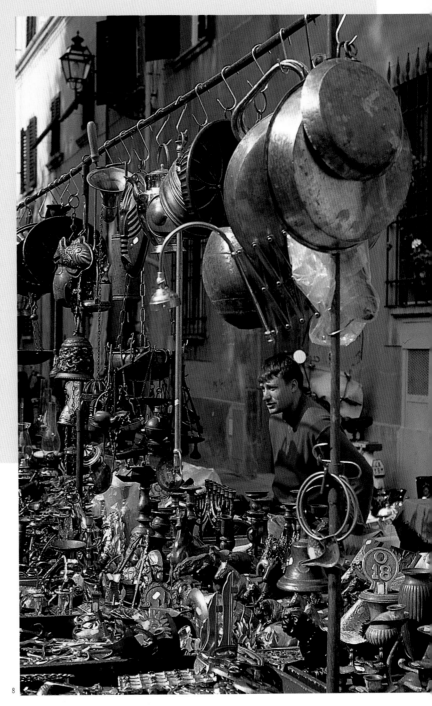

6

7

8

*Fortunately, the 1771 fire, which destroyed part of Santa Maria del Carmine, reprieved the frescoes of the Brancacci Chapel. Masolino and the youthful Masaccio had worked there between 1424 and 1428; their work was completed, after an interruption that lasted almost fifty years, by Filippino Lippi. The pause was due to Masaccio's tragic death at just twenty-eight. He had followed Masolino to Rome, and the latter's work is featured here in this splendidly elegant image of Renaissance Florence. Filippino executed the figure of the prison warder in the scene of the Release of St Peter from Prison.*

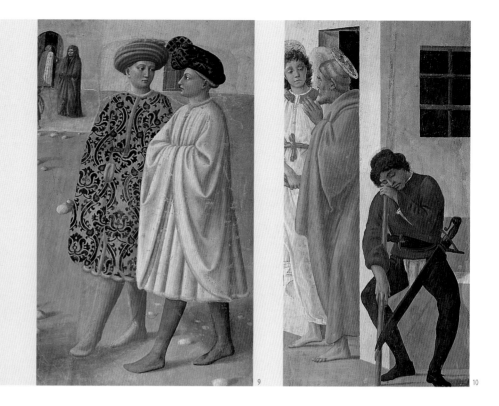

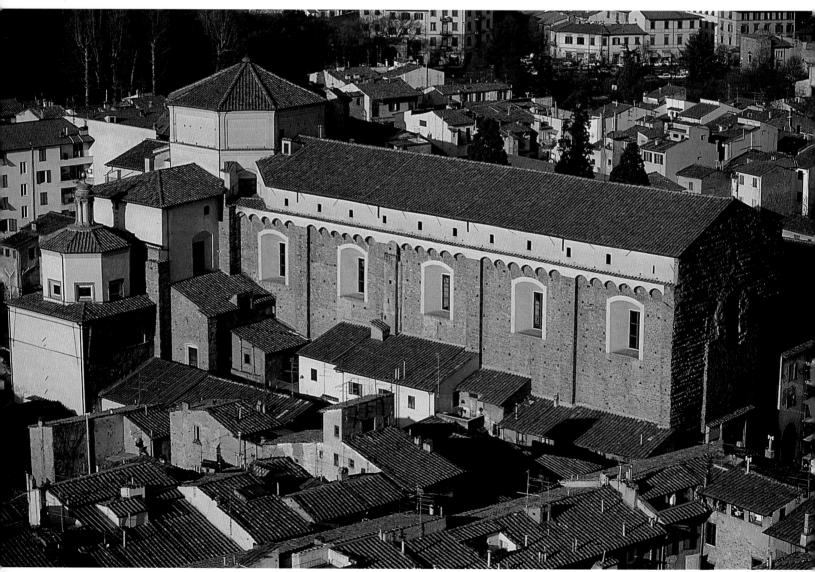

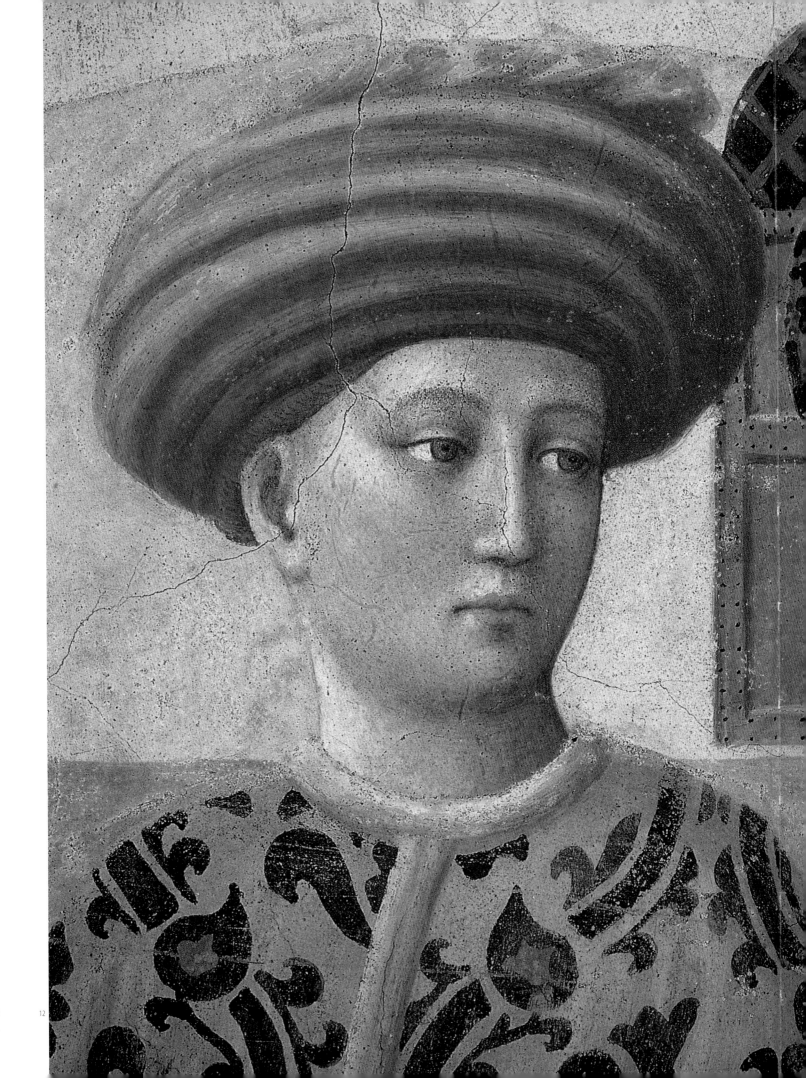

*Filippino Lippi's notables (alongside) contrast with profiles painted by Masaccio (opposite), who slipped in his own self-portrait to look out at us from the past. He also gave us the cry of anguish and the desperate suffering of Adam and Eve being banished from the Garden of Eden. He had learnt from Giotto how to depict reality, while his friend Brunelleschi taught him how to give form and proportion to space through the art of perspective. As Argan notes, 'Masaccio's figures are space concretised and revealed in a human semblance'. In the Tribute Money (below), Masaccio condenses his full moral vision into a narrative that is simultaneously the story and synthesis of events with an extremely powerful use of brush strokes and colour.*

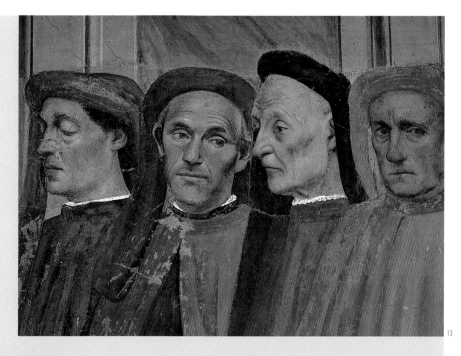

13

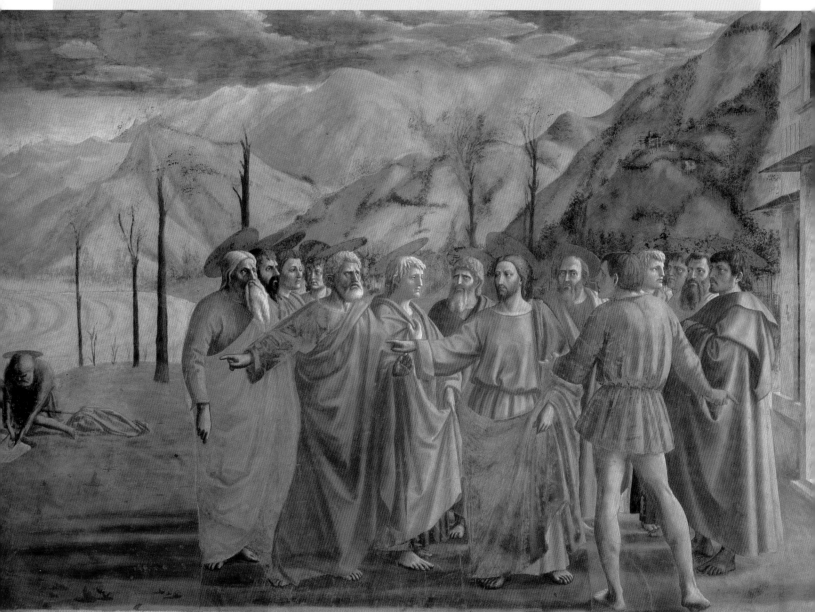

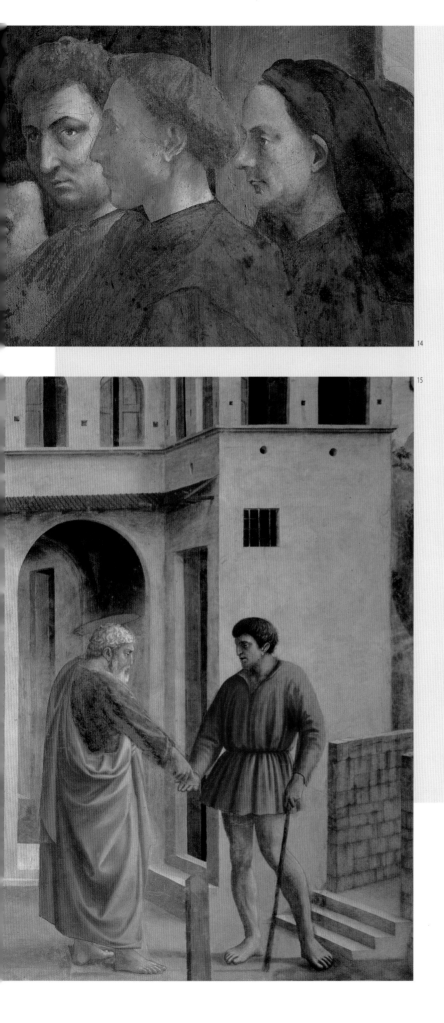

14

15

16

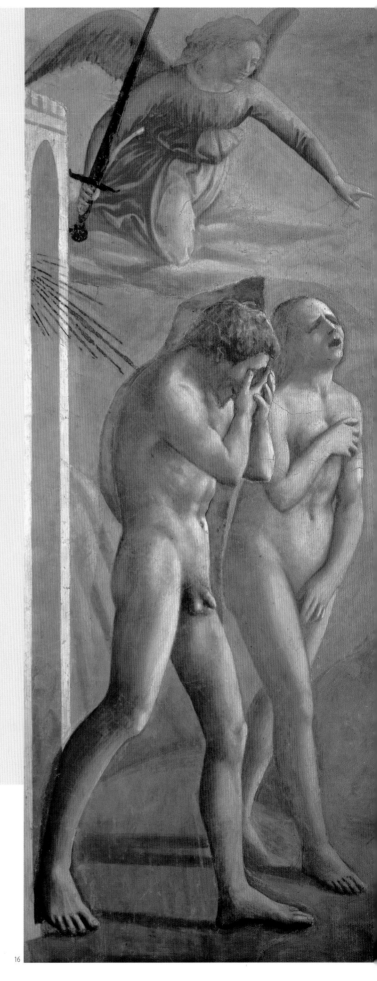

*Glass, silver, silk: the priceless legacy of a past that lives on in the eyes and hands of master craftspeople, in the botteghe and workshops facing onto the narrow streets of the Santo Spirito quarter, in the side-streets off Borgo San Frediano. The sense of measured elegance and the pleasure of work ben finito animate a proud artisan tradition conscious of possessing a knowledge that is centuries old and which is constantly subject to creative renewal. This can be seen in the work of the Brandimarte silversmiths, at the Antico Setificio Fiorentino and at the Locchi glass workshop.*

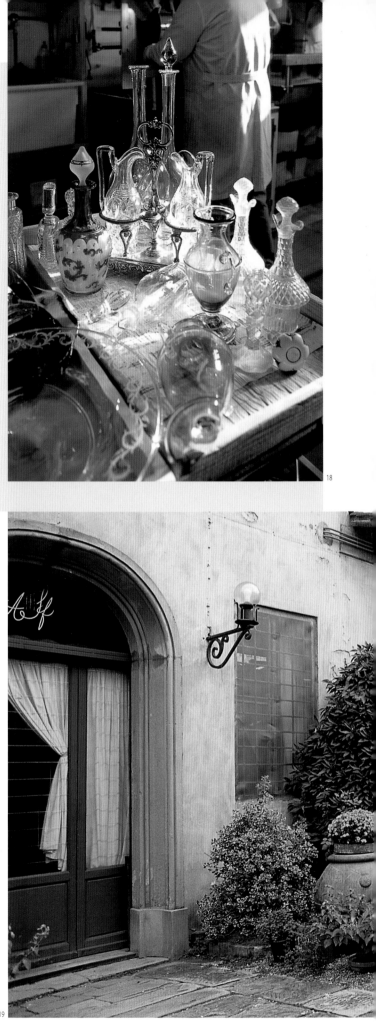

17

18

19

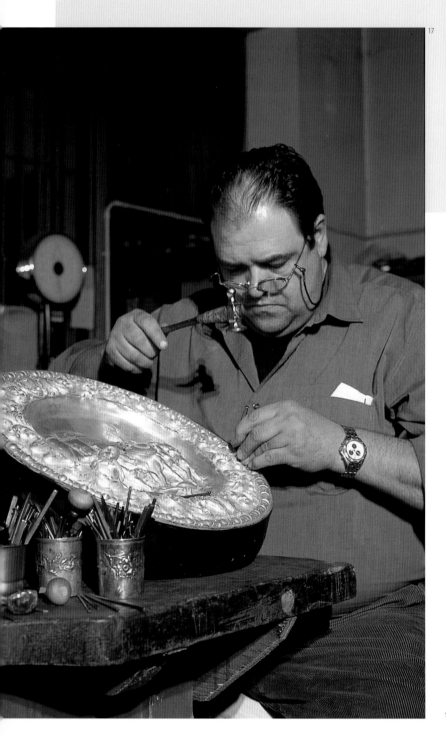

20

21

*Via Maggio is a street of fine palaces, where the spirit of the Renaissance – and the power of the noble families, protected by the Grand Dukes from their opulent residence in nearby Palazzo Pitti – seems to live on. Nowadays, it is also the site of some of the most beautiful antiques shops in Florence, run by antiquarians eager to measure themselves at international fairs against their colleagues from round the world. Here, too, the skill and patience of restorers is evident in the miracles they have worked with the furnishings and works of the past.*

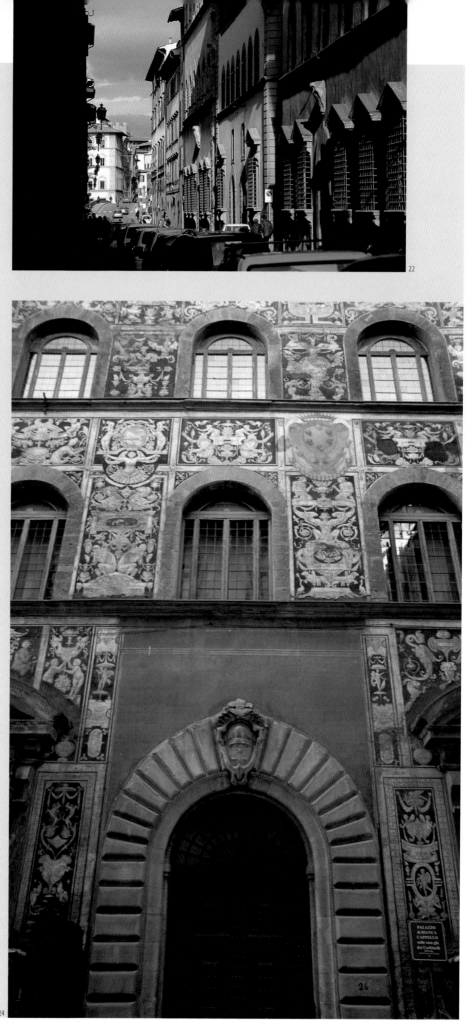

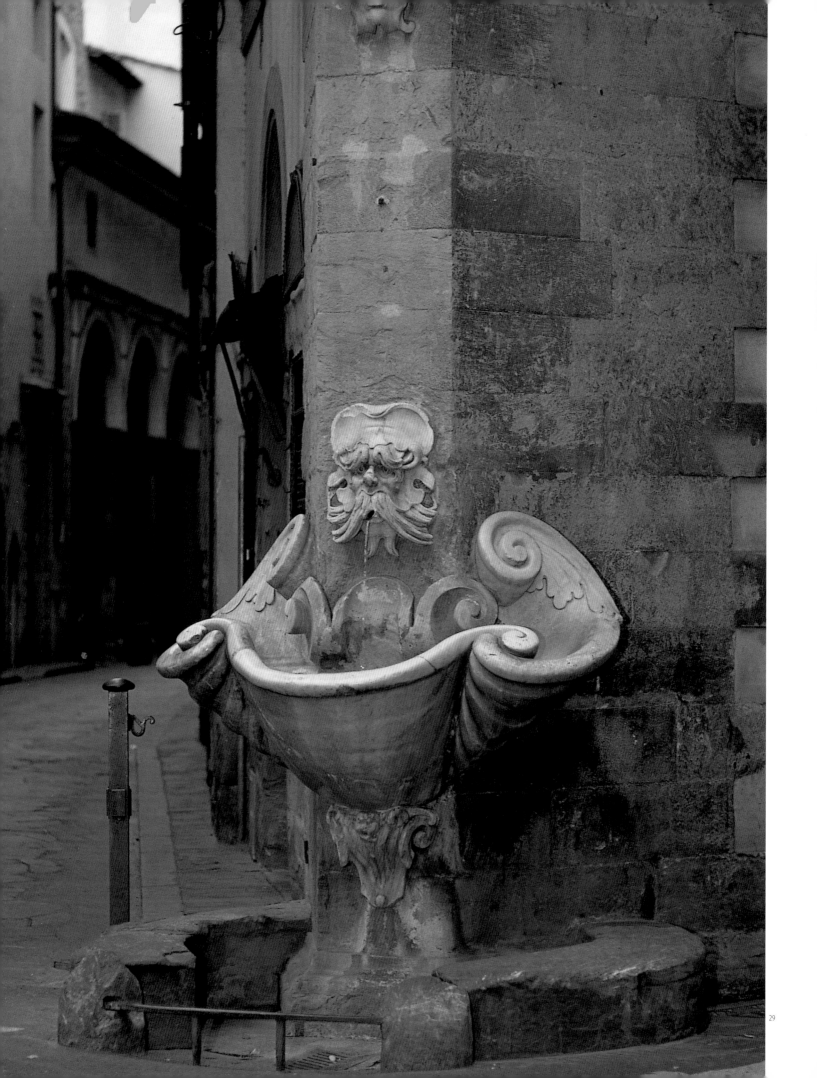

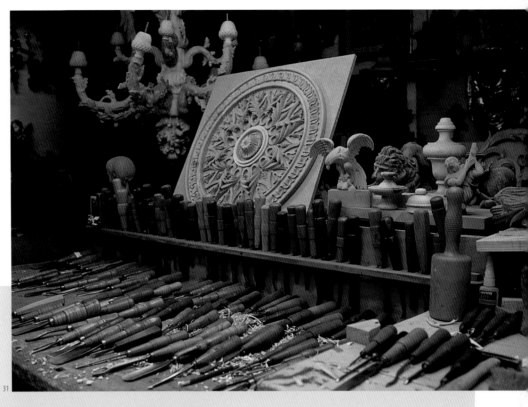

30  31

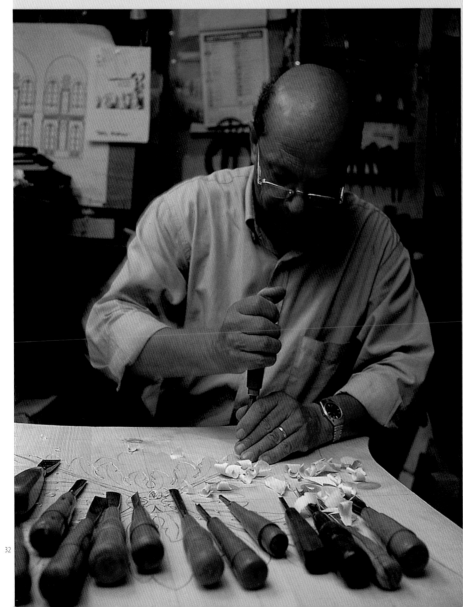

32

Before Via Maggio ends at the start of
the bridge of Santa Trinita, between the
converging streets of Via dello Sprone
and Borgo San Jacopo, a decorative
feature – which, at first glance,
Florence might appear to be short of –
appears unexpectedly amidst the
decorum of the surrounding
architecture. At the corner of the two
streets there is a cartouche fountain in
the style of Buontalenti, which seems to
indicate the artisan tradition of the
area. Nearby a wooden face peers out
from a marquetry workshop; in the
middle of the bench, there is a vast
collection of tools for chiselling wood in
various angles and cavities.

*Ponte Santa Trinita, like all the other bridges over the river (with the exception of Ponte Vecchio), was blown up by the Germans in August 1944, even though the drought-affected river would not have halted either the partisans or the Allies. The bridge was immediately restored to its former glory, exactly as it had been when Ammannati – advised by Michelangelo – first completed it in 1570. The original stone blocks and the statues of the Seasons were also recovered from the river.*

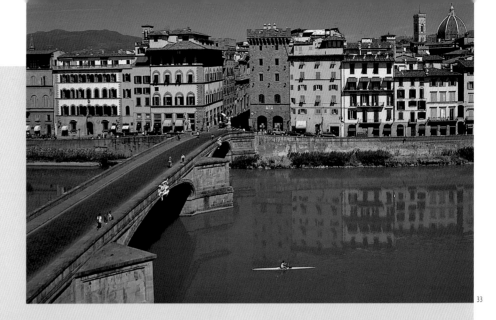

33

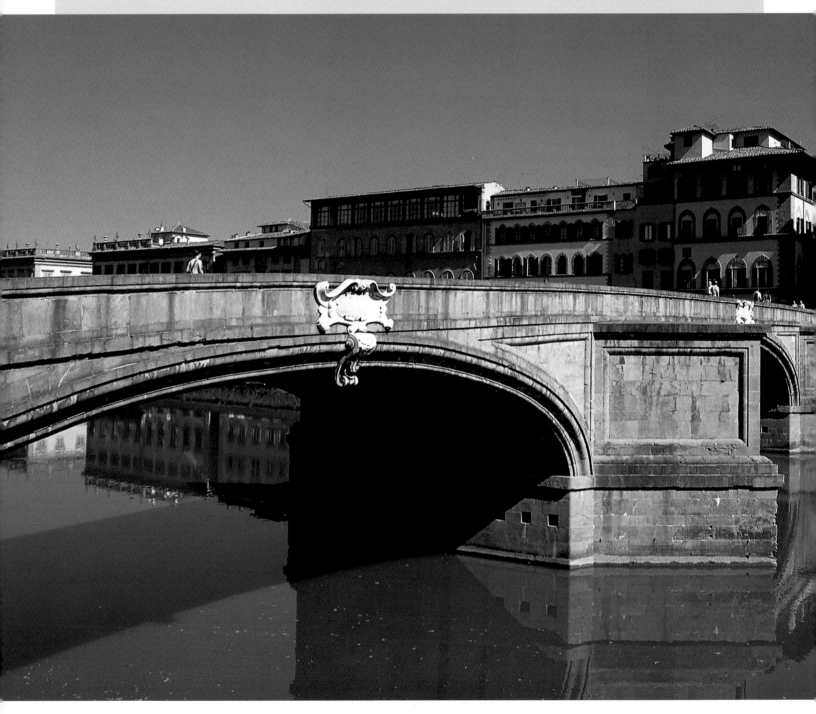

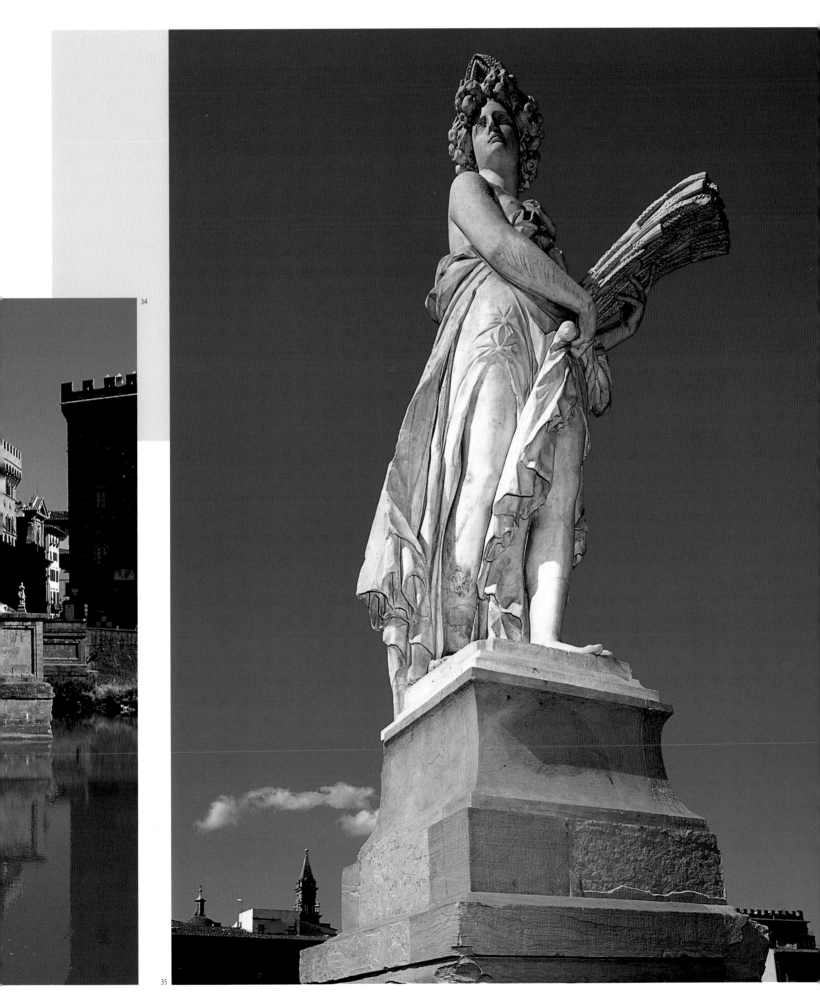

34

35

Not many years ago the elegant arcades of the Loggia Rucellai were walled in and it was impossible to see either the interior architecture or, reflected in the glass, the facade of the palace that Leon Battista Alberti designed together with the loggia. Alberti designed it for Giovanni Rucellai, a leading city merchant and an authoritative exponent of a rich family of linen manufacturers. Inspired by a Roman building style, the building was erected at the same time as – and almost in competition with – Palazzo Medici, which Cosimo il Vecchio was constructing at the time. The lives of the Rucellai and the Medici families came together quite frequently and in 1461 Giovanni's son, Bernardo, married Nannina, the sister of Lorenzo, and the wedding was celebrated in the Loggia. Bernardo also founded the Orti Oricellari, the salon of philosophers and poets who met in the merchant's garden.

36

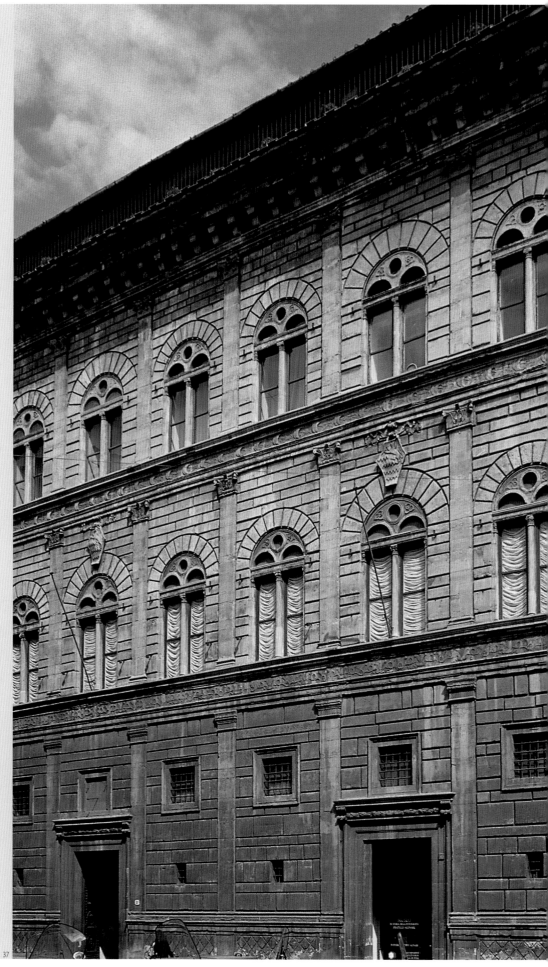

37

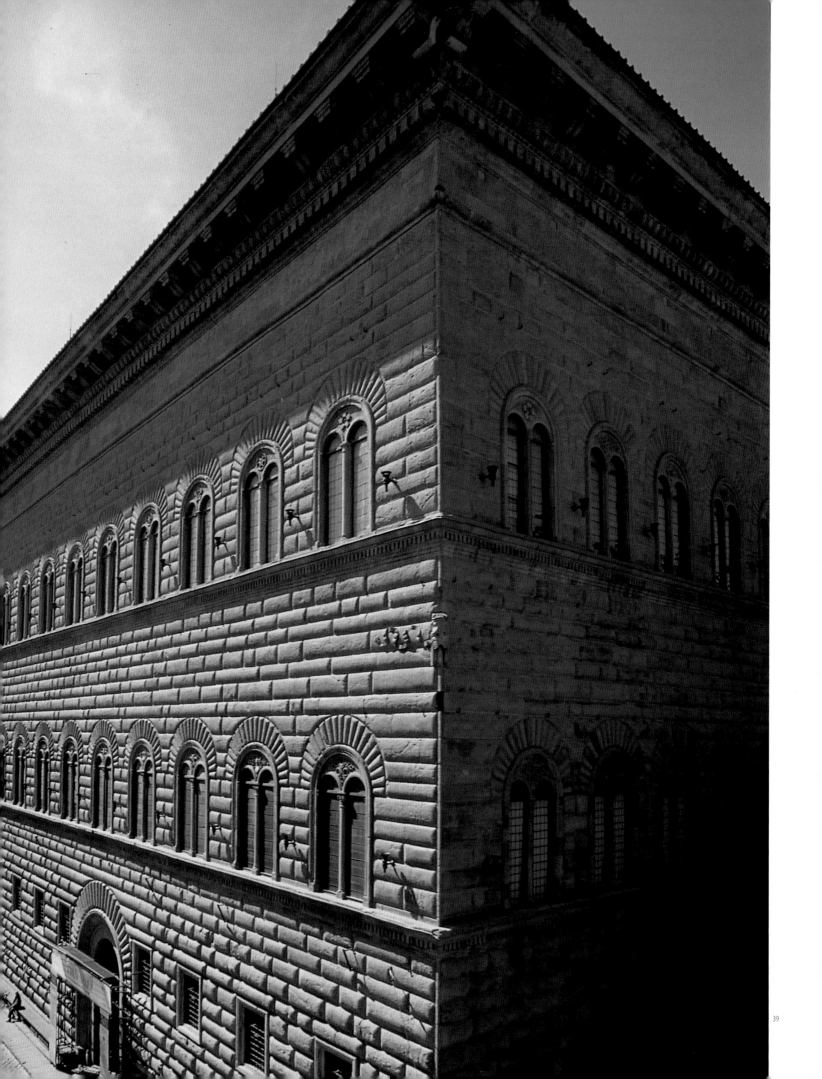

Palazzo Strozzi is a perfectly proportioned parallelepiped, the most fully realised architectural example of the Florentine Renaissance at its peak. Both Benedetto da Maiano and Cronaca worked on the building, following a concept by Giuliano da Sangallo and the suggestions of Lorenzo il Magnifico, who had made peace with the client, Filippo Strozzi, the son of a great enemy of the Medici, Palla. Today, the palace houses two important bodies, the Istituto di Studi sul Rinascimento and the extremely active Gabinetto Vieusseux, which has extensive archives and many original manuscripts.

40

41

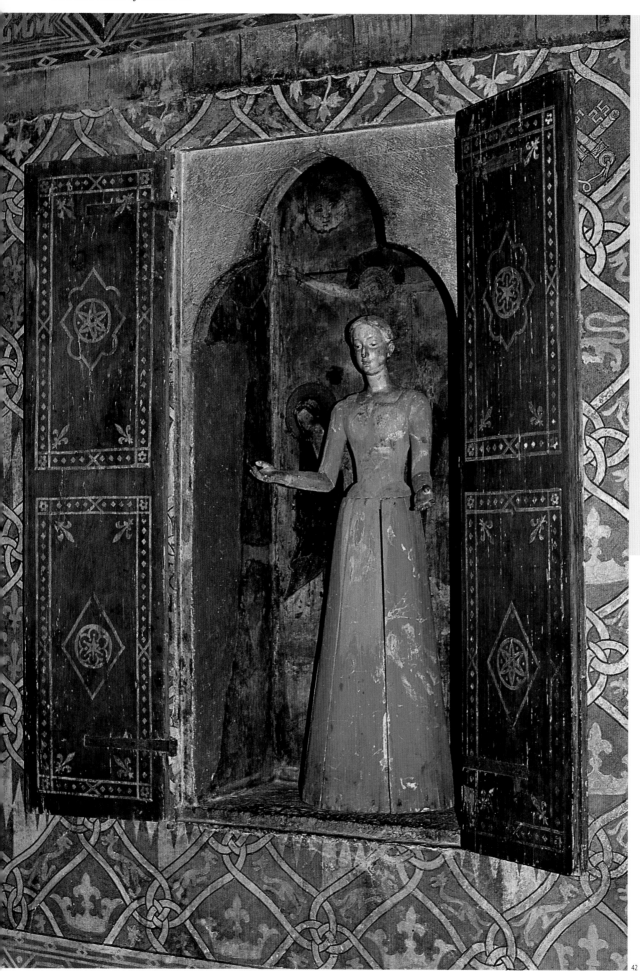

42

The furnishings in the fourteenth-century Palazzo Davanzati (now the Museo dell'Antica Casa Fiorentina) are not the originals, but although they come from elsewhere, every item of furniture and each individual object contributes to recreate the atmosphere of the time, namely the life of rich Florentines. Even the interior, with its wooden balcony and stone stairs, the rooms giving onto the face of the building and the bathrooms adjoining the bedrooms, make this house museum an authentic memory of the past.

43

*Via Tornabuoni, the most elegant street in the city, where the discreetly luxurious shop windows of the Florentine tradition were once lined up – the Giacosa pastry shop, for example, where the famous Negroni cocktail was invented, or the Profumeria Inglese, which has now disappeared. Alongside well-established international names such as Ferragamo and Gucci, there are many other Italian and foreign stylists, who pay whatever rent is asked of them in order to use the prestige of the street to promote their image. A few renowned businesses still remain: the Old England Stores (in an adjacent street); the classic outfitters Neuber; Procacci, with its truffle-flavoured sandwiches; and two favourite destinations for food lovers – Buca Lapi, the entrance to which is on Via del Trebbio, and the Cantinetta Antinori, on the ground floor of the namesake palace.*

45

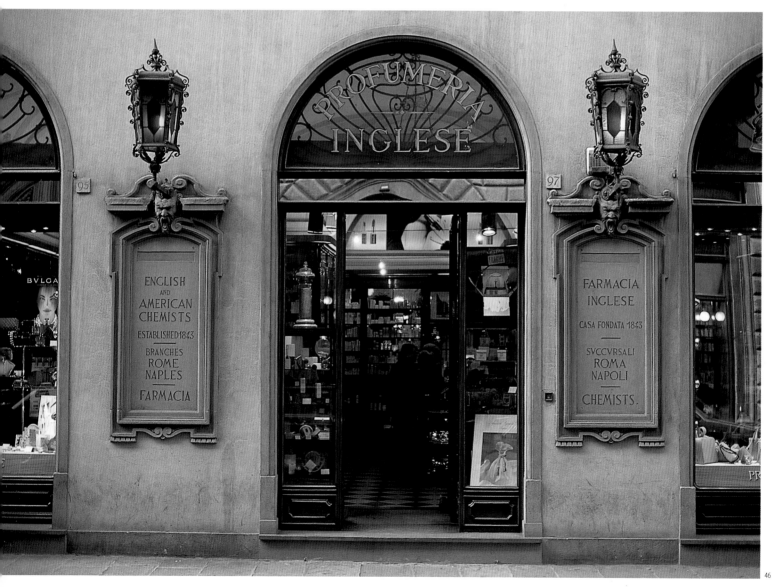

46

47

48

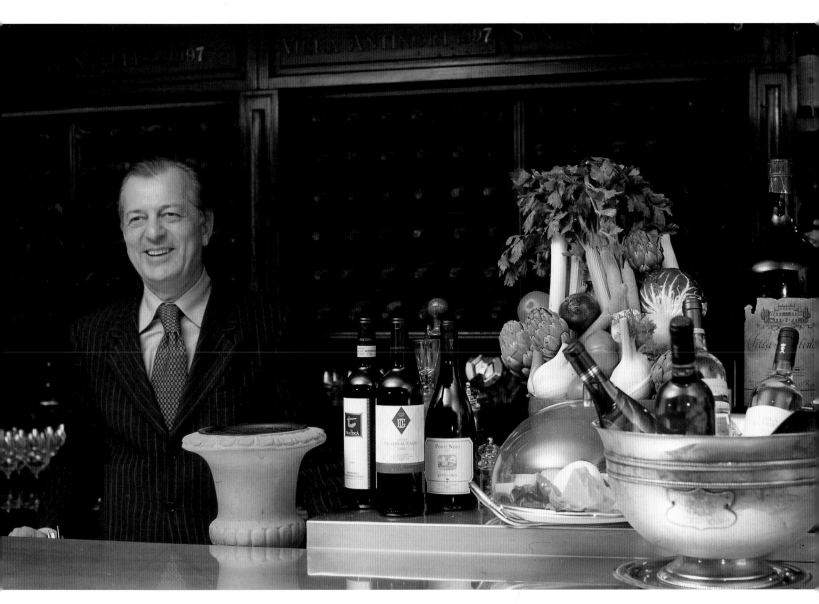

*The best way of entering Via Tornabuoni, the most famous street in Florence, is to approach from Ponte Santa Trinita, with the statues of the Seasons and the architecture of Via Maggio at one's back. Nineteenth-century building programmes did not spare this street either, but the numerous noble palaces facing onto it, including the rear side of Palazzo Strozzi, are still clearly evident. There is a curious interruption almost at the beginning of the street, a small widening in the road called Piazza Santa Trinita, with its namesake church and the obelisk from the Terme di Caracalla; the piazza also contains the sixteenth-century Palazzo Bartolini-Salimbeni, executed in a Roman style, and one side of the imposing medieval Palazzo Spini-Feroni, once a bulwark defending the bridge, now the headquarters of Ferragamo.*

At the far end of Via Tornabuoni, there is another small widening in the road, with the seventeenth-century church of San Gaetano and the solid fifteenth-century Palazzo Antinori, which gives its name to the non-existent piazza. This palace has always been the home and central office of one of the leading wine-producing firms on the international scene.

51

50    52

# In the circle of the hills

Fine monuments from the past – superb villages and beautifully-proportioned villas – a natural setting of vineyards, cypresses and olives shaped by human hands in the undulating hills surrounding Florence

To the north and south, Florence extends into the hills, which protect the city like two large wings and which are more an expression of human culture than they are of nature. The beauty surrounding Florence is not a happy accident of geography but the result of centuries of human intervention. Florence's roots lay in the wealth generated by the economic power of the florin, which provided the material foundations for the civilisation of the new Humanism and of the Renaissance. The big Florentine families bought up lands that had often been neglected and abandoned by a declining feudal system, and built villas to match the grandeur of their city palaces. Generations of the Medici family commissioned architects of the calibre of Michelozzo, Giuliano da Sangallo and Buontalenti to construct splendid country residences surrounded by gardens modelled on those of ancient Rome, and which met criteria of geometric harmony. But even those families less noble, who had profited from commerce and from the craft guilds, also started building on the slopes of the Florentine countryside, which gradually became more and more 'refined' and carefully tended, with vineyards, olive trees and vegetable gardens.

'A veder pien di tante ville i colli par che il terren ve le germogli', wrote the poet Ludovico Ariosto some centuries ago in *Orlando furioso*. But the cause of such splendour was not sprouting from the earth as such but was the work of an affluent and creative society with great faith in the future. A faith rewarded by subsequent history, because following the siege of the city in 1530, the countryside surrounding Florence was to witness no further scenes of destruction for over 400 years until front-line troops passed through the area during the Second World War.

The relationship between rich and refined Florence and the surrounding countryside continued in the age of the Grand Dukes, and Peter Leopold of Lorraine implemented enlightened policies of reform. It was his initiative that led to the foundation of the academy of agriculture, the Accademia dei Georgofili, and he implemented agrarian reforms that brought economic and social benefits to the whole of Tuscany. The beautiful country farmhouses – *case coloniche* – now transformed into villas, often positioned on the tops of low hills and characterised by an arched porch and a well-proportioned *colombaia* (dovecote) began to be built around the end of the eighteenth century according to a rural housing project devised by the Grand Duke's architects. The landscape of the Florentine hills was thus marked by these well-proportioned buildings, which alternated with the older stone houses of the rural labourers or, if there was a hint of a residual tower, of *signori*.

Intellectuals making their grand tour in the eighteenth century had already discovered this unique rural heritage, but it was in the nineteenth and twentieth centuries that visitors really started arriving in Florence and the surrounding hills from the other side of the Alps, and buying houses, sometimes in the city, but more commonly in the hills. With their love of the Renaissance and Mediterranean style, they revived the taste for gardens, though they were unable to resist certain Romantic and Anglo-Saxon embellishments.

Of all the hills, the most widely admired and the one that had the densest concentration of prestigious villas and gardens was undoubtedly, besides the nineteenth-century Viale dei Colli, that of Fiesole. Not a single blade of grass on its terraced slopes is left to the simple will of nature. The dominion of centuries of human endeavour is absolute. However, other locations in the north of the city are also imbued with history, art and nature. The villas and gardens of the Via Bolognese are a prelude to the fabulous Romanesque facade of the Badia Fiesolana and the Italian garden of Villa Gamberaia, with its grand water parterre. And from there, one can go on through the woods of the Castello di Vincigliata, to Settignano, where the sunset, viewed from its gentle slopes, is particularly beautiful.

Across the Arno, to the south of the city, there are velvet-smooth hills and long, sinuous and narrow country lanes and ancient roads stretching out from Florence in the direction of Siena and the sea of the Etruscans. In a landscape shaped by rules of harmony and steeped in the colours of Leonardo, a number of places stand out as being quite magical: Santa Margherita a Montici, Pian de' Giullari, Arcetri, the road to Impruneta, the Certosa at Galluzzo, the Via Chiantigiana and the Via Volterrana, Marignolle, Bellosguardo…So it is impossible not to embrace the enthusiasm of Anatole France when he wrote: 'In no other place is nature so subtle, elegant and refined. The god that created the hills of Florence was an artist! Or was he a jeweller, medal engraver, sculptor, bronze caster and painter?' More accurately, he concluded: 'He was a Florentine!'

*Almost along the same line of vision, the camera lens foreshortens and lengthens the distance of Florence and its hills. A small group of houses and ancient villas immersed in the silence of parks looks out over the city from the hill of Bellosguardo, a site dear to major figures in the past. Galileo, Foscolo, Henry James, Oscar Wilde and many others came to admire Florence in the calm of sunset in the gardens of the Torre or the Villa dell'Ombrellino, a balcony onto the city, finding here the inspiration for scientific innovations and timeless verse and novels.*

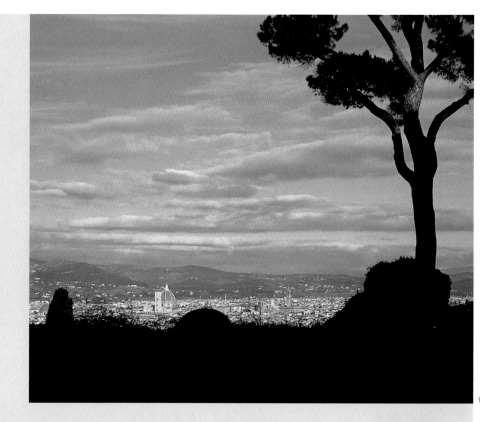

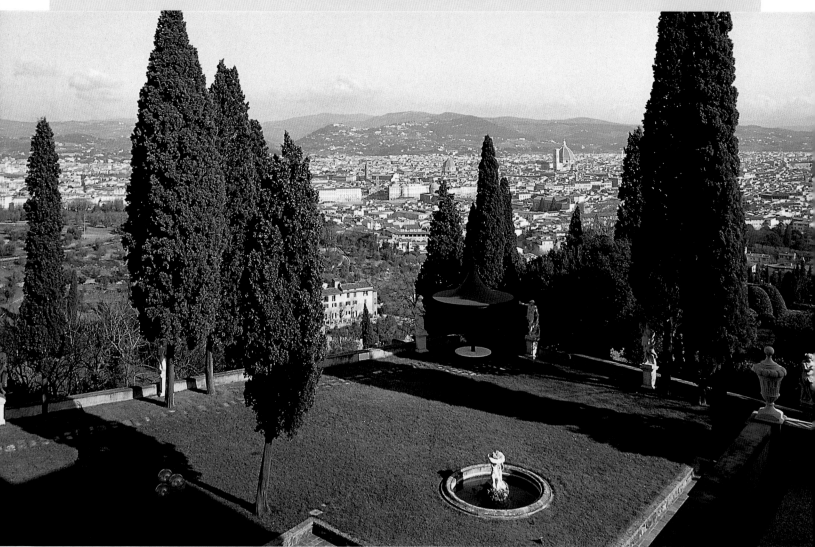

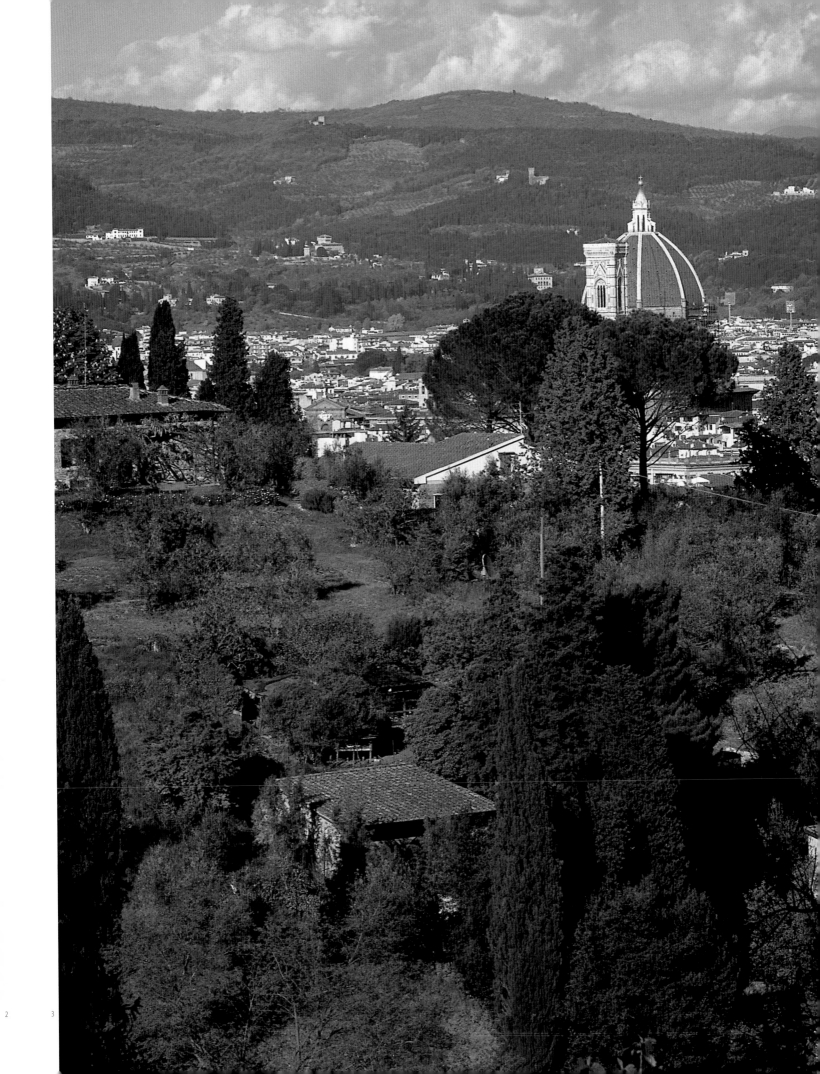

There are cypresses and olives around it on the slopes, but the architecturally complex *Certosa del Galluzzo* stands alone and free on the summit of the hill. It was built to satisfy a rich fourteenth-century Florentine banker named Niccolò Acciaiuoli, who was anxious to perpetuate his name on his return from the court of the King of Naples, where he had acquired wealth and power.

The convent complex, which has a harmonic structure greatly admired by Le Corbusier, was also protected over the centuries by other noble families and was gradually enriched with additional building and works of art.

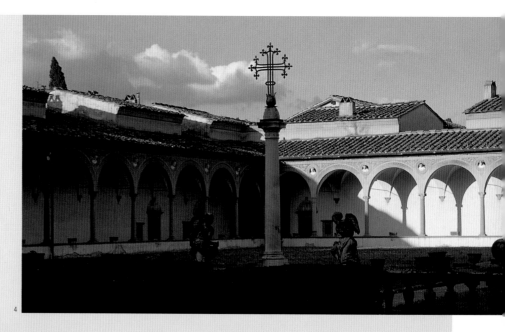

4

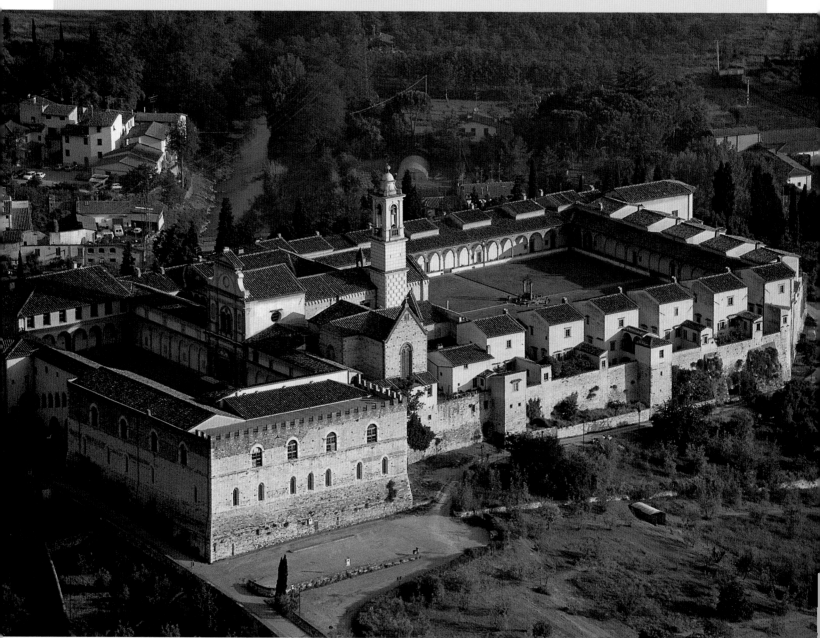

Pontormo frescoed Scenes from the Passion (*now in the Pinacoteca*), while the large cloister was decorated at the end of the fifteenth and during the sixteenth century with majolicas executed by the Della Robbia family. Following the 1966 flood, it was for many years a centre for the restoration of works from the Biblioteca Nazionale.

*At the point where the Colli widen towards the plain to the west of the city, La Petraia, one of the magnificent villas owned by the Medici family, looks out over the harmonious, geometrical Italian-style garden, captured here from above in its entirety. Various noble families had lived in it before it came into the possession of Cardinal Ferdinando de'Medici in 1575, who had it restructured by Buontalenti, while Tribolo organised the garden into three terraces and decorated it with statues by Giambologna.*

*One could trace a route through the landscape and architecture of the countryside along the slopes of the Florentine hills, moving from one to another of the many villas owned by the Medici: from La Petraia to the Villa di Careggi, greatly loved by Cosimo il Vecchio and seat of the Accademia Platonica of Marsilio Ficino, Poliziano, Pico della Mirandola. And from there to the Villa di Castello, where Botticelli painted his* Spring *and* Birth of Venus. *Not far away there is also the sumptuous villa of Poggio a Caiano, with frescoes by Andrea del Sarto and Pontormo, and the nearby hunting residence of Artimino, with its hundred chimneys. In the Mugello, where the family originally came from, the Medici owned, in the early days of their fortune, the fortress villas of Cafaggiolo and Trebbio, while Francesco I later encouraged the creativity of Buontalenti, Ammannati and Giambologna, developing the immense park of the villa of Pratolino near Florence, which had mazes, grottoes and water displays, and which culminated in the enormous Appennino statue.*

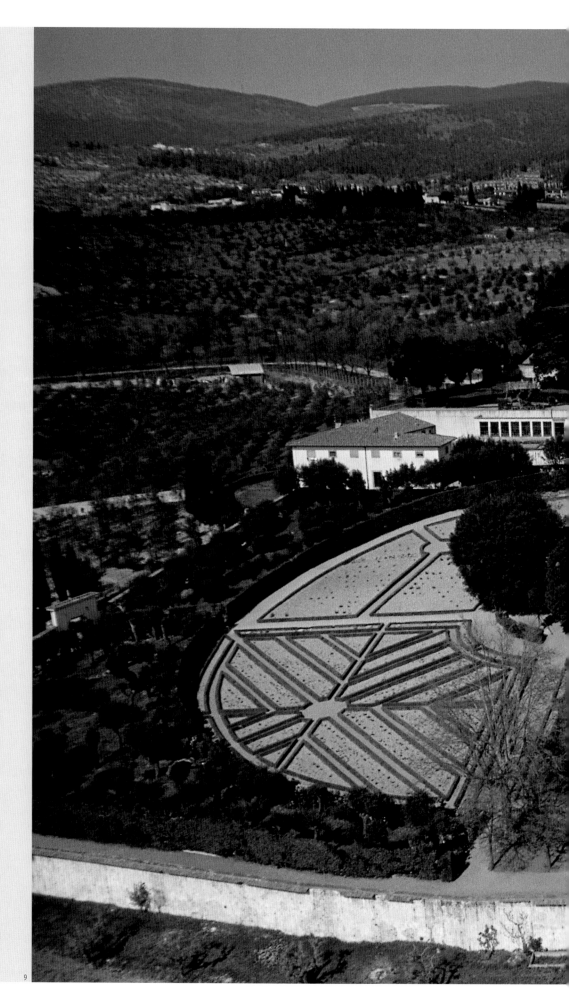

9

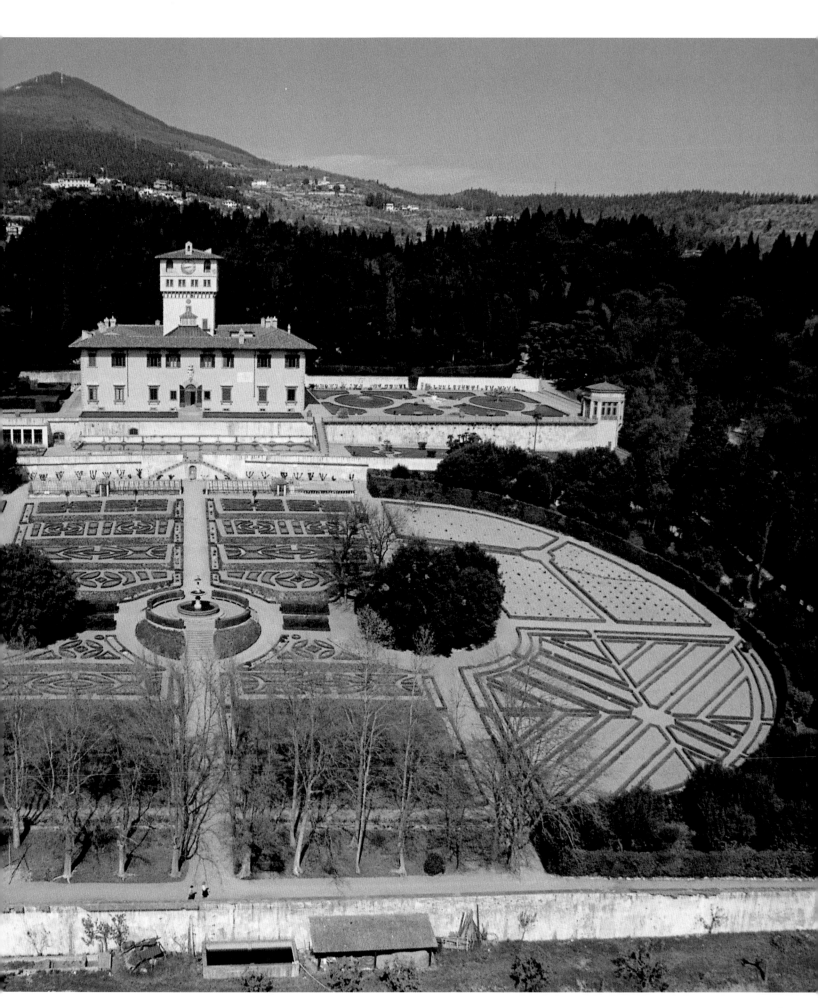

*Narrow, shady and quiet lanes
furrow the Florentine hills. Green
olives occupy terraced fields against a
background of centuries-old cypresses.
Discreet tablets on the walls of small
villages commemorate the birth or
life of local citizens and illustrious
guests. One villa follows another
in a carefully shaped natural
environment on the sunny slopes
of the Fiesole hills.*

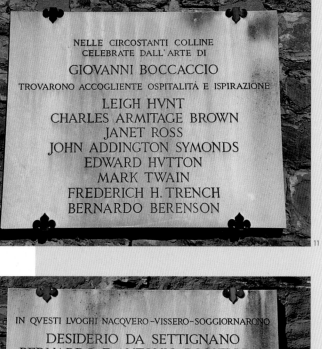

NELLE CIRCOSTANTI COLLINE
CELEBRATE DALL'ARTE DI
GIOVANNI BOCCACCIO
TROVARONO ACCOGLIENTE OSPITALITÀ E ISPIRAZIONE
LEIGH HVNT
CHARLES ARMITAGE BROWN
JANET ROSS
JOHN ADDINGTON SYMONDS
EDWARD HVTTON
MARK TWAIN
FREDERICH H. TRENCH
BERNARDO BERENSON

IN QVESTI LVOGHI NACQVERO-VISSERO-SOGGIORNARONO
DESIDERIO DA SETTIGNANO
BERNARDO E ANTONIO ROSSELLINO
LVCA FANCELLI
MEO DEL CAPRINA
SIMONE MOSCA
MICHELANGIOLO
I JVSTES DI TOVRS
NICCOLÒ TOMMASEO
GABRIELE D'ANNVNZIO
ELEONORA DVSE

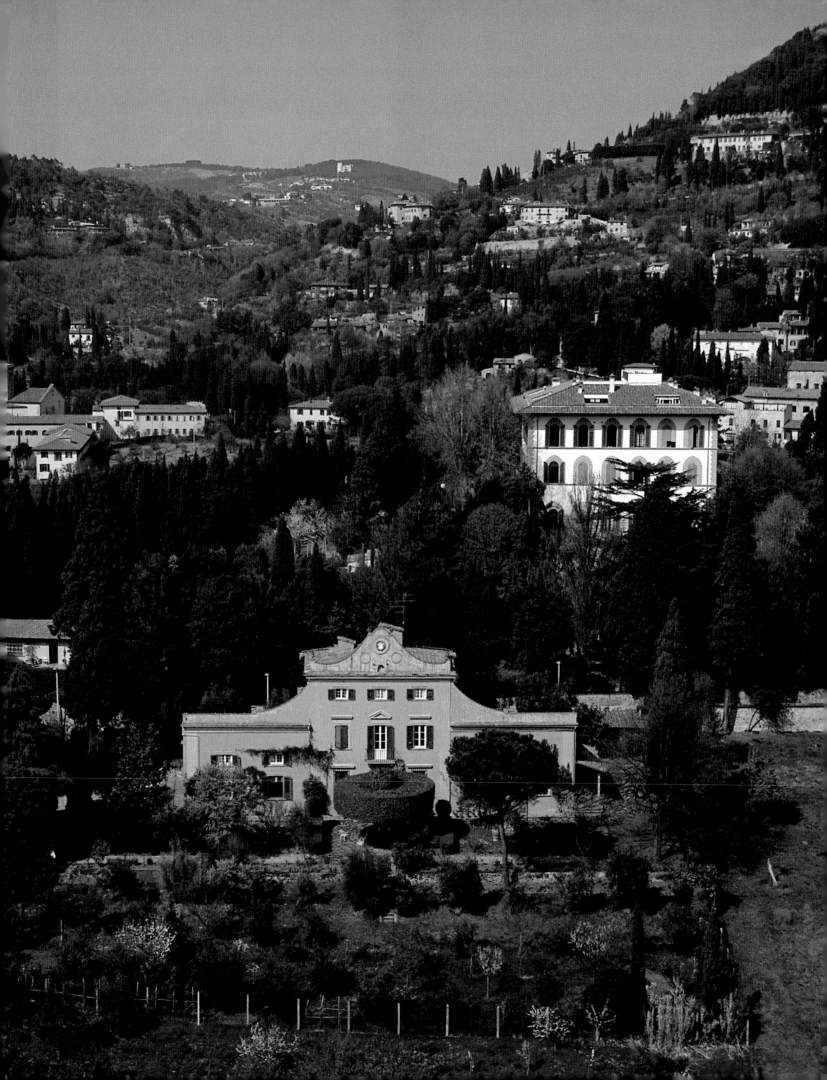

'A hollow like a great amphitheatre, full of terraced steps and misty olives, now lay between them and the heights of Fiesole, and the road, still following its curve, was about to sweep on to a promontory which stood out into the plain.' Was E. M. Forster referring in Room with a View to the ancient and narrow Via Vecchia Fiesolana, which at a certain point in its rapid ascent pauses and opens out long enough to be able to look out at the marvellous view from the low wall? Possibly. Goethe in his Italian Journey, when he saw 'Florence lying in a broad valley' of incredible beauty 'scattered with villas and houses as far as the eye could see' was certainly looking at the hills of Fiesole on his left as they descended from the north along the Via Bolognese, which was already dotted with aristocratic residences. The hill of Fiesole is an ideal reference point for any visitor, and no Florentine – despite a past marked by war and destruction – would wish that it had never existed. Dating back to Etruscan and Roman times, it was established many centuries before Florence, and the legacy of that ancient past is preserved in the first-century BC Roman amphitheatre, which has been rebuilt several times and now hosts concerts and theatrical performances on cool summer evenings. There are also plenty of expressions of Christian faith, for example the Franciscan convent and Sant'Alessandro, built over old Etruscan and Roman ruins.

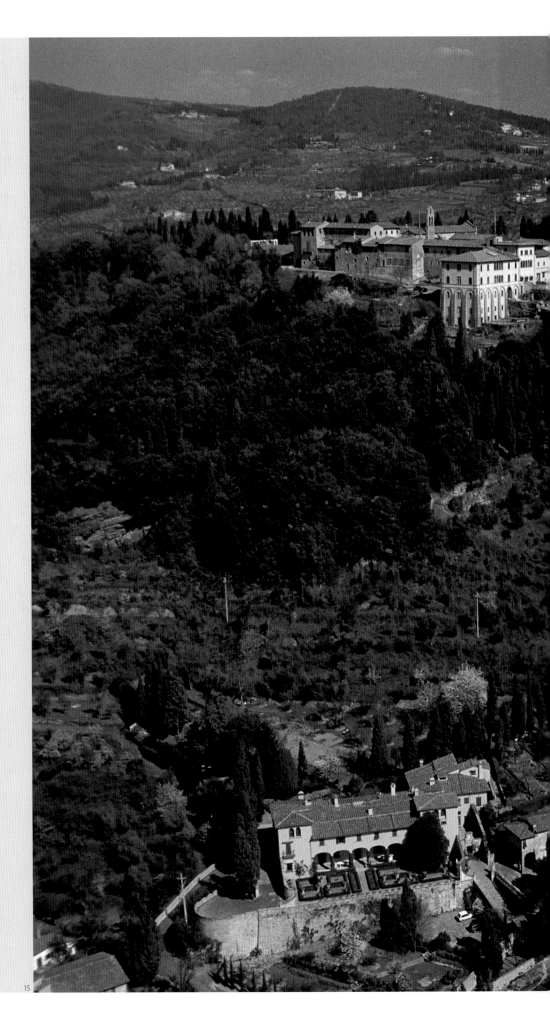

15

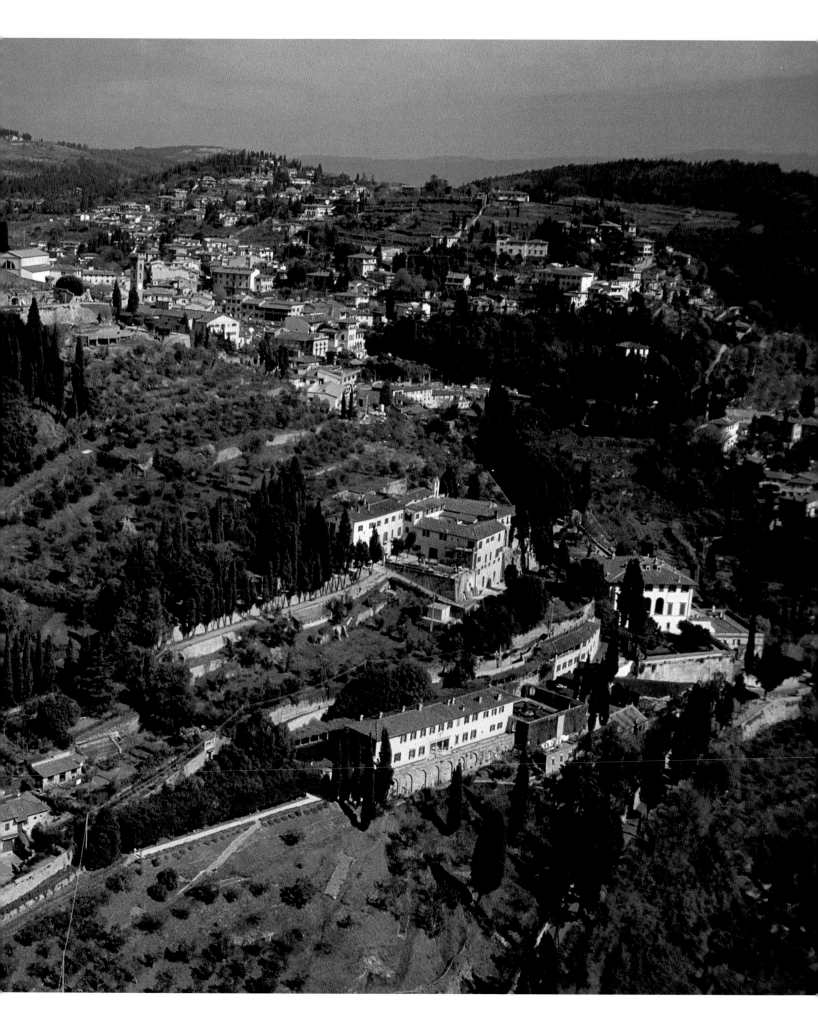

# 2000 years of power and passion: a chronology

## In the name of Flora

In 59 BC, the Romans settled in a small village previously controlled by the Etruscans of Fiesole. There they built a *castrum* and called it Florentia, probably in honour of the goddess *Flora* and the *Ludi floreales*, ritual festivities held in spring.

The Christian faith arrived as business and trade were flourishing with the arrival of Greek and Syrian merchants. One of these was San Miniato, a former Armenian prince, who was the earliest evangeliser of Florence. He was martyred in AD 250.

With the arrival of the barbarians, Florence moved on from the successfully resisted siege of the Ostrogoths in AD 405 to Lombard dominion in AD 570, when it was attached to the Duchy of Tuscia, the capital of which was in Lucca. The city then came under the control of the Frankish Carolingian dynasty and, in AD 854, the union of Florence and Fiesole gave rise to the largest Italian contado. Confirmation of the new strategic and economic importance of the city came at the end of the tenth century when Ugo, the Margrave of Tuscany, decided to move his capital from Lucca to Florence.

## Matilda and the *comune*

The early years of the new millennium were characterised by economic prosperity and a growing population, with Florence gradually becoming an important city in the region. In 1054, it hosted a council held to discuss corruption in the church, which included the buying and selling of ecclesiastical positions. In 1055, Henry III placed the city under the direct control of the Holy Roman Empire, releasing it from the local power of the Margrave of Tuscany. But, in the same period, Florence was also liberating itself from imperial power; during the struggle between the pope and the emperor over the nomination of bishops, which culminated in 1077 with the excommunication of Emperor Henry IV by Pope Gregory VII, the Countess of Tuscany, Matilda, supported the pope, with the consensus of the Florentine craft corporations, which were already a powerful force. This marked the beginning of the Guelph period of the city's history.

In 1060, construction started on the basilica of San Miniato al Monte and work continued on the Baptistery in the heart of the city.

In 1082, Florence triumphantly resisted the siege of the city by imperial troops and by 1115, the year in which Matilda died, the *comune* had more or less been formed and was soon able to establish its own autonomous government. The city began a period of expansion and in 1125 it conquered and destroyed Fiesole. Feudatories of the *contado* (the surrounding area under the control of the city) were obliged to reside in the city so that their activities could be kept in check. This urban migration fuelled tensions between feudal nobles loyal to the Emperor and the merchant corporations, providing fertile terrain for civil discord in the future. The war of the Emperor Frederick Barbarossa with the Italian *comuni* saw the involvement of Florence in the Battle of Asciano in 1177, which resulted in the defeat of the imperial troops and put an end to Frederick's aspirations to interfere in the life of the central Italian *comuni*.

## Guelphs and Ghibellines

The growth of Florence's prestige and independence contrasted with the worsening of the conflict between the most powerful families in the city. The figure of the *Podestà* was created in 1193 with the aim of administering justice and much of the executive and military power.

However, the feuding did not cease and two factions, the Guelphs and the Ghibillines, began to emerge. From behind the banners respectively of the pope and the emperor, the two parties defended the particular interests of the families contending for control of the city. According to Villani's *Chronicles*, the factions were sparked off by the assassination of Buondelmonte Buondelmonti in 1216; his relatives sought justice from the *Podestà*, but the conspirators refused to recognise the authority of the *comune* and appealed to imperial authorities.

In 1246, Frederick II attempted to re-establish a form of hegemony over the city by sending his son Frederick of Antioch as an emissary. The Ghibillines repressed the Guelphs ferociously, forcing some of them to flee into exile. But in 1250, upon the death of the Emperor, the political organisation of the Florentine merchants, the *primo popolo*, assumed power with the support of the Guelphs, replacing the *comune* institutions with their own organs of power; the *Podestà*, suspected of supporting the nobles, was flanked by a *capitano del popolo*, and two councils formed exclusively of common people. A temporary truce in the civil conflict permitted internal prosperity and the resurgence of wars of expansion, chiefly directed against rival Ghibilline *comuni* – Pistoia, Pisa and Siena. But the defeat suffered at the hands of Siena at Montaperti in 1260 marked the return of the Ghibillines to Florence and the dismantling of Guelph organisations. Power returned to the *Podestà*, an imperial nominee.

The Guelphs re-entered Florence in 1267, following the Battle of Benevento, where French troops under Charles of Anjou defeated the imperial army commanded by Manfredi. Charles was nominated *Podestà* of Florence for the following six years. The Ghibillines were thrown out and Guelph rule extended to the cities of Siena, defeated in 1269, and Arezzo, defeated in 1289 at the Battle of Campaldino.

## Merchants, poets, artists

The 'regulations of justice' promulgated by Giano della Bella in 1293 excluded the nobles from public posts of authority and sealed the definitive acquisition of power by the merchant bourgeoisie.

In the course of the thirteenth century, vernacular literature began to establish itself alongside that of medieval Latin. But

with the *Divine Comedy*, Dante Alighieri wrote a work of such power that his language inevitably became a model of literary language that prevailed over many other idioms in the peninsula, which had already produced its own literary forms.

The second half of the thirteenth century saw the start of large-scale architectural projects commissioned by religious, private and public patrons; these included the construction of the churches of Santa Maria Novella and Santa Croce, which belonged to the two major monastic orders, the Dominicans and the Franciscans. A granary loggia, later to become Orsanmichele, was also built as a measure against famine. In 1296, Arnolfo di Cambio was commissioned to build the Duomo, which involved enlargement of the ancient church of Santa Reparata; soon after, in 1299, he also took charge of building the Palazzo dei Priori, which subsequently became known as Palazzo Vecchio.

The Guelph bourgeoisie split into factions and, in 1302, the Black Guelphs led by the Donati family threw out the White Guelphs headed by the Cerchi and their supporters. One of these was Dante.

## The rise of the corporations
At the beginning of the fourteenth century, Florence had a population of almost 100,000; it was extremely wealthy, had trading relations with the major Eastern and Western countries, and its bankers lent money to the majority of the Christian heads of state. Yet there were still tensions: the city was threatened from without by the rising Ghibilline seigniories of the Visconti and Scaligeri and feared the extension of Anjou hegemony; and within Florentine society, the merchant bourgeoisie was unable to keep the *popolo minuto* and the *Arti Minori* at bay as they gradually established themselves as a political force. Florence was ruled first by the seigniory of Charles, Duke of Calabria, and then by that of Gualtiero of Brienne, Duke of Athens. The crisis deepened between 1343 and 1346, when many major bankers went out of business, a calamity exacerbated by two plague epidemics in 1340 and 1348, which severely reduced the population. Boccaccio's *Decameron* is set against the background of the 1348 plague.

On 12 April 1334, Giotto was nominated Master and Director of the Opera di Santa Reparata (that is, of the Duomo) and architect in charge of the city walls. On 18 July of the same year, he began construction of the Campanile.

Between 1375 and 1378, Florence fought a war with Pope Gregory XI, who, having issued an interdict on the city, hindered trade and damaged Florentine companies throughout Europe. The war was conducted by a council of eight citizens, renamed by the people as the *Otto Santi* – the eight saints. Peace was reached in 1378 thanks to the mediation of Catherine of Siena, who was later sanctified and became the patron saint of Italy.

In the revolt of the *ciompi* (wool carders and combers) in 1378, the workers claimed the right to organise themselves into guilds and to have their own representatives in the city government. Michele di Lando, a wool worker, was elected *Gonfaloniere di Giustizia*. But the oligarchy of the *Arti Maggiori* re-established power, which they maintained until the rise of the Medici. The rights of the *ciompi* were abolished and Michele di Lando was exiled.

## A revolution in art
Between the fourteenth and the fifteenth centuries, the newfound political stability of the oligarchic republic favoured economic prosperity and new territorial conquests. This was also the period in which the two great humanists, Coluccio Salutati and Leonardo Bruni, were active in Florence. The expansionist phase led to conflict with the powerful Visconti family in Milan, but Florence resisted and in 1406 it managed to capture Pisa, opening up access to the sea.

In 1420, Filippo Brunelleschi was appointed to superintend the building of the cathedral dome. Masaccio, Ghiberti, Donatello, Paolo Uccello and Beato Angelico were all working in the city during the same period, establishing a revolutionary conception of art that marked a decline in the International Gothic style.

## The Court of the Medici
The Florentine oligarchy was undermined by renewed rivalry between the big families, with the Albizi family to the fore. In 1433, Rinaldo degli Albizi managed to exile his rival Cosimo de'Medici, who had realised that in order to administer power in Florence it was necessary to have the support of the people. In fact, the following year Cosimo made his triumphant return to the city and had himself appointed *Signore* of Florence. Cosimo's prestige was such that the Council of Reunification of the Eastern and Western churches was held in Florence in 1438. This provided an opportunity to consolidate trade with the East and re-establish ties with Greek culture, which had been interrupted for centuries. This was to prove fundamental to the development of Humanism.

In 1469, following the death of Piero the Gouty, Lorenzo il Magnifico, the son of Piero and grandson of Cosimo, became head of the *Signoria* of Florence. Like Cosimo, Lorenzo retained the republican institutions but modified them gradually, stripping them of effective power, which slowly passed into the hands of men loyal to him. Lorenzo thus effectively ruled without holding any official title. Even foreign ambassadors and heads of state recognised his personal authority. However, the oligarchic families were unprepared to resign themselves to the loss of power, and in 1478 Lorenzo was lucky to escape alive from the Pazzi Conspiracy in which his brother Giuliano was killed.

Thanks to Cosimo and Lorenzo, Florence became an incredible cultural centre. The Medici court provided hospitality for artists, architects, poets and men of letters in a constant process of rediscovery and re-elaboration of classicism by the likes of Pico della Mirandola, Marsilio Ficino, Leon Battista Alberti, Andrea and Giuliano da Sangallo, Benozzo Gozzoli, Botticelli, Ghirlandaio, Leonardo da Vinci and Michelangelo.

## The return of the republic
When Lorenzo died in 1492 he was succeeded by his son Piero II; however, he lacked the political ability of his father, and

Charles VIII occupied the city in 1494 during his sweep down the Italian peninsula. The people were roused by the sermons of the Dominican monk Girolamo Savonarola, and drove the Medici out of Florence. For a brief period Florence returned to being a Republic in 1523, with Niccolò Machiavelli as its secretary. Intrigues amongst the families in power led to the excommunication of Savonarola by Alessandro VI Borgia. Savonarola was burnt at the stake in Piazza Signoria in 1498. In the meantime, a member of the Medici family, Giovanni, the son of Lorenzo, became Pope Leo X in 1513 and was succeeded by Giulio, the son of Giuliano, who became Clement VII. This prepared the political climate for the return of the Medici.

Michelangelo was active in Florence both for the republic, for whom he sculpted his *David*, a symbol of rediscovered republican freedom, and for the Medici popes, on whose behalf he worked on the New Sacristy in San Lorenzo. Raphael, Andrea del Sarto, Pontormo and Rosso Fiorentino were also active in this period.

## The splendour of the Grand Duchy

In 1530, the Republicans bowed to the siege by troops under Charles V, who installed Alessandro de'Medici as governor of the city with the hereditary title of duke. After his assassination in 1537 at the hands of Lorenzino de'Medici, nicknamed Lorenzaccio, he was succeeded by Cosimo, son of the military adventurer Giovanni delle Bande Nere, a descendant of another branch of the family. Cosimo concentrated power in his own hands and, with the protection of the Spanish Emperor, he began to build what amounted to a full-blown princedom. In 1569 he obtained from Pius V the title of Grand Duke of Tuscany.

Vasari was the court architect of the Grand Duke; he restructured the interior of Palazzo Vecchio and designed the Uffizi. Bronzino was the family portraitist, while Buontalenti, besides working as an architect, was also responsible for entertaining the Grand Dukes; he devised mobile scenery for splendid theatrical shows that would form the basis for modern stage set techniques. Cellini completed his *Perseus* in 1554.

The title of Grand Duke was passed down over the centuries, and there was a gradual decline, until the last descendant of the Medici family, Gian Gastone, died in 1737. Tuscany then came under the authority of Francis, Duke of Lorraine, who maintained his residence in Vienna while waiting to become Emperor, which happened in 1745. He was succeeded in 1765 by Peter Leopold, who embraced the enlightened ideas of the period and promoted a number of social reforms, including the abolition of the death penalty in 1786. He also improved the Tuscan economy. Recalled to Vienna to assume the title of Emperor, Peter Leopold left Florence to his second son Ferdinand III, who fled the city in 1799 in the face of advancing Napoleonic armies. The Grand Duchy was placed under the authority of Elisa Baciocchi, Napoleon's sister, who held power until the Restoration in 1814, when Ferdinand made his return.

The Grand Duchy of Tuscany remained in the hands of the Lorraine family until 1859, when Leopold II abandoned Florence following the Risorgimento, the aim of which was the unification of Italy and which culminated in the Second War of Independence. The following year, in 1860, Tuscany unanimously proclaimed its adherence to the Kingdom of Vittorio Emanuele II of Savoy.

## From the capital of Italy...

While awaiting the liberation of Rome, which was still part of the Papal State, Florence was the capital of the new Kingdom of Italy from 1865 to 1871. Palazzo Vecchio housed the Parliament and Palazzo Pitti became the residence of the Savoy family. The city underwent profound changes – the ghetto in the city centre was razed to the ground to make way for new buildings and the city walls were knocked down and replaced by the *viali*.

Notwithstanding the transfer of the capital of the Kingdom of Italy to Rome, Florence continued to be a cultural centre of great importance. The late-nineteenth-century Macchiaioli movement in painting was followed in 1908 by the establishment of Prezzolini's literary magazine *La Voce*. Another magazine, *Solaria*, was published between 1926 and 1936, and Eugenio Montale was director of the Gabinetto Viesseux between 1929 and 1939. The Maggio Musicale Fiorentino was established in 1933 and many publishing houses operated from Florence.

Towards the end of the Second World War, the city was occupied by the Germans until, on 11 August 1944, the population rose up and liberated Florence before the arrival of the Allies. The retreating Germans mined all the bridges over the river, except for Ponte Vecchio, but in order to hinder the movement of the Allies, they destroyed the remaining medieval areas to the north and south of the bridge.

## ...to the capital of art

The hard postwar years were dominated by the popular Christian Democrat mayor, Giorgio La Pira, who remained in office from 1951 to 1966, during which time he worked tirelessly for world peace.

On 4 November 1966, Florence was flooded by the Arno.

On 27 May 1993, in a delicate period in the history of the Republic of Italy, and in the course of a bitter struggle between the state and the Mafia, a car bomb exploded in the heart of the city in Via dei Georgofili. The explosion killed five people, injured twenty-nine and forced seventy people to leave their homes. The tower of the Accademia dei Georgofili was destroyed and a wing of the Uffizi Gallery was seriously damaged together with a number of masterpieces.

At the dawn of the new millennium, the population of Florence was 378,000, with almost 9 million visitors each year, 61 museums, 167 churches, convents and other places of worship, and 214 palaces, towers and loggias.

A vast number of books has been written about Florence, and the following list is limited to those that were consulted and cited in the preparation of this book.

Various authors, *Firenze. Guida per il viaggiatore curioso*, Florence, 1986
Various authors, *Gli Alinari fotografi a Firenze (1852–1920)*, catalogue of the exhibition at the Forte di Belvedere, Florence, 1977
Various authors, *Il luogo teatrale a Firenze*, Milan, 1975
Giulio Carlo Argan, *Storia dell'arte italiana*, Florence, 1968–69
Emilio Bacciotti, *Firenze illustrata nella sua storia, famiglie, monumenti, arti e scienze*, Rome, 1977, reprint of Florence ed., 1879–87
Francesco Bandini, *Su e giù per le antiche mura*, Florence, 1983
Piero Bargellini, *Questa è Firenze*, Florence, 1968
Bernard Berenson, *The Italian Painters of the Renaissance*, Florence–London, 1957
Luciano Berti, *Firenze. Tutta la città e la sua arte*, Florence, 1979
Domenico Cardini (ed.) *Il bel San Giovanni e Santa Maria del Fiore*, Florence 1996
Franco Camarlinghi, *Ripensare Firenze*, in *Storia d'Italia. Le Regioni dall'Unità a oggi. La Toscana*, Turin, 1986
Guido Carocci, *I dintorni di Firenze*, Rome, 1968, reprint of Florence ed., 1906–07
Emilio Cecchi, *Giotto*, Milan, 1959
Emilio Cecchi, *Firenze*, Milan, 1969
Alessandro Conti (ed.), *I dintorni di Firenze*, Florence, 1983
Alessandro Conti, *Artisti del Quattrocento*, Florence, 1998
Carlo Cresti, *Firenze*, Florence, 1985
Robert Davidsohn, *Storia di Firenze*, Florence, 1956–68
Marco Dezzi Bardeschi (ed.), *Giovanni Michelucci. Un viaggio lungo un secolo*, Florence, 1988
Giovanni Fanelli, *Brunelleschi*, Florence, 1977
Giovanni Fanelli, *Firenze*, Bari, 1980
Silvano Fei, *Nascita e sviluppo di Firenze città borghese*, Florence, 1972
Edward M. Forster, *A Room with a View*, London, 1908
Gloria Fossi, *Firenze*, Milan, 1987
Eugenio Garin (ed.), *L'uomo del Rinascimento*, Bari, 1988
J.W. Goethe, *Italian Journey*, London, 1816
Hermann Hesse, *Dall'Italia*, in the Milan edn., 1990
Henry James, *Italian Hours*, London, 1962
Onorio Lelli, Geno Pampaloni, *Firenze*, Novara, 1986
Pier Francesco Listri, *Il dizionario di Firenze*, Florence, 1998–99
Roberto Longhi, *Opere complete*, Florence, 1975
Giulio Lensi Orlandi, *Le ville di Firenze di qua d'Arno*, Florence, 1954
Graziella Magherini, *La sindrome di Stendhal*, Florence, 1989
Pietro C. Marani, *Leonardo*, Milan, 1994
Lara Vinca Masini, *Itinerari per Firenze*, Rome, 1981
Mary McCarthy, *Le pietre di Firenze*, Milan, 2001. *The Stones of Florence*, San Diego and New York, 1963. Orig edn., 1956.
Daniele Mignani, *Le botteghe di Firenze*, Florence, 1988
Franco Nencini, *Firenze. I giorni del diluvio*, Florence, 1966
Guido Piovene, *Viaggio in Italia*, Milan, 1957
Vasco Pratolini, *Le ragazze di Sanfrediano*, Florence, 1952
Vasco Pratolini, *Il Quartiere*, Florence, 1954
Filippo Rossi, *Il bel San Giovanni e Santa Maria del Fiore*, Florence, 1964
Guido Alberto Rossi and Mario Sabbieti, *Firenze. Emozioni dal cielo*, Milan, 1989
John Ruskin, *Mattinate fiorentine*, in the Milan edn., 1984
Mario Salmi, *Civiltà fiorentina del primo Rinascimento*, Florence, 1967
Giovanni Spadolini, *La piccola storia di Firenze*, ed. P.F. Listri, Florence, 1992
Charles Spencer, *Viaggio in Toscana*, Florence, 2000
Stendhal, *Roma, Napoli e Firenze*, in the Roma-Bari edn., 1974
Renato Stopani, *Medievali 'case da signore' nella campagna fiorentina*, Florence, 1981
David Tutaev, *Il console di Firenze*, Turin, undated
Giorgio Vasari, *Lives of the Artists, Vols 1–2*, London ed., 1965
Frederico Zeri and Mario Luzi, *Firenze*, Florence, 1994
Klaus Zimmermanns, *Firenze*, Milan, 1990
Ludovico Zorzi, *Il teatro e la città. Saggi sulla scena italiana*, Turin, 1977

Ilka Singelmann Guaraldi: 16, *6-7*; 17, *8-9*; 21, *18*; 28, *23-24*; 29, *29*; 30, *30-31*; 31, *33-37*; 32, *38-41*; 35, *44*; 40, *56-58*; 41, *59-60*; 48, *67-68*; 49, *69-71*; 52, *1-2*; 55, *5*; 56, *9-11*; 57, *14*; 66, *30*; 68, *33*; 70, *36-37*; 71, *38-39*; 73, *45*; 76, *49-51*; 77, *52-54*; 78, *55-59*; 79, *60-64*; 84, *3*; 86, *5-7*; 87, *8*; 88, *11-12*; 94, *22*; 96, *27*; 97, *30*; 99, *35-36*; 101, *42*; 102, *43-46*; 103, *48*; 108, *1-3*; 109, *4*; 112, *9-10*; 113, *11*; 132, *44-46*; 139, *54*; 142, *59*; 148, *2*; 158, *22-24*; 159, *25*; 159, *28*; 161, *30*; 164, *36*; 167, *40-41*; 173, *51-52*; 176, *1*; 178, *4-5*; 179, *6-8*; 182, *10-13*; back cover;

Giuliano Valsecchi: 9; 14, *2-4*; 15, *5*; 18, *10*; 20, *12*; 21, *13*; 22, *14*; 23, *15*; 24, *16*; 24, *17*; 24, *19*; 25, *20*; 27, *22*; 28, *25*; 29, *26-28*; 30, *32*; 33, *42*; 36, *45-46*; 37, *48*; 38, *49*; 39, *51-55*; 41, *61*; 42, *62*; 45, *65*; 55, *6-8*; 57, *12-13*; 60, *16*; 62, *21*; 63, *22-23*; 64, *24-26*; 66, *28-29*; 67, *31*; 68, *32*; 68, *34*; 69, *35*; 71, *40*; 74, *41-43*; 73, *44*; 73, *47*; 80, *65*; 81, *66-68*; 84, *1-2*; 84, *4*; 87, *9*; 88, *10*; 89, *13*; 90, *14*; 91, *15-16*; 92, *19*; 93, *20*; 96, *24-26*; 97, *28-29*; 97, *31*; 98, *32-34*; 99, *37-38*; 100, *39*; 101, *40-41*; 102, *47*; 109, *5*; 110, *6-7*; 114, *12*; 115, *14*; 116, *15-16*; 116, *17*; 118, *18-20*; 119, *21*; 120, *22*; 125, *29*; 126, *30-32*; 128, *34-36*; 129, *37-38*; 130, *39-40*; 131, *41-42*; 132, *43*; 134, *48*; 136-137, *50*; 138, *52*; 139, *55-56*; 142, *58*; 143, *60*; 148, *3*; 149, *4*; 151, *6-8*; 152, *9-10*; 152, *12*; 154, *13*; 156-157, *17-21*; 159, *26-27*; 160, *29*; 161, *31-32*; 162, *33-34*; 163, *35*; 164, *37*; 165, *38*; 166, *39*; 168, *42*; 169, *43-44*; 170, *45-46*; 171, *47-49*; 176, *2*; 177, *3*;

Antonio Quattrone: 6; 46-47, 66; 60, *17*; 61, *18-20*; 111, *8*;

Mario Quattrone: 94, *21*; 94, *23*;

Auro Lecci: 127, *33*; 172, *50*;

Archivio DoGi: 19, *11* (Mario Quattrone); 34, *43* (Serge Dominge, Marco Rabatti); 36, *47* (Serge Dominge, Marco Rabatti); 38, *50* (Serge Dominge, Marco Rabatti); 43, *63* (Mario Quattrone); 44, *64*; 73, *46* (Serge Dominge, Marco Rabatti); 91, *17*; 92, *18*; 114, *13* (Serge Dominge, Marco Rabatti); 120, *23*; 121, *24* (Serge Dominge, Marco Rabatti); 122, *25-26* (Serge Dominge, Marco Rabatti); 123, *27*; 124, *28* (Serge Dominge, Marco Rabatti); 135, *49*; 140-141, *57*; 154-155, *14-16* (Antonio Quattrone);

Archivio Manetti e Gusmann 104-105, *49*;

Archivio Officina Profumo Farmaceutica 138, *51*; 138, *53*;

Guido Alberto Rossi 12-13, *1*; 53, *3*; 54, *4*; 58-59, *15*; 65, *27*; 74-75, *48*; 133, *47*; 146-147, *1*; 150, *5*; 152, *11*; 180-181, *9*; 183, *14*; 184-185, *15*;

Archivio Scala 10; 26, *21*; 50; 82; 106; 144; 174; front cover